ROSS HODDINOTT

Digital Macro & Close-up

PHOTOGRAPHY

REVISED & EXPANDED EDITION

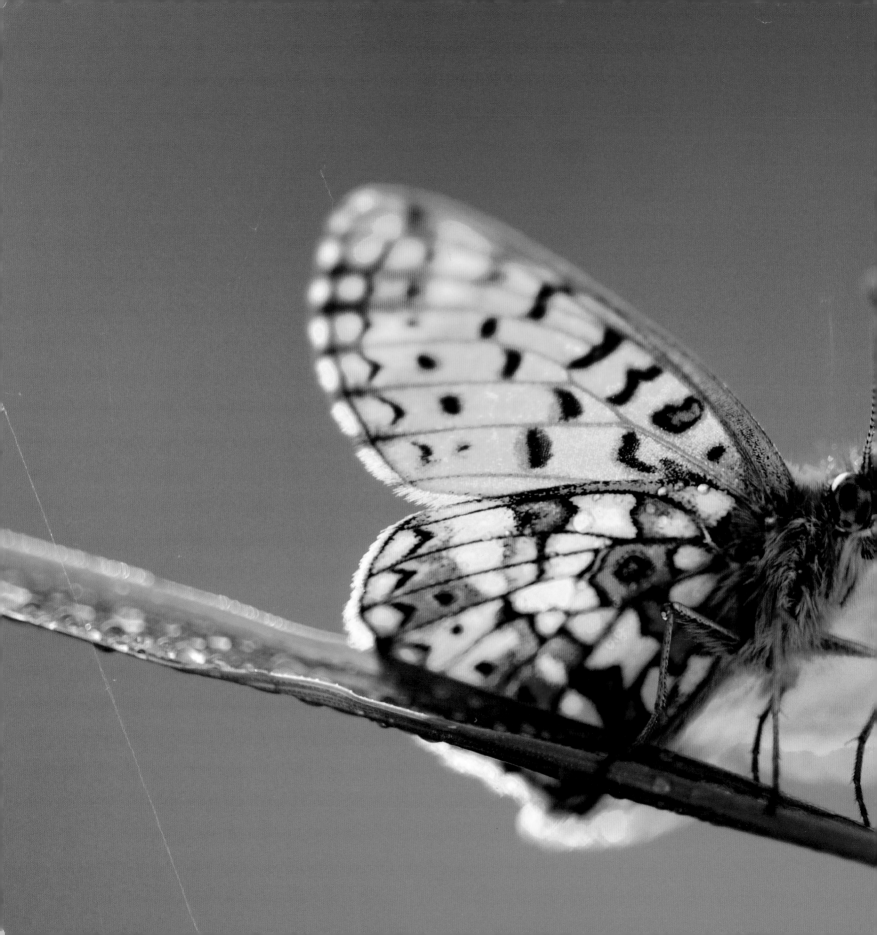

ROSS HODDINOTT

Digital Macro & Close-up
PHOTOGRAPHY

REVISED & EXPANDED EDITION

AMMONITE
PRESS

First published 2013 by
Ammonite Press
An imprint of AE Publications Ltd
166 High Street, Lewes,
East Sussex, BN7 1XU,
United Kingdom

This title has been created with materials first published in Digital Macro Photography (2007)

ISBN 978-1-90770-876-3

A catalogue record for this book is available from the British Library.

Publisher: Jonathan Bailey
Production Manager: Jim Bulley
Managing Editor: Gerrie Purcell
Senior Project Editor: Wendy McAngus
Editor: Susie Behar
Managing Art Editor: Gilda Pacitti
Designer: Robin Shields

Set in DIN
Colour origination by GMC Reprographics
Printed and bound in China

Dedication
To Ronald Bell – a good family friend who introduced me to close-up photography by giving me a set of close-up filters, when I was aged just 9 or 10. He might not have known it at the time, but he helped shape my career. You are sadly missed.

Photo credits:
© 2020VISION/Ross Hoddinott pages 18, 21, 27, 49, 54, 55, 78, 82–83, 85, 93–94, 96, 104–105, 126–127, 136–137, 142–143, 144–145, 161 (bottom).
© Matt Cole pages 69, 71–75.
Additional images by: Olloclip 10 (left); Nikon 10, (right), 15, 27, 38, 66, 70; Panasonic 11; Canon 12, 14, 28 (bottom); Sigma 28 (top); Kenko 34; Novoflex 37; Wimberley 39; Wildlife Watching Supplies 40; Manfrotto 41 (bottom); Joby 41 (top); Lexar 173.

CONTENTS

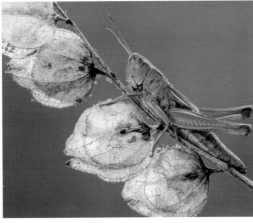

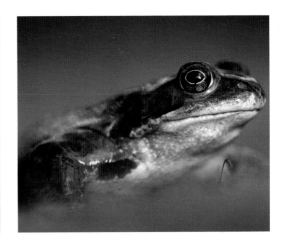

INTRODUCTION

A close-up is a photograph that has been taken at a very short distance away from the subject. This opens up a whole new perspective by allowing an intimate and detailed view but on a relatively large scale.

Through a macro or close-focusing lens, the world around you will appear very different. In close-up, you begin to see and appreciate the design and beauty of miniature things. At magnification, you can reveal exquisite detail and highlight your subject's true shape, form and colour. Close-up photography will completely change your perspective and give you a fresh appreciation for all things small.

I'm often asked why I began shooting close-ups. I have always been fascinated by nature, so when I got my first camera, aged eight or nine, I instinctively wanted to photograph wildlife. Since I couldn't afford long, costly telephoto lenses, birds and mammals were out of my reach. A family friend gave me a cheap, close-up filter to try. For the first time, I was able to shoot frame-filling photographs of wildlife and capture the dragonflies, butterflies and plantlife near my home. I was quickly hooked on macro and close-up photography.

Natural history is my preferred close-up subject – you will no doubt notice a bias towards nature in this book. However, a close approach can suit almost anything; by cropping in tight to an object, you have the ability to highlight, disguise or abstract it. Its great accessibility is one of the biggest appeals of close-up photography.

Macro work has a reputation for being a somewhat specialist form of photography, which deters many photographers. While it is true that shooting at higher magnifications presents certain technical challenges, with a little guidance, knowledge and practice, they are easily overcome. Which is hopefully where this title fits in. While no technique book is exhaustive, *Digital Macro and Close-up Photography* is designed to take you through the steps needed to create your own stunning close-ups. It has a wide range of information, from the kit you need through to technique and advice on how to light miniature things. The final chapter is dedicated to post-processing and ways to realize the full potential of your close-up images. I have also dedicated a section of the book to a number of 'Top Tips' – quick hints and pointers with the ability to significantly improve your close-ups.

Whether you are a complete beginner or enthusiast, hopefully reading this book will benefit your photography. I also hope my enthusiasm for the subject is obvious over the coming pages and that I am able to help, motivate and inspire you to take better macro and close-up images. Have fun and good luck.

REPRODUCTION RATIO – WHAT IS IT?

Reproduction ratio is a way of describing the actual size of the subject in relation to the size it is projected onto the sensor; it does not refer to the size to which the image is subsequently enlarged or printed. For example, if an object 40mm wide appears 10mm on the sensor, it has a reproduction ratio of 1:4, or quarter life-size. If the same object appears 20mm in size, it has a ratio of 1:2, or half life-size. If an object is projected the same size on the sensor as it is in reality, the reproduction ratio is 1:1, or life-size. This can also be expressed as a magnification factor, with 1x being equivalent to 1:1 life-size, 0.5x half life-size, and so on.

MACRO AND CLOSE-UP – WHAT IS THE DIFFERENCE?

The terms 'macro' and 'close-up' are often used interchangeably. However, there is actually a distinct difference between the two. Technically, a 'close-up' is an image captured using a reproduction ratio ranging from 1:10 (0.1x) to just below 1:1 (1x) life-size; while a true 'macro' image depicts a subject at 1:1 (1x) life-size up to 10:1 (10x) life-size. Anything taken with a greater magnification than 10:1 (10x) belongs to the specialist field of photomicrography. Photographers, books and magazines often use the word 'macro' to describe practically any close-up image. Although this is technically incorrect, in truth the distinction is often fairly academic.

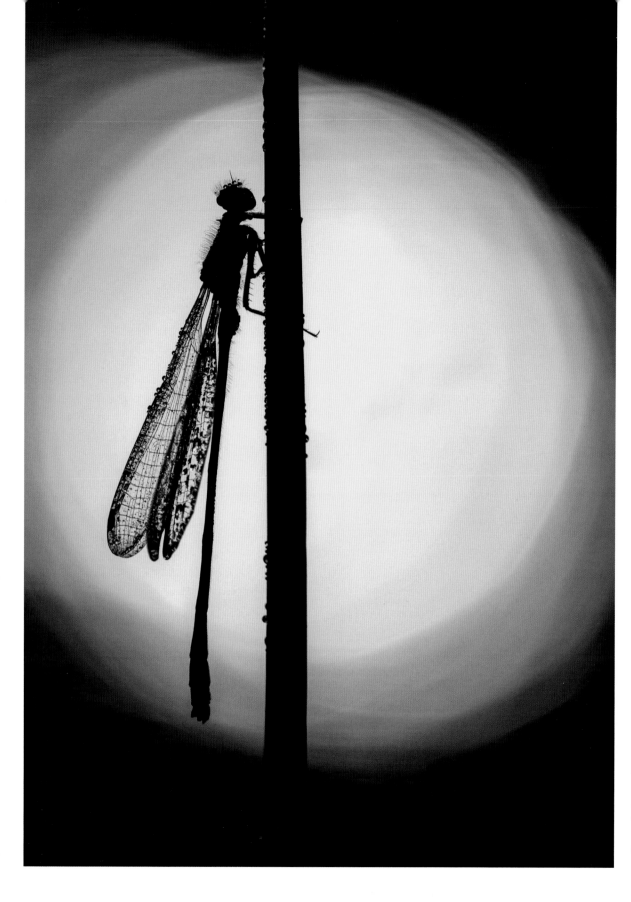

BLUE-TAILED DAMSELFLY
The world of macro and close-up photography is truly fascinating. Using a close focusing lens will completely change your perspective and outlook on the world around you. Arguably, nature is the most popular close-up subject, but there are opportunities to photograph all types of miniature objects and detail everywhere. You don't have to have pricey kit, either, to capture great close-ups. This is a form of photography accessible to all. In this instance, I used a macro lens to reveal the delicate detail of this damselfly.
Nikon D800, 150mm, ISO 100, 1/1250sec at f/6.3, tripod

DIGITAL CAMERAS AND TECHNOLOGY

In order to take great close-ups, you need a good understanding of your camera and how it works, including its key features and also any limitations it might have for this type of work.

Thanks to digital cameras, photography has never been so popular or accessible. Even the cameras on our mobile phones are capable of capturing good-quality images, and many have excellent close-focusing ability too that makes them suitable for shooting miniature objects close by. Compact cameras and bridge cameras can focus on nearby subjects without the use of any attachments. Today, it really is possible to capture great close-ups at anytime and anywhere. However, for close-up enthusiasts, a digital SLR system (pages 12–13) is the best option, providing photographers with the greatest versatility, speed, image quality and level of control. This chapter looks at the different camera options for close-up photography and how best to use them.

SNOWDROP
The equipment you use and how you choose to use it matters. When taking this photo, the correct choice of metering mode (pages 20–21) and white balance (pages 16–17) helped to capture a correctly exposed and natural-looking result. The choice of low ISO (pages 18–19) helped maximize image quality.
Nikon D300, 150mm, ISO 200, 1/320sec at f/4, tripod

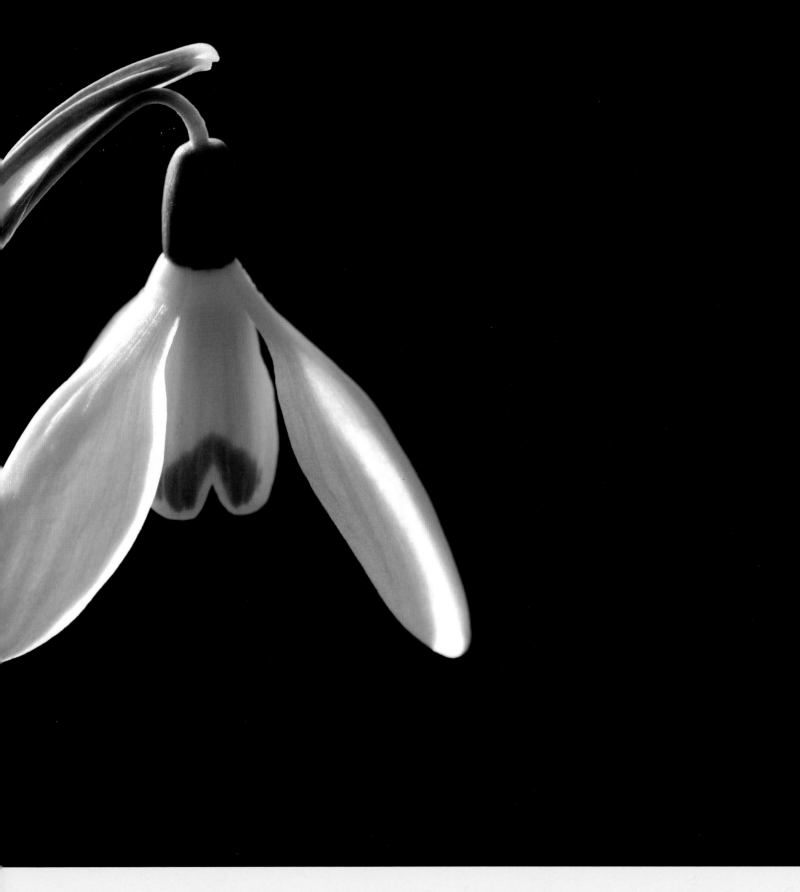

DIGITAL CAMERAS

THANKS TO DIGITAL CAMERAS, PHOTOGRAPHY HAS NEVER BEEN MORE POPULAR.

There is a wealth of different cameras and camera types available for macro photography. The majority are well suited, or can be easily adapted, to capture great close-ups.

CAMERA PHONE

These days the picture quality from camera phones is so good that you can't overlook them. They're typically capable of good near focus, making them surprisingly well suited to point-and-shoot close-ups of inanimate subjects. Since they can struggle to focus on something extremely bright and close up, it is best not to use them to shoot in bright, direct lighting. If you are really serious about shooting close-ups using your mobile, invest in an attachment like the Eye Scope or Olloclip. These clip onto the corner of your iPhone, converting it into a macro, and can generate high levels of magnification of up to 10x. However, in truth, camera phones offer only limited control over settings.

COMPACT CAMERAS

The Panasonic Lumix DMC-LX7 has a macro setting that allows you to focus on a subject just 1cm (⅜ in) away from the lens, when set to 24mm wideangle. Not only is it possible to capture excellent results using a compact but, at their wider settings, depth-of-field is extensive, making it possible to capture eye-catching shots of subjects within their environment.

OLLOCLIP

This clever little attachment is three lenses in one. It easily clips onto your iPhone, converting its lens into either a fisheye, wideangle or macro (see page 28). It works with your favourite apps and is capable of creating a magnification of up to 10x.

COMPACT AND BRIDGE CAMERAS

Digital compact cameras are designed to be small and portable and are generally aimed for casual and snapshot photography, which is why they are sometimes referred to as point-and-shoot cameras. Bridge cameras are higher-end digital cameras that physically and ergonomically resemble a digital SLR and share with them some advanced features and a larger level of control and customization. They are designed to bridge the gap between a compact camera and a digital SLR.

There is a vast range of digital compact cameras and bridge cameras. The lens of a compact or bridge camera is non-interchangeable, but its integral zoom normally offers a versatile range of focal lengths, from wideangle to medium

BRIDGE CAMERA
Bridge cameras offer users greater control over a digital compact, but are more compact and portable than a digital SLR system. Many have a vari-angle monitor – useful for low-level close-up work – and also boast a macro mode, which allows them to focus within just a few centimetres of the subject.

telephoto. Most are capable of a very useful level of magnification and are light and portable. They offer high image quality, particularly at low ISOs, and most have a dedicated macro mode, normally symbolized by a flower, which is designed for close-ups.

The design and specification of both camera types varies hugely depending on model and cost, but most offer users some level of control over exposures. This is important. Close-up photographers require control over aperture size (page 48) in order to vary depth of field (page 50). Without this type of control, you will find creative opportunities severely limited. The minimum aperture of most compacts is no smaller then f/8, but small sensor sizes possess more depth of field, so this is not as limiting

as it sounds. More recently, compact system cameras have been introduced and are growing increasingly popular thanks to their size and lightweight design.

PRO TIP

Some compacts are compatible with close-up attachments, enabling higher levels of magnification. For example, Raynox produce snap-on adapter rings and dioptres (page 31) compatible with a number of non-interchangeable lens camera types.

COMPACT SYSTEM CAMERAS (CSC)
The compact system camera doesn't have a traditional mirror box and a pentaprism. In other words, it lacks an optical viewfinder. Instead, users of micro system cameras use either the rear LCD screen, or an electronic viewfinder, to compose their images. The main benefit of this type of camera over the digital SLRs is that both the camera and optics can be produced smaller and lighter, making them ideal for travel. In addition, dedicated macro lenses are available for compact system cameras. Also, because they house a significantly larger sensor than most compact or bridge cameras, image quality is superior. Quite simply, they are designed to offer high image quality in a convenient, compact form.

DIGITAL SLRs

THE QUALITY AND VERSATILITY OFFERED BY THE DIGITAL SINGLE LENS REFLEX (DIGITAL SLR) MAKES
IT A LOGICAL CHOICE FOR MOST OF YOUR CLOSE-UP WORK.

A digital SLR camera (often called a DSLR) allows the photographer to look through the lens. This is because the camera has a mechanical mirror and pentaprism system that directs light from the lens to the viewfinder at the rear of the camera.

When a picture is taken, the mechanical mirror swings upwards; the aperture narrows (if set smaller than wide open) and the shutter opens so that the lens can project light onto the sensor. This process can occur in just a fraction of a second, with some top-end models offering a continuous frame rate of up to 12fps (frames per second). However, while speed is key for wildlife, sports and action photographers, in reality, most close-up subjects are static, making a digital SLR's speed less significant. Instead, its appeal lies in its high image quality and unrivalled level of control. Due to their larger sensor size, digital SLRs boast excellent ISO performance (page 18–19), allowing higher sensitivities to be selected without a significant drop in quality; this is ideal when shooting close-ups in low light.

Framing and focusing needs to extremely precise when working at higher magnifications and an optical viewfinder still remains best for critical focusing. The large, high-resolution LCD monitors of modern digital SLRs greatly aid image review and Live View focusing (page 56). Although when working in close-up I normally recommend focusing manually (page 56), a digital SLR camera's autofocusing is fast and often reliable. Lastly, digital SLRs are compatible with a vast range of interchangeable lenses, accessories and flash units. As a result, the ability and potential of an SLR system is quite literally endless.

TYPES OF SENSOR

There are three different sensor types used in digital SLRs, which are full-frame, APS-C size and Four Thirds.

A full-frame digital SLR's sensor is 36 x 24mm, and equivalent to a traditional 35mm film negative. This is the largest sensor type employed in an SLR and, due to being more costly to produce, is only found in high-end models. It has no multiplication factor, so the lens attached retains the field of view and lens characteristics that it would have on a 35mm film camera. Full-frame sensors have larger photosites, helping them to capture light with less noise, resulting in smoother, more detailed images. Therefore, full-frame digital SLRs typically boast superior high ISO performance compared to cameras with a smaller chip.

An APS-C size sensor is found in most consumer digital SLRs. This sensor is roughly equivalent in size to 'Advanced Photo System' images, which are 25.1 x 16.7mm. Since it is smaller than the 35mm standard, this format is often referred to as 'cropped'. Due to its smaller sensor size, it appears to multiply the focal length of the lens attached. To what degree depends on the exact size of the sensor, but it is typically 1.5x. Therefore, a 100mm lens will appear to have a focal length of 100 x 1.5 = 150mm when attached to camera with a multiplication factor of 1.5x. This can prove beneficial when shooting close-ups, effectively extending the lens's magnification. Compared to a full-frame model, you can work further away from the subject while achieving the same magnification.

The size of the imaging sensor found in digital SLRs using the Four Thirds system is approximately 18 x 13.5mm (22.5mm diagonal). It has an aspect ratio of 4:3 – hence the name. This is squarer than a conventional frame, which is typically 3:2. The diameter of its lens mount is almost twice as large as the image circle. This allows more light to strike the sensor from straight ahead. The smaller sensor size effectively multiplies the focal length by a factor of 2x, enabling manufacturers to produce smaller, lighter lenses.

DIGITAL SLR
If you wish to take your close-up photography seriously, I would highly recommend a digital SLR. In addition to its high image quality and level of control, it offers superior ergonomics and handling compared to smaller camera types. Digital SLRs also have large, bright viewfinders, which will appeal to photographers who prefer not using Live View.

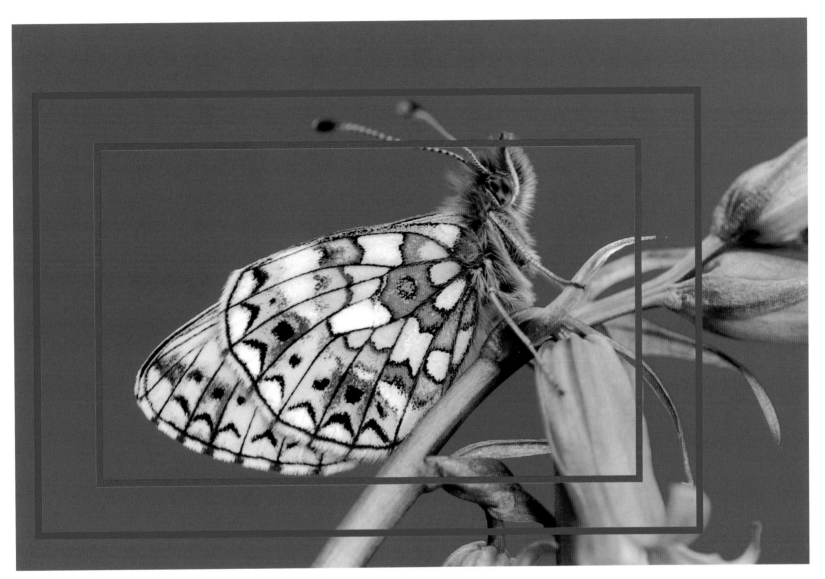

SENSOR SIZES
The full image shows the area captured using
a full-frame sensor, while the coloured rectangles
show the equivalent area that an APS-C size
sensor (blue) and Four Thirds (red) chip would
have captured.

RESOLUTION

THE SENSOR DETERMINES THE CAMERA'S RESOLUTION AND, TO A GREAT EXTENT, IMAGE QUALITY.

Every time you take a photo, your camera makes millions of calculations in order to capture, filter, interpolate, compress, store, transfer and display the image. However, at the hub of a digital camera is the sensor, or digital chip. The two most common designs are Charge-Coupled Device (CCD) and Complementary Metal Oxide Semiconductor (CMOS).

The majority of modern digital SLRs have a high resolution, exceeding 16 megapixels. A megapixel is equivalent to one million pixels. More pixels (or photosites) mean larger files, and the more information a camera records should, in theory, result in sharper, more detailed images. Naturally, this is of particular importance to close-up and macro photographers, as capturing very fine, intricate detail is often a primary aim. Exactly how many pixels you need greatly depends on how you intend to use or market your images. However, presuming you intend to print, sell or enter your images into competitions, ideally opt for a resolution of 16 megapixels or higher. There are advantages of using a camera with a much higher pixel count. Larger, higher resolution files give photographers greater ability to crop results and this is particularly relevant to close-up photographers, as cropping effectively increases the level of subject magnification.

The ability to crop is particularly useful in situations where getting closer to the subject isn't practical due to the risk of frightening the subject away. Alternatively, maybe you've reached the extent of your lens's close focusing ability; or getting closer to the subject would result in obstructing light. In situations like this, the ability to shoot from further away and later crop the image as required is very desirable. This is an option only higher resolution cameras give you.

It's important to underline, though, that more pixels doesn't always equate to better image quality. Squeezing more and more photosites onto smaller digital chips can result in noisier images (particularly in the shadow areas) and significantly worse high ISO performance. For this reason, it is actually possible for a lower resolution digital SLR with a physically larger sensor to capture cleaner, sharper images than a higher resolution digital compact employing a smaller chip. Which is why, if your budget can stretch to it, a full-frame digital SLR is normally the best option for macro photography. However, the image quality of cropped-type digital SLRs is now almost on a par with full-frame, particularly at lower ISO sensitivities. With some digital SLRs now boasting a huge resolution of almost 40 megapixels, manufacturers are expected to place less emphasis on increasing resolution much further, but instead concentrate on pixel quality – exploring ways to further reduce the effects of noise and expand dynamic range.

CMOS SENSOR
CMOS and CCD chips are the most common sensor types. This particular chip is the 22.3-megapixel CMOS full-frame sensor found in the Canon EOS 5D Mark III.

PRO TIP

While large resolution cameras capture more detail, the larger files produced require more card and disc space. However, with digital memory growing increasingly more affordable, this shouldn't prove a major deterrent.

DYNAMIC RANGE

Within the realms of digital photography, dynamic range – also known as contrast range or latitude – refers to the range of intensities that a camera's sensor can record, from shadows to highlights. Our eyes have a remarkably wide dynamic range, allowing us to distinguish between shade and light with incredible speed and accuracy. A digital chip has a much narrower perception, though, and can struggle to simultaneously record detail in the darkest and lightest regions. Therefore, when photographing high-contrast scenes a camera can struggle to record detail throughout. With some types of photography, filtration can solve the problem; or you can merge differently exposed images together in post-processing to effectively extend dynamic range – High Dynamic Range (HDR) photography. However, due to working so near the subject, close-up photographers often have a good degree of control over lighting, being able to employ flash or reflected light in order to lower the level of contrast to within the sensor's dynamic range.

HIGH RESOLUTION

I'm currently using a Nikon D800. It is a full-frame digital SLR with a resolution of 36.2 megapixels. I find it ideally suited to close-ups. Its large file size allows me to capture remarkable detail and sharpness and, if I feel an image would benefit from being cropped, I can do so. Thanks to the camera's large file size, I'm still left with a sufficiently large file for high-quality reproduction.

WHITE BALANCE

WHITE BALANCE (WB) IS INTENDED TO NEUTRALIZE THE COLOUR CASTS THAT ARE PRODUCED BY DIFFERENT TEMPERATURES OF LIGHT.

Our eyes are so sophisticated that they naturally adjust for the temperature of both natural and artificial light. This enables us to always see it as white or neutral. However, a chip is not so discerning, which is why it needs a helping hand in the form of white balance.

COLOUR TEMPERATURE

Every light source contains varying amounts of the three primary colours: red, green and blue (RGB). At lower temperatures, a greater percentage of red wavelengths are emitted, making light appear warmer; higher temperatures have more blue wavelengths so it appears cooler. The light's temperature is measured in degrees Kelvin (K). For example, the warm light of a candle flame has a low value in the region of 1,800K, while shade under a blue sky is equivalent to around 7,500K. Light is considered neutral at around 5,500K, which is roughly equivalent to equal amounts of the RGB wavelengths of white light.

In order to capture close-ups with faithful colours, you need to match the colour temperature of the light falling on the subject with the appropriate white balance value. Digital SLRs, and many compacts too, are programmed with a choice of white balance presets, designed to mimic a range of common lighting conditions, such as 'daylight', 'cloudy' and 'shade'. By setting white balance, you are telling the camera that the light is that colour, so that it can bias settings in the opposite direction. Cameras also have an auto white balance mode (AWB), which is very reliable in most types of light. It is possible to select a custom white balance as well, and there are tools like a grey card or ExpoDisc designed to help evaluate the light's temperature precisely. However, it is important to underline that it is often the light's colour and quality that helps make the image. For example, I often photograph butterflies early in the morning when they are still relatively inactive. At this time of day and close to sunset, the light is much redder and more golden than it is at other times. The light's quality and warmth can often prove a key ingredient to the image's success, so in instances like this, I would rarely opt to neutralize the light's temperature. If you are shooting in Jpeg, it is important to get white balance correct in-camera, as colour casts are trickier to remove later. However, if – as I recommend – you shoot in Raw format (page 172) you can easily alter colour temperature during post-processing. Therefore, in most situations, I tend to take photos with white balance set to 'auto' for ease and speed, and later fine-tune colour temperature and tint in my Raw converter.

Although white balance is intended for correction, it can just as easily be used creatively. By deliberately mismatching white balance, it is possible to generate colour casts. For example, by selecting the camera's 'incandescent' or 'fluorescent' preset in normal daylight, you will create a cool blue hue; while setting the 'cloudy' or 'shade' preset will warm up photos. Shifts in colour can radically change the overall feel of an image. However, in practice, you will want to record light authentically for most close-up subjects; just be aware that the most pleasing result will not always be created by choosing the technically correct result.

COMPARING WHITE BALANCE PRESETS
This image sequence should help illustrate the effect of different white balance settings. Presets designed to correct a low colour temperature, like 'tungsten' and 'fluorescent', will cool down an image; while settings designed to balance a high colour temperature, like 'cloudy' and 'shade', will produce a warm cast. Auto is normally highly reliable, but it can be deceived, particularly by scenes in which one colour dominates. I took this close-up of a silhouetted dew-laden grass just as the sun was rising. In this instance, the natural warmth of the sun is an integral part of the image, but in auto mode, the camera attempts to neutralize the light. Instead, the 'daylight' setting produces the most faithful result.
Nikon D800, 150mm, ISO 100, 1/sec at f/11, tripod

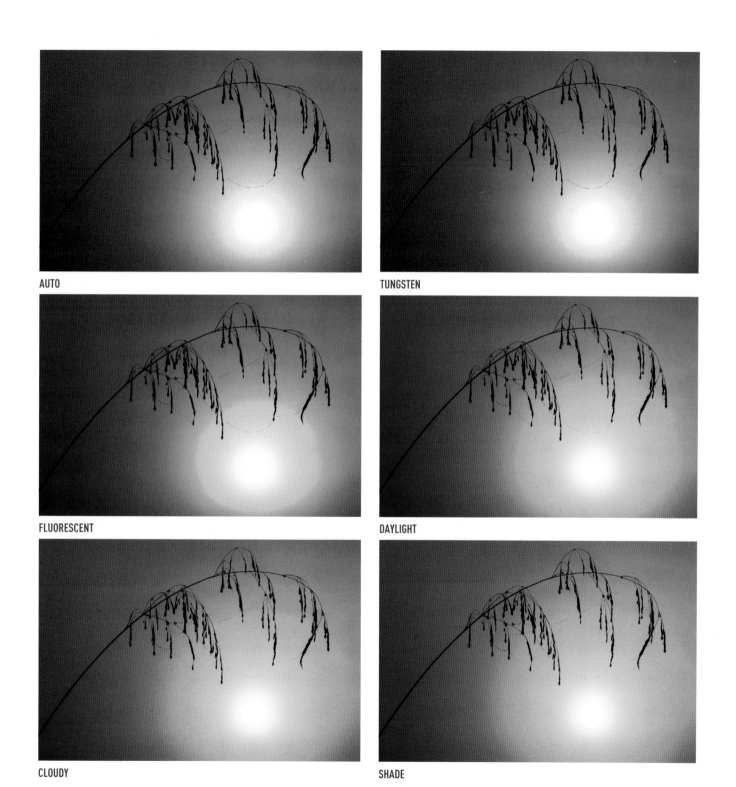

AUTO

TUNGSTEN

FLUORESCENT

DAYLIGHT

CLOUDY

SHADE

ISO SENSITIVITY

ISO (INTERNATIONAL STANDARDS ORGANIZATION) REFERS TO A SENSOR'S SENSITIVITY TO LIGHT.

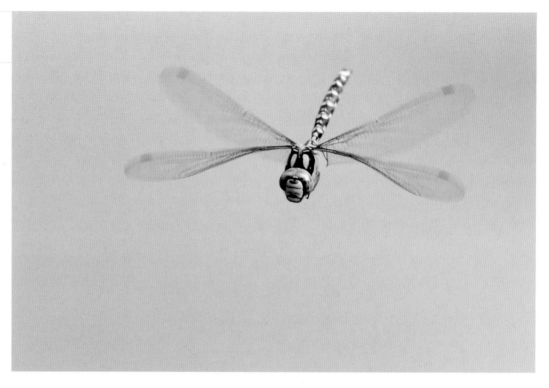

The term comes from film photography, when film was rated depending on the way it reacted to light. A low ISO rating is less sensitive to light, which means that the sensor requires longer exposure to achieve a correctly exposed result. A high ISO equivalency number is more sensitive to light, meaning the sensor needs less exposure. Increasing ISO is a useful way to generate faster shutter speeds in order to freeze subject motion or to eliminate camera shake in low light.

A camera's ISO range varies from camera to camera, but most today have a large native sensitivity range, ranging from as low as ISO 50, up to a staggeringly high 102,400. Just as they are for aperture and shutter speed, changes to ISO are measured in stops. Each time the sensitivity is doubled it is equivalent to one stop. For example, adjusting sensitivity from ISO 100 to 200 will generate one stop of light, ISO 400 two stops and so on. Therefore, ISO sensitivity has a direct influence on the exposure. For example, at low sensitivities, more light is required to expose the sensor. This means that you either need longer exposure or a wider aperture. At higher ISOs, less light is required (a faster shutter speed or smaller f/number) to achieve the right exposure.

The drawback of employing higher ISOs is that random digital noise (see box) is enhanced, which can obscure fine detail. For this reason, if you select the camera's lowest ISO setting, you will maximize image quality. Having said that, modern digital SLRs boast excellent high ISO performance, making it more and more possible to employ higher ISOs without significantly

degrading image quality. This is highly relevant to close-up photographers. For example, the risk of camera shake is greatly enhanced at higher magnifications, as even the smallest movement appears greatly exaggerated.

In situations where a tripod can't be used, 'upping' the ISO generates a faster, more practical shutter speed, and greatly enhances the likelihood of capturing sharp, shake-free close-ups handheld. Even in situations where you don't require a faster shutter, increasing the ISO can still be useful and a smaller aperture can be used. This means you will generate a larger depth of field (page 50) without having to lengthen shutter speed. At high magnifications, when it can be tricky to simultaneously achieve a sufficiently fast shutter speed and large enough depth of field, the ability to increase the ISO is a welcome one. Therefore, if you are buying a digital SLR for the first time, or upgrading, a camera's high ISO performance is a key consideration.

DRAGONFLY IN FLIGHT
To photograph this hawker dragonfly in flight, I required a fast shutter speed capable of freezing its rapid movement. Natural light was insufficient to do this, but by setting ISO 1000, I was able to generate a shutter speed of 1/1250sec. Without upping the ISO, images like this just wouldn't be possible without employing an elaborate flash set-up.
Nikon D300, 70–200mm (at 200mm) TC-20III, ISO 1000, 1/1250sec, at f/5.6, handheld

PRO TIP

The high ISO performance of most modern digital SLR cameras is so good today that photographers can, when required, work at speeds of ISO of 3200 or higher and still capture good-quality results.

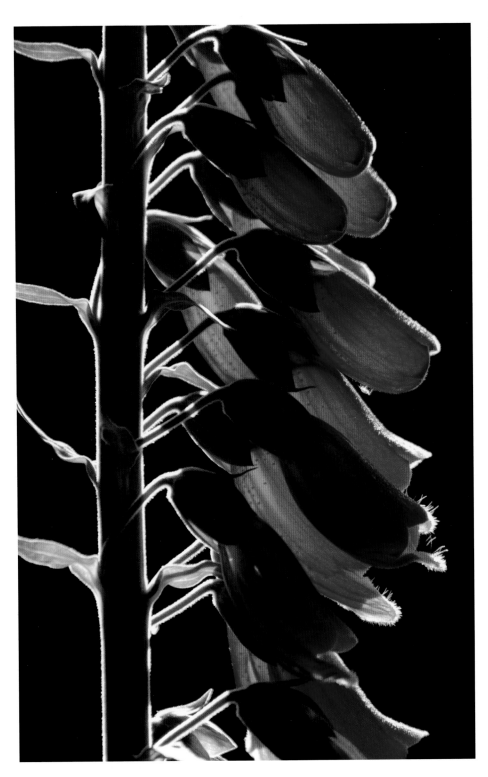

NOISE

Noise is the digital equivalent to film grain and can manifest as unrelated, brightly coloured pixels appearing randomly throughout the image. Today, noise is almost invisible at a camera's lowest ISO rating, but increasing the sensor's sensitivity to light amplifies it. There are different types of noise such as, 'random' or 'fixed pattern' noise. Since it can also affect long exposures – typically upwards of 8 seconds – many digital SLRs have a long exposure noise-reduction function. Advances in sensor technology have greatly reduced the effects of noise at higher ISOs. That said, it is still advisable to select the lowest practical ISO for any given situation. The effects of noise can be reduced during post-processing using noise-reduction software, such as Photoshop or Noise Ninja.

FOXGLOVE
Although modern digital SLRs boast excellent high ISO performance, when practical, it is still best to select the camera's lowest ISO number. This will help minimize the effects of noise and, therefore, aid the capture of fine detail. When photographing this foxglove, I was able to use a tripod, and as a result, it was practical to employ the camera's lowest sensitivity.
Nikon D300, 400mm, ISO 200, 1/250sec at f/9, tripod

EXPOSURE MODES

DIGITAL SLRS, AND ALSO MANY SMALLER FORMAT DIGITAL CAMERAS, HAVE A CHOICE OF EXPOSURE MODE.

Although most cameras have a range of pre-programmed modes, I recommend you rely on the 'core four': programmed auto, aperture priority, shutter priority and manual mode. They are often referred to as the 'creative modes', offering a level of control that will appeal to close-up enthusiasts.

PROGRAMMED AUTO

Programmed auto (P) is a fully automatic mode, in which the camera selects both aperture and shutter speed. However, you can't rely on this mode to achieve consistently good results, since the camera cannot predict the effect you wish to achieve. In reality, it is best suited to snapshot photography.

SHUTTER PRIORITY MODE

In shutter priority (S or 'Tv') mode, you select the shutter speed, while the camera sets the corresponding f/number. Typically, shutter speeds can be set to values ranging from 30sec to 1/4000sec. This mode is useful for determining how motion will be rendered. For example, to blur subject movement select a slow shutter speed, but if you wish to freeze it, prioritize a fast shutter speed. Shutter priority is useful when photographing moving subjects, such as a hoverfly visiting flowers. It is also useful when you need a shutter fast enough to eliminate camera shake. However, by prioritizing a fast shutter, the camera will need to select a large aperture, which means that depth of field will usually be shallow.

APERTURE PRIORITY MODE

Aperture priority (A or 'Av') works in reverse to shutter priority; you select the f/stop and the camera sets the shutter speed. For close-up photography, this is a camera's most useful mode. Aperture priority gives photographers full creative control over depth of field; the smaller the aperture, the larger the zone of sharpness will be and vice versa. Depth of field dictates what will and won't be recorded as 'sharp' in the final image and it is a key control for capturing creative close-ups. The range of apertures available is not determined by the camera itself, but by the lens attached.

MANUAL MODE

In manual (M) mode, the photographer sets both aperture and shutter speed. Although a very flexible mode, it is the one that relies most on the photographer. Just as with the other modes, the camera takes a light reading from the subject when the shutter-release button is semi-depressed. However, rather than applying the values to the exposure settings, the information is only displayed in the viewfinder and/or LCD control panel. It is left to the photographer's discretion whether to use them or ignore the recommended settings in order to expose creatively.

❁ MACRO PICTURE MODE

In addition to the 'core four' exposure modes, most digital cameras are designed with a choice of subject-biased picture (or subject) modes. They are programmed to bias settings to suit specific types of photography, with the camera setting both aperture and corresponding shutter speed. Picture modes don't offer photographers a great degree of control, but they can prove helpful to beginners unsure about which settings to select in certain shooting conditions. Most cameras boast a 'macro' picture mode – typically represented by a flower symbol on the mode dial. In this mode, your camera will try to select the best f/stop and shutter speed combination to provide adequate depth of field to render miniature subjects in focus. Normally, the camera will also activate the central AF sensor as it assumes the subject will be positioned centrally. Picture modes are designed to do all the hard work in order to allow the photographer to concentrate on taking photos. However, in practice, Aperture Priority remains the mode best suited to macro.

PRO TIP

Regardless of the exposure mode you employ, a camera's TTL (through-the-lens) metering can usually be relied upon to achieve correctly exposed results. However, it is not infallible and in awkward light, exposure errors can occur. Thankfully, this is easy to detect by reviewing the picture's histogram (page 22) and simple to correct using exposure compensation (page 67).

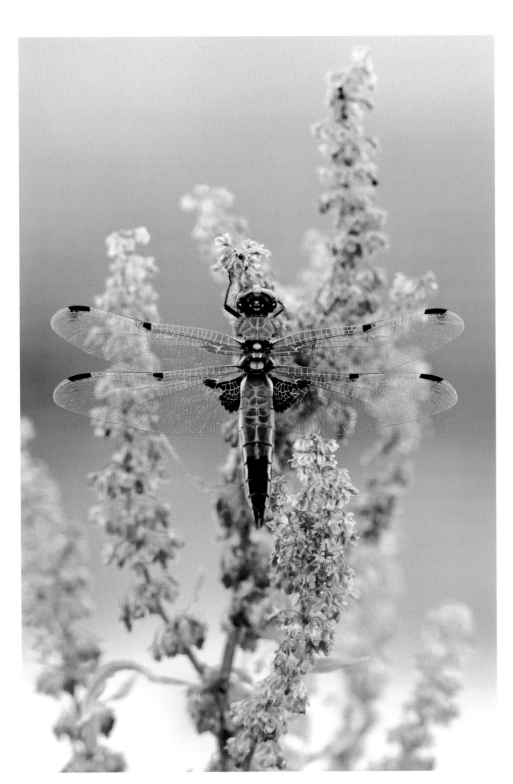

FOUR-SPOTTED CHASER DRAGONFLY
Despite the choice of exposure modes, aperture priority will prove the best mode in the vast majority of shooting situations. It offers the perfect mix of control and ease of use, allowing close-up photographers to quickly and efficiently select the aperture they require and therefore the amount of depth of field. For the majority of my images – including this one – I use aperture priority, as depth of field is often a close-up image's key ingredient.
Nikon D300, 150mm, ISO 200, 1/60sec at f/4, tripod

HISTOGRAMS

A HISTOGRAM IS A TWO-DIMENSIONAL GRAPH THAT REPRESENTS AN IMAGE'S TONAL RANGE.

Whatever subject you're photographing, close-up or otherwise, a camera's histogram screen is arguably its most useful tool. Interpreted correctly, it will help you always achieve good exposures.

When you replay an image on the camera's monitor, it is possible to scroll through several pages of picture information. The histogram is the most useful, providing a graphic illustration of how the tones are distributed in that particular photo. Histograms are two-dimensional graphs, typically resembling a range of mountains. The horizontal axis represents the image's extent from pure black (0, far left) to pure white (255, far right); while the vertical axis shows the amount of pixels that have that value.

When a histogram shows a large proportion of pixels grouped close to either edge, it's often an indication of poor exposure. A large peak to the left of the graph means there are a large number of dark pixels – potentially a sign of underexposure; while peaks to the right of the graph can indicate that the shot is overexposed, with detail lost in the highlights. When this happens, a histogram is often referred to as being 'clipped'. A graph with a narrow peak in the middle, which lacks black or white pixels, represents a photo that lacks contrast.

With just a little practice, reading histograms is straightforward. Although photographers often strive to achieve the 'perfect' histogram – one showing a good range of tones across the horizontal axis, with the majority of pixels positioned around the middle (128, mid-point) – in reality, there is no such thing. A histogram simply informs photographers how an image is exposed, allowing them to decide whether, and how, to adjust exposure settings.

EXPOSING TO THE RIGHT

When shooting close-ups, you want to capture the biggest, highest-quality file possible. If you shoot Raw (page 172), you can use a technique known as 'exposing to the right' (ETTR). This requires you to push exposure (using positive (+) compensation) as far to the right of the graph as possible, without clipping highlights. This will produce Raw files with more tonal information and less noise. This is because sensors are linear devices, with each stop of its dynamic range recording half the light of the previous one.

For example, say your camera has a usable dynamic range of six stops and is able to capture a 12-bit file, capable of recording 4,096 tonal levels (the more tonal levels, the smoother the transition between tones). An image's tones are not spread evenly throughout the sensor's brightness range, though. Instead, half are located in the brightest stop (2,048); half the remainder (1,024) is devoted to the next stop, and so on. As a result, the last and darkest of the six-stop range only contains 64 brightness levels. Therefore, if you lighten an underexposed image during processing, the tonal transitions will not be smooth due to working with fewer tonal levels. In contrast, if you record more data in the sensor's brighter stops, you will capture more valuable data.

The difference in file quality is easy to illustrate by taking two images – one exposed normally and the other exposed to the right. Compare the file sizes and you will notice that the ETTR image is larger. Although, at first glance, ETTR images appear too bright and lack contrast, simply adjust the exposure, brightness and contrast sliders during Raw conversion in order to achieve a technically correct final result.

Exposing to the right will lengthen exposure time, something that, when photographing wildlife or working handheld, may not be practical to do. However, when shooting inanimate subjects while using a tripod, ETTR will ensure you capture the best-quality Raw files.

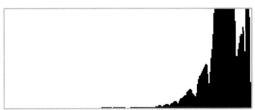

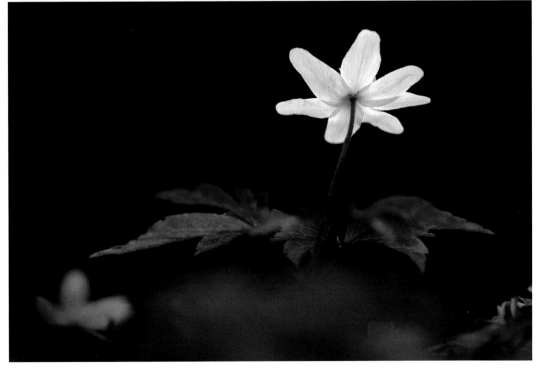

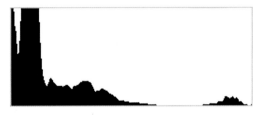

HISTOGRAMS

Histograms can vary greatly depending on the subject and the result desired. While an even spread of pixels throughout the greyscale is considered desirable, when assessing histograms, remember to consider the subject's colour and brightness. For example, if you are photographing a close-up of a white flower, expect the graph to be naturally skewed to the right. When photographing a silhouette or subject with a dark background, expect graphs to be weighted to the left. By regularly reviewing histograms, you can quickly identify exposure errors and rectify them using compensation (page 44). These two images are both correctly exposed, but have very different looking histograms due to the subject matter.

LENSES AND ACCESSORIES

In order to achieve frame-filling shots of miniature subjects, you'll need some specialist equipment. Spending wisely can reduce your outlay.

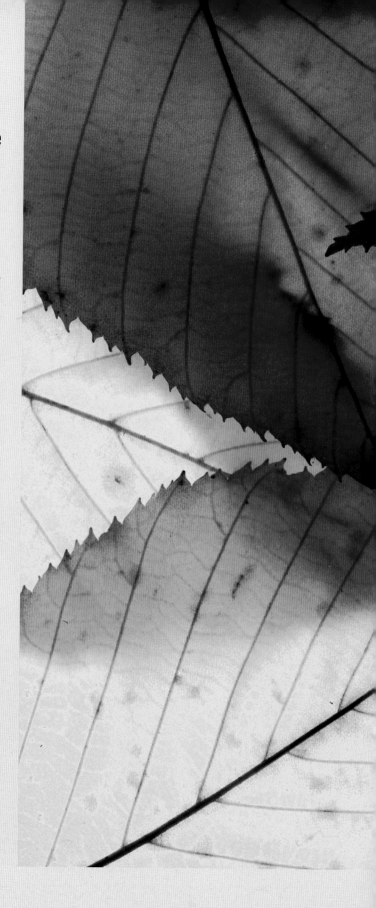

Although many of today's kit lenses and telephoto zoom lenses have a useful maximum reproduction ratio of 1:8 or 1:4 life-size, they are limited when it comes to close-up photography. If you want to capture truly awe-inspiring close-ups, you need to invest in either a close-focusing lens or close-up attachment. If budget is no object, a dedicated macro lens (page 28) is the best option. Although they can be pricey, macros are optimized and designed for this type of photography and are the perfect choice for close-up enthusiasts. However, you don't have to spend a small fortune in order to capture great close-ups. There are a number of good, relatively inexpensive attachments available that work by transforming standard optics into close focusing ones; close-up photography really is accessible to everyone, regardless of your budget. I began by using cheap close-up filters (page 30) in combination with an everyday, standard lens. These provide a low cost, low-risk introduction to close-up photography.

Your choice of lens is important since it determines the level of magnification you can achieve and working distance. In addition, there are a number of useful accessories that will greatly aid your close-up photography. This chapter is designed to highlight the options available and help you make good decisions when investing in close-up kit.

BACKLIT LEAVES
To capture great close-ups, you need either a close-focusing lens or attachment. There are a number of options, to suit every budget. Close-up filters and extension tubes are easy to use and typically inexpensive. However, without doubt, a dedicated macro lens is the best long-term choice for close-up enthusiasts. While I started out using close-up filters, today I favour a macro lens for capturing images like these backlit autumn leaves.
Nikon D200, 150mm, ISO 100, 1/10sec at f/11, lightbox, tripod

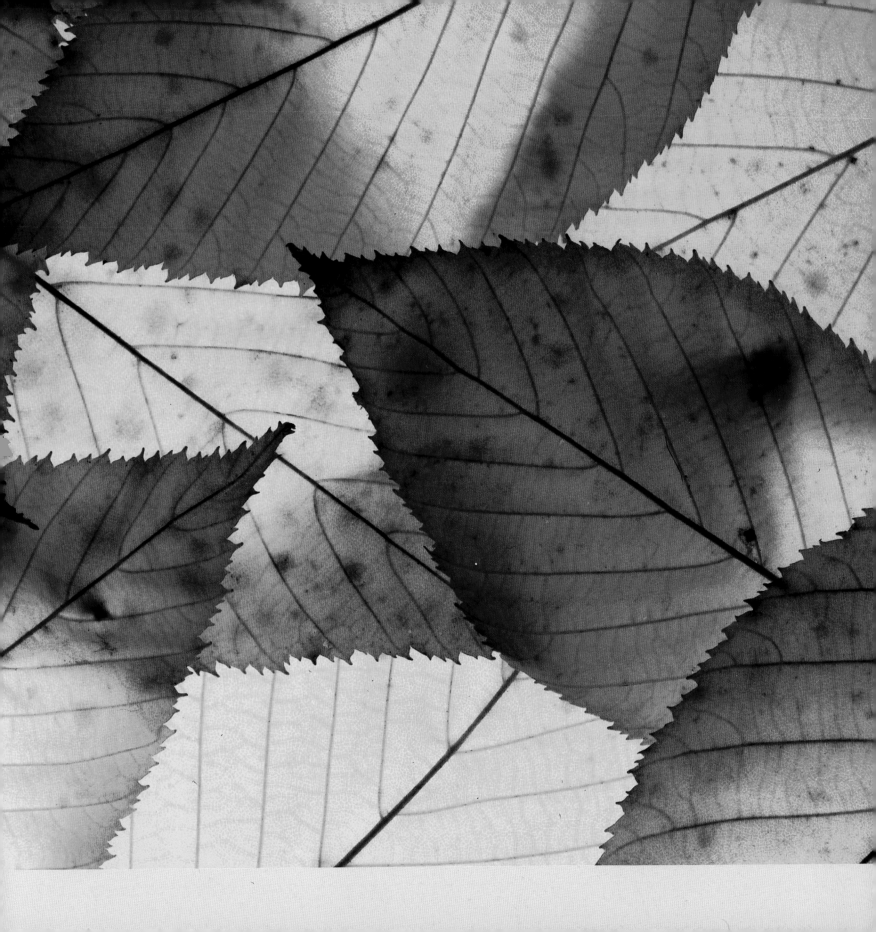

TYPES OF LENS

MANY OF TODAY'S OPTICS HAVE IMPRESSIVE CLOSE-FOCUSING ABILITY, OFFERING A USEFUL LEVEL OF MAGNIFICATION, WHILE OTHERS CAN BE EASILY ADAPTED BY USING CLOSE-UP ATTACHMENTS.

Since different focal lengths provide different perspectives and opportunities, close-up photographers should ideally carry a good range of focal lengths. Wideangle, fisheye and telephoto lenses all have a place in macro photography.

WIDEANGLE LENS

A focal length of or below 35mm is generally considered to be wide-angle, which means that it possesses a wider field of view than the human eye. Their wide, stretched perspective means that wideangle lenses are most closely associated with landscape photography. However, they are designed with a short minimum focusing distance (typically in the region of 4–12in/10–30cm), which means they are suitable for larger close-up subjects, like dragonflies, fungi and large flowers. Although you need to get very close to your subject to capture it large in frame, a wideangle creates a unique, distorted perspective, capable of producing close-ups with a real three-dimensional quality. They naturally possess an extensive depth of field – even at relatively large f/numbers – allowing you to capture images of your subject looming large in frame, but still within its background. A wideangle is the perfect lens choice for capturing environmental portraits, which can convey far more about your subject, its size and surroundings than a normal close-up. It's worth bearing in mind, though, that when working so close to your subject, natural light can be severely restricted.

FISHEYE LENS

For the most extreme effect, consider a fisheye lens. Offering a field of view of 180° or more, fisheyes are typically between 8–15mm. Two types are available: circular and full frame. Circular fisheyes create a circular image surrounded by black edges; while full-frame fisheyes fill the frame. They create a huge degree of distortion, capable of producing extraordinary looking results of nearby objects.

STANDARD LENS

A focal length in the region of 50mm – roughly equivalent to our own eyesight – is considered a standard lens. They display minimal distortion and provide a natural-looking perspective, although they are often considered to be a rather boring lens type. Standard 50mm prime lenses have now been greatly superseded by more versatile 'standard zooms', boasting a focal range in the region of 28–80mm. However, a standard 50mm lens is an excellent lens choice for photographers intending to use a close-up attachment. It is generally considered the best lens type to use with close-up filters, extension tubes, or for 'reversing' (page 27). Why? Well, they are typically inexpensive, optically excellent and boast a fast maximum aperture of f/2 or faster. Close-up attachments are generally best combined with the optical quality and speed of a prime lens, and 50mm is a very suitable focal length. You certainly shouldn't overlook their usefulness for close-up photography.

TELEPHOTO LENS

A focal length that exceeds 50mm is generally considered telephoto. They have a narrower angle of view to the human eye, so a scene or subject appears magnified. Both fixed focal length telephotos and tele-zooms are available. The longer the focal length, the more they foreshorten perspective. While designed to magnify, they are not really intended for small, close-up subjects; instead, they're aimed for more distant objects. Typically, they are constructed with a fairly restrictive minimum focusing distance of 5ft (1.5m) or longer. As a result, they are not well suited to shooting small subjects. However you can use extension tubes to reduce their minimum focusing distance and effectively increase magnification. This makes them suitable for larger subjects like orchids or even larger insects.

Due to their inherently shallow depth of field, longer focal lengths are useful for isolating subjects against a nicely diffused out-of-focus background. However, due to their weight and size, a tripod – or beanbag if working at ground level – is usually essential for stability when using a telephoto for close-up subjects. Due to their power, telephotos allow you to work from further away, so they are ideally suited to photographing timid subjects, like reptiles.

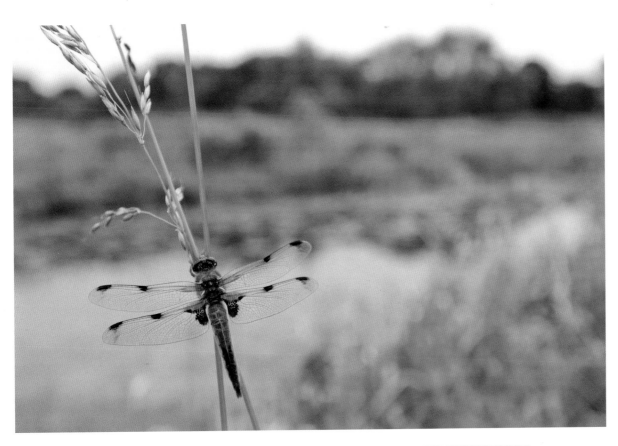

TELECONVERTER

The teleconverter, also known as an extender, is an accessory placed between the camera and lens. It works to magnify the focal length by the converter's strength. They are typically made in 2x and 1.4x strengths and can prove a useful addition to a close-up photographer's kit bag. Small and lightweight, they allow close-up photographers to shoot subjects from further away. However, by placing extra elements between the lens and camera, converters inevitably degrade image quality to some degree. Although the effect is negligible, it is advisable to buy the best-quality converter you can afford, and one that matches your lens. Converters also absorb light. Attaching a 1.4x extender will incur a 1-stop loss; while using a 2x converter will result in a 2-stop light loss. Therefore, attaching a 1.4x extender to a telephoto with a maximum aperture of f/2.8 would effectively make f/4 the widest f/stop available to you. Your camera's TTL metering (page 20) will automatically compensate for the loss of light. Not all lenses are compatible with teleconverters, so check before you buy.

FOUR-SPOTTED DRAGONFLY
Shot with a wideangle, this dragonfly can be seen in close-up within its surroundings. This is due to the wideangle's large depth of field. Images created with a wideangle can covey far more about the subject, its size and surroundings than a generic close-up.
Nikon D700, 17–35mm (at 35mm), ISO 400, 1/100sec at f/8, tripod

AF-S NIKKOR 50MM F/1.8G
A standard 50mm lens is not generally considered very exciting or useful today. However, they are optically superb, fast and inexpensive. They are an ideal focal length for 'reversing', using with extension, or in combination with close-up filters.

MACRO LENSES

MACROS ARE SPECIALIST LENSES CAPABLE OF FOCUSING FAR CLOSER THAN ANY CONVENTIONAL LENSES ARE ABLE TO DO. THIS MAKES THEM A VALUABLE ADDITION TO THE ENTHUSIAST'S KIT.

Although many of today's standard and tele-zooms have the word 'macro' in their title, only a lens capable of a reproduction ratio of 1:1 life-size can be truly classed a macro lens. Thanks to their highly corrected optics, they offer high image quality at high magnifications. For quality and ease of use, the macro lens is the number one choice for close-up enthusiasts.

Macros don't require any attachments in order to achieve a (truly macro) reproduction ratio of 1:1 life-size. This is when the subject is projected onto the imaging sensor the same size as it is in reality. The vast majority of macro lenses are produced in prime, fixed focal lengths, ranging from 35mm up to 200mm. While, barring one or two exceptions, they all offer the same level of magnification (1:1 life-size), the actual focal length itself is still very significant, helping determine the lens's weight, size and working distance. Typically, macros are available in two types: 'short' and 'tele'.

SHORT MACRO

This type of lens tends to have a focal length of between 35mm and 90mm. Physically, they are quite compact and relatively lightweight, making them well suited to being used handheld. This is ideal when speed and manoeuvrability are the biggest priorities – when stalking butterflies, for example. Short macros also tend to be less costly. However, they don't provide a very large camera-to-subject distance, meaning you have to get near to your subject should you wish to achieve frame-filling shots. While this isn't a problem when the subject is static, if you wish to photograph wildlife, you will want to work from further away.

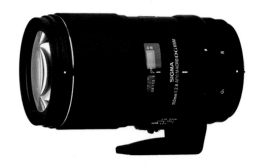

SIGMA 150MM F/2.8 EX DG OS MACRO
Before buying a macro lens, consider what type of subjects you will be shooting. This will help you decide whether to invest in a 'short' or 'tele' macro. If it is mostly inanimate subjects, like still lifes or flowers, then it won't matter if you have to get very close to them – they're not going to jump or fly away. Therefore, opt for a 'short' macro in the region of 40–90mm. However, if you wish to shoot more timid subjects, such as insects and amphibians, I'd strongly recommend you opt for a longer focal length in order to generate a more generous working distance.

CANON MP-E 65MM F/2.8 1-5X MACRO
Few lenses offer a magnification greater than 1:1 life-size without the help of a supplementary close-up attachment. However, the Canon MP-E 65mm is a unique macro lens, designed to achieve magnifications exceeding life-size unaided. This is a very specialist lens, but one that will appeal to macro specialists who are also Canon users. Using the lens it is possible to capture subjects at up to 5x life-size – allowing photographers to capture extraordinary images of miniature subjects. The lens design contains UD-glass elements to suppress chromatic aberrations, which often become apparent at high magnifications.

IMAGE STABILIZING
An increasing number of macros now benefit from Optical Image-Stabilizing (OIS) technology. OIS is designed to compensate for the photographer's natural movement, minimizing or eliminating the degrading effect of camera shake. 'Shake' shifts the angle of incoming light relative to the optical axis during exposure, resulting in image blur. OIS technology can allow photographers to shoot at up to 3 or 4 stops slower than would otherwise be possible. Using internal motion sensors, or gyroscopes, it works in inverse relation to the lens's movement, maintaining the position of the incoming light rays on the sensor.

Lens brands have different names for this technology: for example, Image Stabilization (Canon); Vibration Reduction (Nikon); Optical Stabilization (Sigma) and Vibration Compensation (Tamron), but the principle of the design remains the same. This technology can prove hugely beneficial to close-up photographers when there is no choice but to work handheld. It allows sharp, shake-free images to be captured at slower shutter speeds – without OIS, the alternative is to select a higher ISO (page 18) setting, but this will affect image quality to some degree.

TELEMACRO

This lens has a focal length upwards of 90mm, which gives a larger working distance. This is particularly useful for nature since it helps to minimize the risk of disturbing subjects. Due to their narrower angle of view, they appear to produce a narrower depth of field compared to shorter macros. This means your focusing must be precise when using one, as the zone of sharpness, even at smaller f/stops, can be wafer thin. That said, the shallower depth of field created by longer lengths can actually prove very beneficial to your close-ups, throwing foreground and background detail quickly out of focus and helping your subject standout. They do tend to be long, weighty and costly, though. They are also best used in combination with a support and most telemacros with a focal length of 150mm or more are supplied with a tripod collar.

All macros tend to boast a fast maximum aperture in the region of f/2.8. Not only does this help provide a lovely bright viewfinder image, aiding focusing and composition, but the narrow depth of field provided at the lens's maximum aperture is ideally suited to capturing close-up images with beautifully diffused backgrounds.

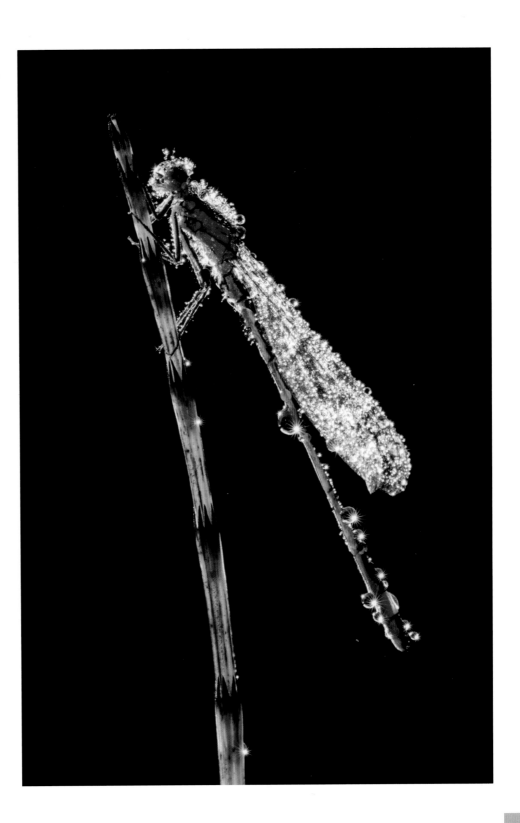

PRO TIP

Although optimized for close-focusing, macros are also suitable for general photography and are particularly popular for shooting flattering portraits.

BLUE-TAILED DAMSELFLY
Like many of my close-up images, I took this damselfly with a telemacro. Although the lens is physically quite large and weighty, the focal length provides a good, practical working distance from easily disturbed subjects.
Nikon D800, 150mm, ISO 200, 1/2sec at f/22, tripod

CLOSE-UP FILTERS

CLOSE-UP FILTERS ARE AN AFFORDABLE WAY TO TRANSFORM A NORMAL LENS SO YOU CAN SHOOT MINIATURE SUBJECTS. THESE CIRCULAR SCREW-IN TYPE FILTERS ACT LIKE A MAGNIFYING GLASS.

The simplest, most affordable way to shoot miniature subjects is to use a close-up filter (also known as a supplementary close-up lens). These filters act to reduce the lens's minimum focusing distance, and, by doing so, are able to transform a normal lens into one with close-focusing ability.

Close-up filters are lightweight, don't affect the camera's automatic functions (like metering and autofocusing) or reduce the amount of light entering the lens. They couldn't be easier to use; you just screw one onto the front of your lens and you are ready to take close-ups. They are inexpensive and perfectly suited to newcomers and photographers on a budget. Most major filter brands have close-up filters in their range – including Hoya, Kood and Nikon. Also, Raynox and Micro Tech Labs are among the companies to introduce a new range of high magnification dioptres.

Close-up filters work by shifting the camera's plane of focus from infinity to the distance corresponding to the focal length of the close-up lens attached. Their level of magnification is measured in dioptres – a unit you might be familiar with from visits to an optician. They are convex meniscus-type lenses, which means that they are thicker in the middle than at the edges, and are usually a single-element construction. They are available in a range of strengths, typically +1, +2, +3 and +4. The higher the number, the greater is their magnification.

Powerful +10 versions are also available, but they tend to be of lower quality. Filters can be purchased singly or as a set and, generally speaking, are best used with short prime lengths, in the region of 50mm–135mm. They also work perfectly well with zooms and are suited to all types of close-up subject, from still lifes to nature. However, they don't provide a large working distance, so be prepared to get close to your subject to capture frame-filling shots.

BACKLIT LEAF
When viewed at 100% or larger, the telltale signs of using a close-up filter – spherical and chromatic aberration – often grow obvious. However, viewed or printed at a normal size, images like this backlit leaf – captured using a +3 dioptre – look sharp and are difficult to discern from ones taken using a macro lens. Close-up filters are a good budget option.
Nikon D300, 50mm, ISO 200, 1.3sec at f/11, +3 close-up filter, tripod

WITHOUT FILTER

+ 1

+2

+4

+10

CLOSE-UP FILTER COMPARISON
This image sequence shows the magnification of close-up dioptres of progressive strength. While they may not be able to match the image quality of a dedicated macro, they are still capable of producing very usable results and offer a great entry route into shooting miniature subjects.

CALCULATING A DIOPTRE'S STRENGTH

It can be useful to be able to calculate the level of magnification achieved by any given lens and close-up filter combination. To do this, be prepared to do a little arithmetic – so if maths wasn't your strong point at school, it may be time to reach for your calculator. First, establish what the dioptre's equivalent value is in millimetres. To do this, divide 1000 by the strength of the dioptre, for example, to calculate the value of a +4 dioptre: 1000 / 4 = 250mm. Next, divide the focal length of the lens in millimetres by the equivalent focal length of the filter. So, for instance, if you attach a +4 dioptre to a 50mm prime lens, you will achieve a magnification of: 50 / 250 = 0.2x – approximately 1:5 life-size. So, the equation to remember is: magnification = focal length of lens / focal length of dioptre. However, this calculation only reveals the magnification of the lens when set to infinity – greater levels of magnification are possible by focusing closer.

It is possible to combine close-up filters to achieve even higher levels of magnification – for example, coupling a +1 and +2 filter together will achieve a level of magnification equivalent to a +3 dioptre. However, if you do this, always attach the most powerful first and the weakest last, as this will help maximize image quality. Avoid coupling three or more close-up filters together, as this will significantly degrade image quality and exaggerate any optical flaws.

While there are many advantages to using close-up filters, they cannot compete with the image quality of other close-up attachments. This is hardly surprising when you consider their low price-tag and basic construction. Edge sharpness in particular can suffer, and they are prone to 'ghosting' and spherical and chromatic aberration. However, you can maximize image quality by selecting an aperture no smaller than f/8 and only combining them with the better quality optics, such as, for example, prime, fixed focal lengths. Opting for higher-quality filters with two elements (double construction) is another option, but they are more expensive.

COMMON FROG
One of the drawbacks of using close-up filters is that they don't provide a generous working distance. In this instance, I had to slowly move into position in order not to alarm this frog. By having to work closer to your subject, you naturally enhance the risk of disturbing it. However, the image quality of close-up filters is impressively good when you consider their low cost.
Nikon D300, 50mm, ISO 200, 1/25sec at f/5,
+3 close-up filter, handheld

PRO TIP

Close-up filters are available in different filter threads. The most common sizes are 49mm, 52mm, 58mm and 67mm. Remember to check which size you require before buying.

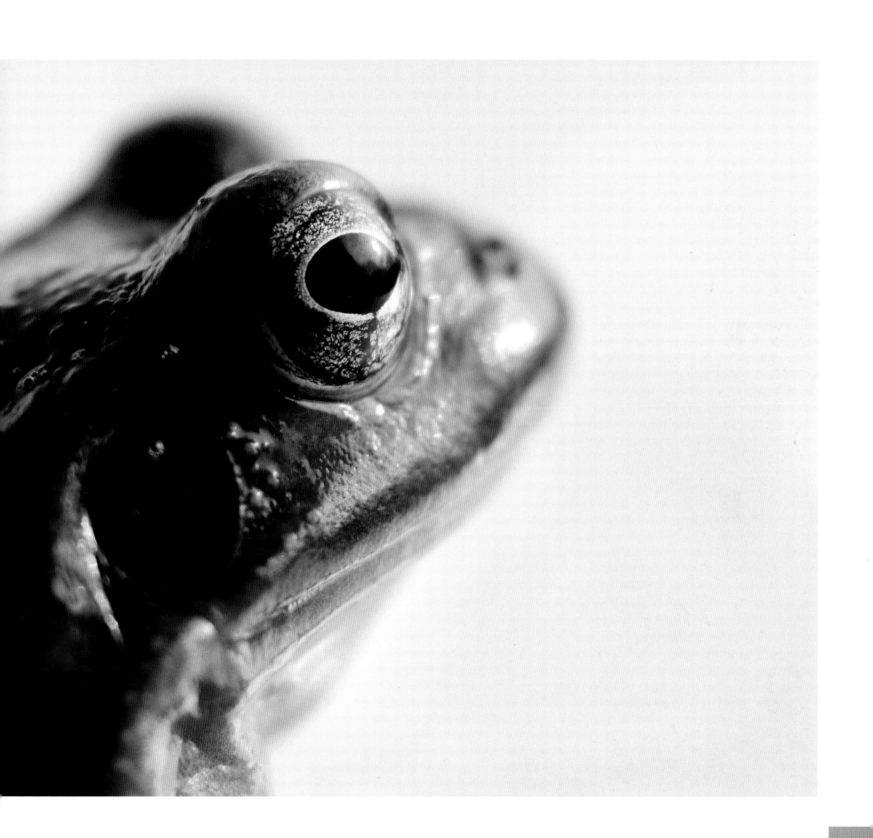

AUTO EXTENSION TUBES

THIS CLEVER DEVICE REDUCES THE MINIMUM FOCUSING DISTANCE OF A LENS, WHICH ALLOWS THE PHOTOGRAPHER TO FOCUS CLOSER AND ACHIEVE A GREATER LEVEL OF MAGNIFICATION.

If you can't justify buying a dedicated macro lens but don't want to compromise on image quality by using close-up filters, consider investing in a set of auto extension tubes. These are hollow tubes that fit between the camera and lens in order to extend the lens further away from the sensor plane.

Auto extension tubes are available in different camera mount fittings and, as they're constructed without any optical elements, do not alter the lens's image quality. They do, however, reduce the amount of light entering the camera; the higher the magnification, the more light will be lost. Your camera's TTL metering will automatically compensate for this reduction, but shutter speeds will lengthen as a result of using one, which is an important consideration when shooting handheld. The tubes are compact and light and, when combined with a good quality lens, are capable of producing excellent results.

They can be purchased individually, or in sets. The most common lengths are 12mm, 25mm and 36mm – the wider the tube, the greater the level of extension. They can also be combined together in order to generate even higher levels of magnification, equal to or exceeding 1:1 life-size. Overall, they are a very useful close-up attachment.

Non-auto versions are available and are typically very cheap to buy. However, they disable many of the camera's key automatic functions, like metering and focusing. Auto extension tubes retain all the camera's metering and focusing connections, making them convenient and simple to use. Their biggest drawback is that, like close-up filters, they don't provide a large working distance from the subject, which can make it difficult to position additional light sources and also enhances the risk of frightening away live subjects. However, they are a good alternative to a macro lens and a useful attachment to have in your camera bag.

WHICH FOCAL LENGTH IS BEST?

If you want to generate high magnifications, combine extension with short focal lengths: a lens in the region of 35–100mm is ideal. Small amounts of extension, like 12mm or 25mm, are most effective coupled with a 35mm or 50mm prime lens. The amount of extension you require will greatly depend on the size of the subject and the level of magnification desired. While extension tubes can be useful with any focal length in order to reduce its minimum focusing distance, achieving high reproduction ratios using focal lengths exceeding 100mm is usually impractical; the amount of extension required is too great and results in too much light being lost.

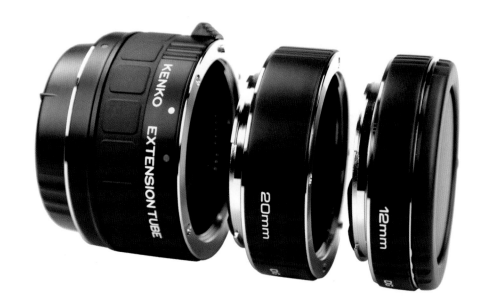

EXTENSION TUBES
Canon, Kenko and Nikon are among the brands that produce extension tubes. Although more costly, opt for automatic tubes – they boast upgraded circuitry in order to be fully compatible with the latest digital SLRs.

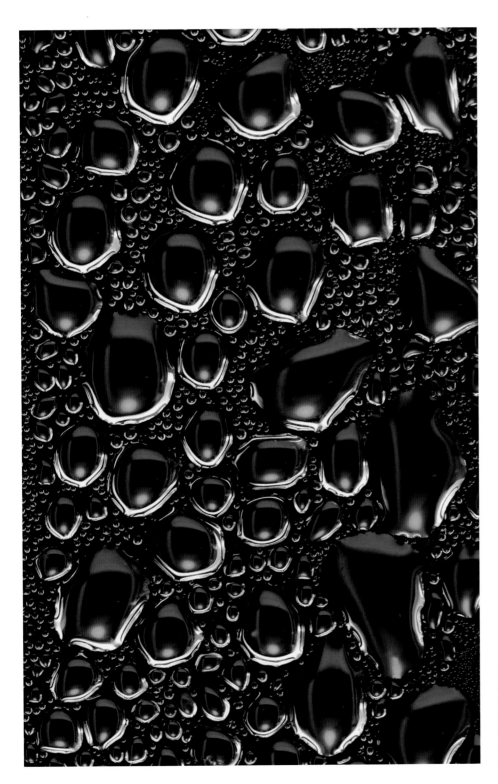

MAGNIFICATION

The magnification achieved using extension tubes varies depending on the width of the tube and focal length of the lens. However, approximating the reproduction ratio of any given tube and lens combination is fairly simple. You just divide the amount of extension by the focal length of the lens. For example, if you combine a 25mm extension tube with a 50mm lens, the magnification is 25 / 50 = 0.5x or 1:2 half life-size. Using the same level of extension with a 100mm lens would result in a reproduction ratio of 1:4, quarter life-size. If you want to achieve a level of magnification equal to 1:1 life-size, you need to employ a level of extension equal to that of the focal length of the lens – for example, 50mm of extension with a 50mm lens.

Below is a quick reference chart for the level of magnification achieved using extension tubes with three popular focal lengths.

Extension:	35mm	50mm	100mm
12mm	0.34x (1:2.9)	0.24x (1:4.1)	0.12x (1:8.3)
25mm	0.71x (1:1.4)	0.5x (1:2)	0.25x (1:4)
36mm	1.03x (1:0.97	0.72 (1:1.3)	0.36x (1:2.7)

WATER DROPLETS
Although extension tubes do not provide a large camera-to-subject distance, they are excellent for photographing inanimate subjects, like these water droplets.
Nikon D300, 50mm, ISO 200, 1/5sec at f/11, 25mm extension tube, tripod

REVERSING RINGS

CAPABLE OF HIGH MAGNIFICATIONS, REVERSING RINGS WORK BY ALLOWING A LENS TO BE MOUNTED BACK-TO-FRONT ON THE CAMERA, WHICH ENABLES CLOSER FOCUS.

Reversing rings are one of the best close-up attachments available and are capable of high magnifications. They work by allowing a lens to be mounted back-to-front on the camera. By reversing a lens in this way, its optical centre is displaced from the sensor plane, generating a level of extension and enabling it to focus much closer. The adapter is designed with a rear lens mount on one side and a male filter thread on the other – lenses are designed with a female thread, while screw-in filters are male – allowing the lens to attach to the body.

It is possible to get a high level of magnification, exceeding twice life-size, using reversing rings, although the subject-to-camera distance will be little more than a few millimetres at such high reproduction ratios. The level of magnification achieved by reversing a lens depends on the lens's focal length and the level of displacement; the shorter the lens, the higher the magnification. A prime lens is generally considered best, with a focal length in the region of 28–50mm a good choice. You might be wondering how an optical quality of a lens isn't degraded by being reversed. Well, to maintain the highest image quality, a lens should have its largest element facing the longest distance. Normally, the distance between camera and subject is much larger than the one between lens and sensor. However, when working so close to the subject, the opposite can be true. As a result, having the front element of the lens reversed helps ensure high image quality.

When working at such high levels of magnification, depth of field is exceptionally shallow and light severely restricted. Therefore, when using reversing rings, it is normally best to take photos of static subjects, ideally in a controlled, or studio, environment. They are generally not considered a practical close-up attachment for fieldwork.

MANUAL OR AUTO?

It is possible to buy manual or automatic reversing rings. Although manual rings are inexpensive, automatic metering and focusing will be disabled and, for some lens types, another adapter is required to hold the lens diaphragm open. Therefore, auto-reversing adapters are the best choice. You need to buy an adapter that will fit the mount of the camera model you use. Also, the male filter thread of the adapter needs to fit that of the lens you want to reverse. Some reversing adapters, like the Novoflex EOS-RETRO, have a set, standard 58mm thread. Therefore, to use different diameter lenses, photographers require a 'step-up or step-down ring', which is designed to adapt a filter to a lens, when the two have differing filter thread diameters.

CAMERA BELLOWS

Camera bellows work using a similar principle to extension tubes, extending the distance between the lens and sensor in order to allow the lens attached to focus closer. However, despite their old-fashioned accordion-style design, bellows are more sophisticated and can be employed to achieve a variety of reproduction ratios over a greater range.

Bellows are one of the most effective and precise accessories available to close-up photographers. The pleated, expandable bellows provides a flexible dark enclosure between the lens and sensor. This allows the lens to be moved in order to vary the level of magnification with great precision. The image quality of the attached lens is unaffected as there are no glass elements within the design. On the rear plate of the accordion-style design is a camera mount, with a lens mount on the front plate. Most modern bellows are mounted on a mechanical rail to aid positioning and focusing. By extending the bellows, magnification is increased. However, as when using rings, more light is lost at higher levels of extension and, combined with their bulky, weighty design, bellows are generally better suited to studio work than outdoor photography. Bellows are capable of magnifying a subject beyond the realms of a macro, and can even be coupled with a microscope lens.

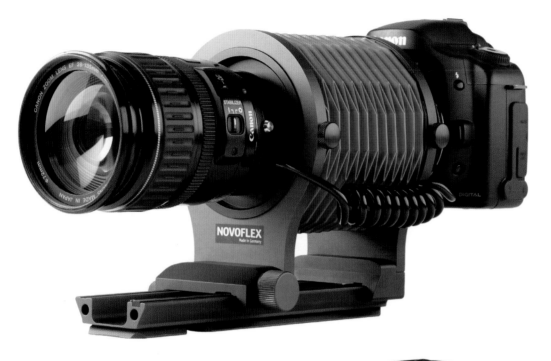

BELLOWS

Bellows are a specialist close-up attachment and are not suited to the vast majority of close-up enthusiasts. Generally speaking, they are not cheap. German manufacturer Novoflex makes one of the leading brands of automatic bellows that are compatible with digital SLRs.

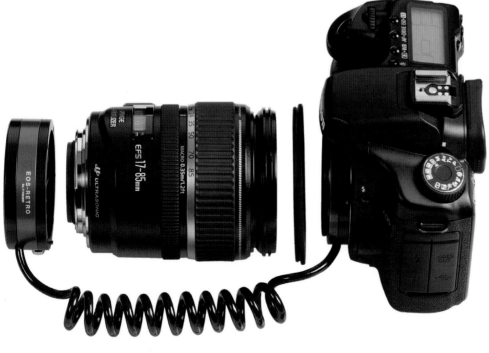

REVERSING RING

Although only compatible with Canon EOS cameras, the EOS-RETRO allows users to mount the lens in reverse position on the camera while retaining all camera functions. There are many other simpler, cheaper designs on the market, but not all will retain the camera's auto features.

CLOSE-UP ACCESSORIES

REMEMBERING TO PACK ALL THE ACCESSORIES YOU'LL NEED BEFORE YOU SET OUT TO TAKE YOUR CLOSE-UP SHOTS CAN MAKE THE DIFFERENCE BETWEEN A PRODUCTIVE OUTING AND A WASTED TRIP.

In your camera backpack, carry at least one fully charged spare camera battery and two or three extra, formatted memory cards. A groundsheet of some variety will come in useful for keeping you and your kit clean and dry when working at ground level. However, in addition to this, there are a handful of useful specialist close-up accessories that you should ideally always carry with you.

REMOTE DEVICE

When shooting at high magnifications, the tiniest movement can be greatly exaggerated. Even when the camera is tripod mounted, physically depressing the shutter release button can generate a small amount of movement that, at slower shutter speeds, can affect image sharpness. Although the effect is often minimal, it can be noticeable when the photo is enlarged. One answer to this is to use a remote device whenever practical. Personally, I favour using a remote cord, which attaches to the camera via its remote terminal. It consists of a wire with a trigger button at the end. They can vary greatly in size and design – basic models are designed with a simple trigger; more sophisticated devices are equipped with such things as interval timer, backlit control panel and timer. Remote cords are also useful when using your camera's mirror lock-up facility (page 56). Infrared wireless devices are also available and handy if you wish to trigger the shutter remotely.

RIGHT-ANGLE FINDER

A right-angle finder is an L-shaped attachment that fits onto the camera's eyepiece to allow photographers to view and compose images by peering downwards, rather than horizontally, into the viewfinder. When taking pictures at low or ground level, an angle finder is a very useful attachment. You will be able to compose images comfortably, without having to contort your body in order to look through the actual eyepiece. A few years ago, an angle finder was a necessity for close-up enthusiasts. However, today, Live View (page 56) has greatly reduced the need to own one and, if you have a digital SLR boasting a vari-angle LCD design, you won't require an angle finder at all. However, for many photographers, they remain an essential aid for low-level close-up work.

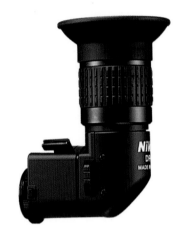

RIGHT-ANGLE FINDER
Although Live View has reduced the necessity to own a right-angle finder, they remain a useful tool for low-level photography. Personally, I always carry one in my camera bag.

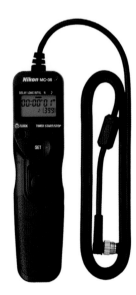

REMOTE CORD
Depressing the shutter button with your finger can create a small amount of movement, capable of softening the image at slower shutter speeds. To help guarantee sharp results, always use a remote device in combination with your tripod set-up.

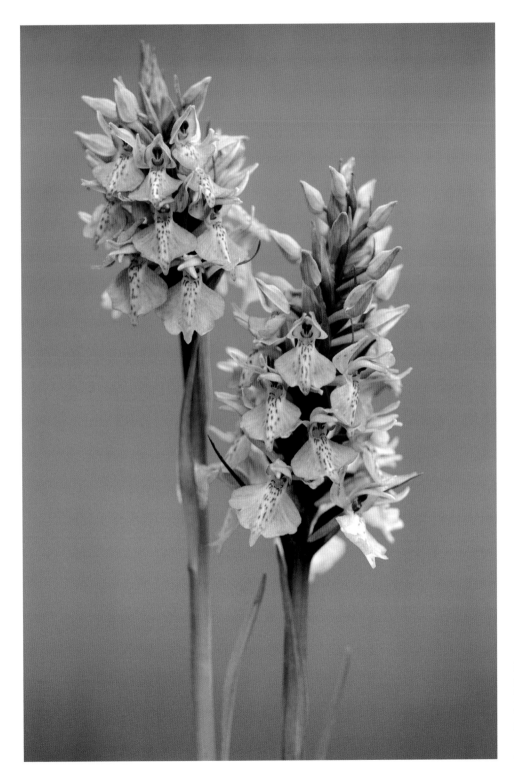

WIMBERLEY PLAMP

I regularly use a Plamp from Wimberley when shooting close-ups. I usually use it to hold a reflector in place. They fold away neatly when not in use, making them an easy and lightweight accessory to carry around. Basically, a Plamp is a ball-and-socket segmented arm with a clamp fixed at each end. One clamp can fasten to your tripod leg, while the other can be used to grasp an object. For example, you can use one to keep a windblown flower or branch steady, or to hold a small reflector in place. Quite simply, the Plamp acts like an extra arm. However, avoid using one to clasp the clamp to delicate flower stems, as you may damage the plant. Extensions are also available to lengthen the Plamp, but the arm will be less rigid and steady as a result.

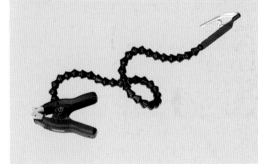

HEATH SPOTTED ORCHID
Despite this image being taken close to ground level, I was able to compose the image comfortably, and without having to lie in wet grass, thanks to using a right-angle finder.
Nikon D300, 150mm, ISO 200, 1/400sec at f/3.2, beanbag and angle finder

SUPPORTS

AS WELL AS PROVIDING STABILITY, A SUPPORT WILL AID PRECISE FOCUSING AND COMPOSITION AND SO ADD GREATLY TO THE FINISHED IMAGE.

Although it won't always be practical to employ a support when shooting close-ups, you should do so whenever possible. Most close-up subjects such as flowers and still lifes are inanimate, which means there is rarely any excuse for not using a support.

TRIPOD

A tripod offers an unrivalled level of stability. They help ensure pin-sharp results, and allow photographers to fine-tune their composition and place the point of focus with accuracy. However, there is a wide choice of designs available, so do your research before buying. Avoid cheap, flimsy, one-piece models – their lightness and compact design might seem appealing, but they just aren't up to the task. Instead, opt for good, sturdy legs. Close-up photographers require certain functionality in a tripod, in particular, the ability to shoot at low level. Look for a design where the legs can be positioned low to the ground – for example, Manfrotto's XPROB design allows the centre column to be positioned horizontally. Benbo and Uni-Lock's unusual, innovative designs are also perfectly suited to close-up work, although the legs can prove fiddly to arrange at times. I use a Gitzo Systematic tripod, which lacks a centre column so that it can be used at low level quickly and easily. Quality tripods have a good load capacity and legs can be adjusted individually so that they can be positioned in almost any way – ideal for the often awkward nature of close-up work. Good legs can prove quite weighty. Lugging a tripod around is far from fun, but your images will benefit massively as a result of using them. Although more expensive, carbon fibre legs are a good option, being lighter, yet just as sturdy.

TRIPOD HEAD

The benefit of buying legs and head individually is that you can select the style of head you prefer. I regularly get asked which tripod head is best for shooting close-ups. However, it is a tricky thing to advise on. There are various types of head available, all good in their own right. Much depends on personal preference and what type of head you do and don't get on with. Most are simply a variation on either a traditional pan-and-tilt head or a ball-and-socket design. Ball-and-socket heads allow photographers to smoothly rotate the camera around a sphere and then lock it into position. They are rapid to adjust and position, making them popular for nature photography. However, budget designs can prove fiddly at times and difficult to level and lock precisely into position. The ball-and-socket heads produced by Really Right Stuff are among the best designs I've seen. Alternatively, consider a pan-and-tilt design, which offers three separate axes of movement – left-right tilt, forward-back tilt and horizontal panning. Typically, there are three separate handles for locking the various movements. Geared versions are also available, which, although more costly, allow you to make very precise adjustments. Personally, my preference is for the geared design. For static subjects, they are just perfect, allowing photographers to make very fine adjustments to composition. They are well suited to the challenges of macro work and I would certainly recommend them. However, the leg/head combination you prefer is hugely subjective; always try them out before buying.

BEANBAG
When rested on a stable surface, such as the ground, a tree stump or wall, beanbags offer surprisingly good support. The bags' filling naturally moulds around the camera and lens, absorbing the majority of the movement. They are inexpensive, easy to use, and, in the right situation, the most practical type of support. There are a couple of different designs on the market. The 'H' shape of the 'Grippa' beanbag is ideal if using from a car, but close-up photographers should opt for a simple single bag design. I regularly use a beanbag when taking low-level close-ups, lying prone on the ground.

PRO TIP

All good heads are designed with a quick release plate. This attaches directly to the camera via its tripod bush, and snaps on and off the tripod head to allow photographers to quickly attach and detach their set-up. The plates are not universal; the size and design of the plate varies from head to head.

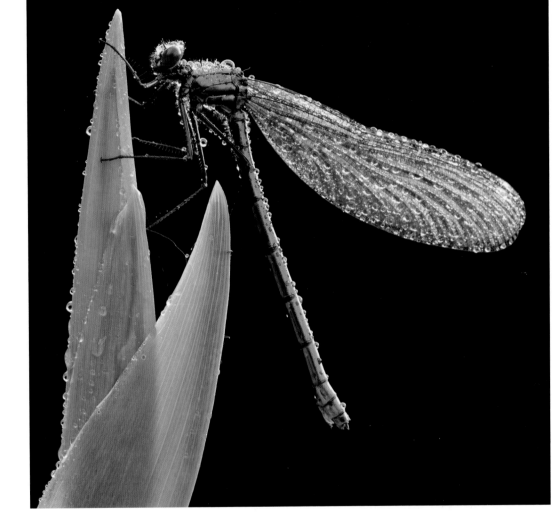

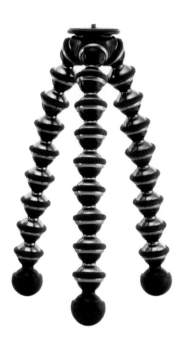

GORILLAPOD
Joby's innovative Gorillapod design is another potentially handy camera support. It has bendable, 'grippy' legs, which can be positioned in an infinite number of ways, making it ideal for awkward or low viewpoints. Its legs can even be wrapped tightly around a post or branch. The largest Gorillapod can support an impressive 11lb (5kg). However, personally I find them slightly too fiddly and frustrating to use. They are certainly no tripod substitute and for ground-level photography I favour a beanbag.

GEARED HEAD
It is difficult to say which head is best suited to close-ups; much depends on personal preference, not to mention budget. However, in my experience, a geared head such as the Manfrotto 410 is one of the most precise and easy-to-use heads for static close-up subjects.

BANDED DEMOISELLE
To capture razor-sharp insect images like this, the camera needs to be in a fixed position. This enables you to select a smaller aperture to generate a sufficient depth of field. It also allows photographers to carefully position and align their camera.
Nikon D800, 150mm, ISO 100, 0.8sec at f/16, tripod

TECHNIQUE

Your choice of camera, lens and accessories is important, but it is your technique and skill that will have the greatest impact on the final result.

Working in close-up is a very precise, unforgiving style of photography with very little latitude for error. This means that, quite simply, your technique has to be good. You can own the best kit money can buy, but it doesn't guarantee good results. In particular, you should have a confident understanding of exposure (page 44), shutter speed (page 46) and lens aperture (page 48). Remember that at higher magnifications the smallest movement will be seen (page 38).

Good technique is important for achieving pin-sharp images, and is equally essential for creative photography. For example, selective focusing (page 50) will help you to highlight your subject or neatly direct the eye to your chosen focal point. Also, don't overlook the art of composition (page 52). You have to be able to arrange the key elements within the image space so that they create an aesthetically pleasing, harmonious and compelling composition. This chapter is designed to help you hone your close-up technique.

SMALL PEARL-BORDERED FRITILLARY BUTTERFLIES
Poor technique will lead to images that are badly exposed, poorly composed or simply lack critical sharpness. Good technique is essential for all types of photography, but particularly for close-ups when errors appear greatly magnified. Even when photographing wildlife, like these butterflies, I am careful not to rush the picture-taking process for risk of making silly errors. Instead just try to work efficiently, remembering what you have learnt.
Canon Nikon D700, 150mm, ISO 200, 1/100sec at f/9, tripod

EXPOSURE

EXPOSURE IS THE PROCESS OF LIGHT STRIKING A PHOTOSENSITIVE MATERIAL, SUCH AS A DIGITAL SENSOR.

Camera technology has changed dramatically since the early days of photography, but the three key parameters controlling exposure remain unchanged: lens aperture, shutter speed and the photographic material's sensitivity to light (page 18).

Read any photo book, magazine or online tutorial and you will notice the importance of achieving correct exposure is regularly discussed. The question is; how do you define this? Simply, a 'correct' exposure is one that achieves the result or effect you intend. If the image is too light, it is overexposed; if it is too dark, it is underexposed. Many close-up photographers prefer to work in aperture priority mode (page 20), so they select the ISO and aperture desired, and allow the camera to calculate the corresponding shutter speed. Thanks to the accuracy of through-the-lens (TTL) metering systems, cameras can be relied upon to achieve the right level of exposure. They base their settings on the amount of light coming through the lens.

Therefore, they automatically compensate for the light absorbed by the level of magnification – or for any close-up accessory attached, like an extender or converter. TTL metering is fast, convenient and reliable in most lighting conditions, allowing photographers to work confidently and efficiently. However, no metering system is infallible and, obviously, your camera is unable to predict the effect you wish to achieve. Therefore, don't simply rely on your camera – a good understanding of exposure is essential, allowing you to correct errors or expose creatively.

EXPOSURE COMPENSATION

Light meters work on the assumption that the subject is mid-tone. Although this is a reliable system, capable of producing consistently good results, it is not foolproof. High contrast, backlit and predominantly dark and light subjects can fool your camera. Thankfully, many of the errors your metering system is likely to make are quite predictable with experience and easy to correct using exposure compensation. If an image is too light, shorten exposure by applying negative (-) compensation. If it is too dark, dial in positive (+) compensation to lighten the shot.

Use the image's histogram (page 22) to guide you as to how much compensation is required. Most cameras have a dedicated 'Exposure Compensation' button. Dial in the level of compensation you require by pressing the button while simultaneously rotating the command dial/wheel. Most digital SLRs allow exposure compensation to be applied in 1/3, 1/2 or 1-stop increments.

PRO TIP

Although digital files – particularly Raw (page 172) – have a reasonable tolerance to error, achieving the right exposure in-camera remains just as important today. Although you can easily lighten or darken images during editing, image quality is degraded if the original is poorly exposed. For example, if a photograph is overexposed, detail can be irretrievably lost in the highlights; while lightening an underexposed image introduces noise (page 19), obscuring detail and sharpness.

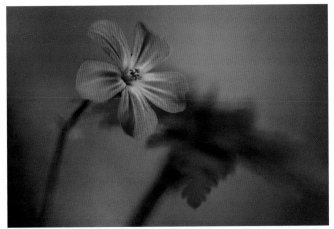

-1EV

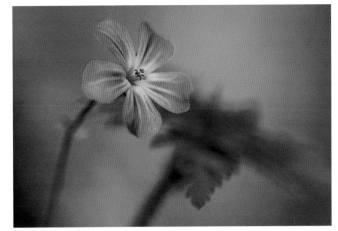

-0.5EV

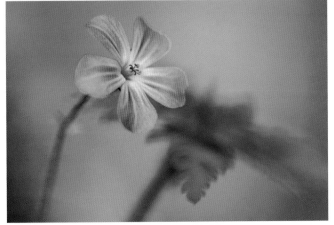

0EV

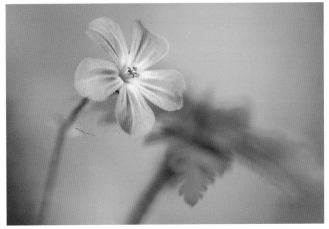

+0.5EV

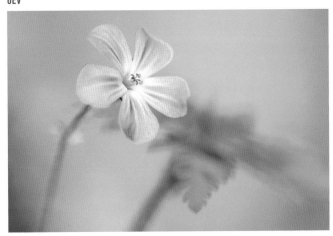

+1EV

EXPOSURE VALUE

You can correct underexposure by selecting a larger aperture, slower shutter speed, or upping ISO sensitivity. Conversely, you can correct overexposure by making the lens aperture smaller, increasing shutter speed, or reducing the sensor's sensitivity to light. Having selected an appropriate combination of lens aperture and shutter speed – for a given ISO sensitivity – a change in one will require an equal and opposite change in the other. It is these three variables that control exposure. 'EV' stands for 'exposure value'.

SHUTTER SPEED AND MOTION

SHUTTER SPEED IS THE LENGTH OF TIME THE CAMERA'S SHUTTER IS OPEN DURING EXPOSURE.

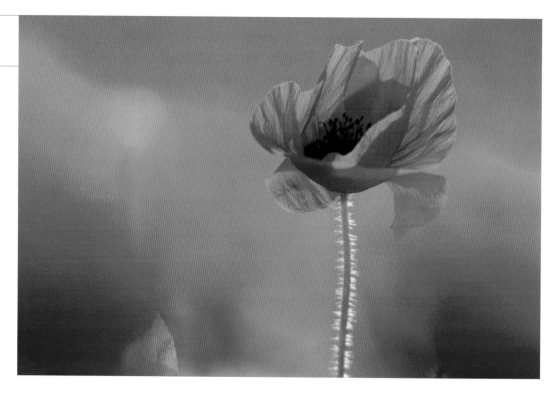

If the shutter speed is too short, insufficient light will reach the sensor and the resulting image will be too dark (underexposure). If the shutter is open too long, too much light will strike the sensor and the final image will be too bright (overexposure). Shutter speed has a reciprocal relationship with aperture size (page 48).

The shutter speed required for correct exposure depends on the light, size of the aperture, the ISO selected and also the result you desire. Different cameras offer different shutter speed ranges. However, the majority of digital SLRs offer a wide range from 30sec up to 1/4000sec, or faster. It is possible to select even longer exposures using the camera's 'Bulb' setting, which allows photographers to manually hold the shutter open. However, speeds of this length are rarely required, or are practical, for close-up work.

Shutter speed has a pivotal role in how an image is formed. Although designed to ensure that just the right amount of light reaches the sensor to achieve a 'correct' result, the exposure length also controls how motion is recorded. Faster shutter speeds will help freeze movement, while slow shutter speeds will blur motion. Slower speeds are useful if you wish to create a feeling of motion.

For example, when photographing windblown flowers, you may decide a degree of motion blur makes your image more interesting and appear less static. Landscape, sport and wildlife photographers often employ lengthy shutter speeds in order to creatively blur subjects.

However, generally speaking, this approach is less practical and beneficial for close-ups. Instead, the priority is usually a shutter fast enough to record miniature subjects sharply, or to prevent the camera shaking when it is handheld.

POPPY
When I photographed this poppy, it was exceptionally windy. The flower was being badly blown about, making focusing and composing very challenging. Subject motion can create very arty, interesting results, but in this instance I wanted to record the flower sharply. Therefore, I used a fast shutter speed in order to freeze its movement.
Nikon D300, 70–200mm and TC-20E III teleconverter (at 400mm), ISO 200, 1/800sec at f/5.6, tripod

PRO TIP

Changes in shutter speed – and aperture – values are referred to in 'stops'. A stop is a halving or doubling of the amount of light reaching the sensor. For example, altering shutter time from 1/250sec to 1/125sec will double the length of time the shutter is open, while adjusting it to 1/500sec will halve exposure time. Almost all modern cameras allow exposure to be adjusted in 1/3, 1/2 and 1-stop increments for optimum control.

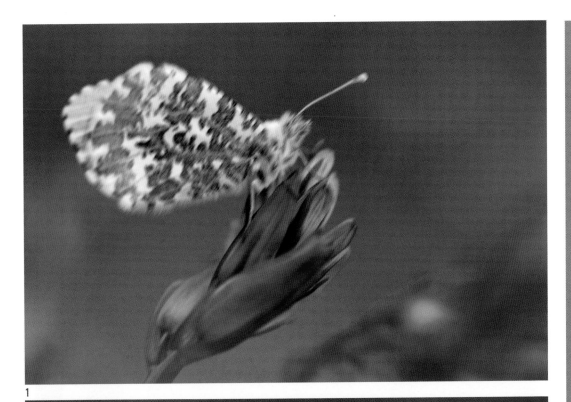

1

2

CAMERA SHAKE

Camera shake is a common problem, occurring when the selected shutter speed isn't fast enough to eliminate the photographer's own movement. The result is a blurry image, or one lacking critical sharpness. Close-up photographers are particularly susceptible to the problem, as camera movement appears exaggerated at higher levels of magnification.

There are two ways to rectify camera shake: select a faster shutter speed or use a camera support, such as a tripod or beanbag. A tripod is the best solution – providing stability, while allowing you to retain your original exposure settings. However, when shooting some close-up subjects – particularly wildlife – it is not always practical to use a support. In situations like this, a faster shutter speed is required. This can be generated by selecting a larger aperture, or higher ISO (page 18). However, opting for a wider f/stop will reduce depth of field, while higher ISOs result in noisier files. If the lens you are using has image stabilizing technology, switch it on; sharp images can be produced at speeds two or three stops slower than normal.

SHARP VERSUS BLURRED

It is easy to overestimate how still you can hold your camera. However, at higher magnifications, the risk of camera shake is greatly enhanced. In this instance, I took the first image handheld using a shutter speed of 1/30sec, but it proved too slow to freeze my movement (1). For the second image I used a tripod and the result is bitingly sharp (2).
Nikon D300, 150mm, ISO 200, 1/30sec at f/4

APERTURE

Aperture is the common term for the 'iris diaphragm' of a lens. This consists of a number of thin blades that adjust inwards or outwards to alter the size of the hole they form – the aperture – through which light can pass. By altering the size of the iris, photographers can determine the amount of light allowed to enter the lens and strike the sensor. Lens aperture has a reciprocal relationship with shutter speed and is the overriding control over depth of field.

An aperture works in a similar way to the human eye. Our pupils widen and contract in order to control the amount of light entering the retina. When you alter the size of the aperture, you adjust the speed at which light can pass through the lens to expose the sensor. Select a large aperture and light can pass through quickly. This generates a faster corresponding shutter speed. Opt for a small aperture, and it will take longer for sufficient light to enter the lens and expose the sensor. This results in a slower shutter speed. Visually, the aperture size determines the amount of depth of field (page 50).

Apertures are stated in numbers, known as f/stops. Typically, this scale ranges from f/2.8–f/22 although it varies, depending on the lens's speed, with some optics having more or fewer settings. The typical standards for apertures are: f/2.8, f/4, f/5.6, f/8, f/11, f/16, f/22. Each f/number relates to a 1-stop adjustment from the value next to it. However, apertures can also be adjusted in 1/3 and 1/2 stop increments, for even greater control.

Apertures can prove confusing due to the way that large f/stops are represented by small numbers, for example, f/2.8 or f/4; while small f/stops are indicated by large numbers, like f/22 or f/32. To help you remember which value is bigger or smaller, it can be useful to think of f/numbers in terms of fractions. For example, 1/16th (f/16) is smaller than 1/8th (f/8).

Until the past few years, many optics were constructed with an aperture ring, which the photographer physically altered in order to select the f/stop required. However, today few lenses are designed with an adjustable ring. Instead, the aperture is quickly and conveniently adjusted via the camera itself, often using a command dial or wheel.

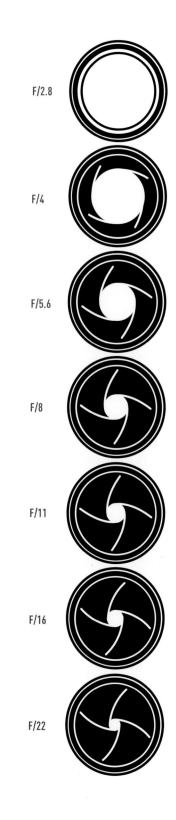

F/2.8

F/4

F/5.6

F/8

F/11

F/16

F/22

LENS APERTURE
This graphic helps illustrate how the size of the aperture varies at different f-stops.

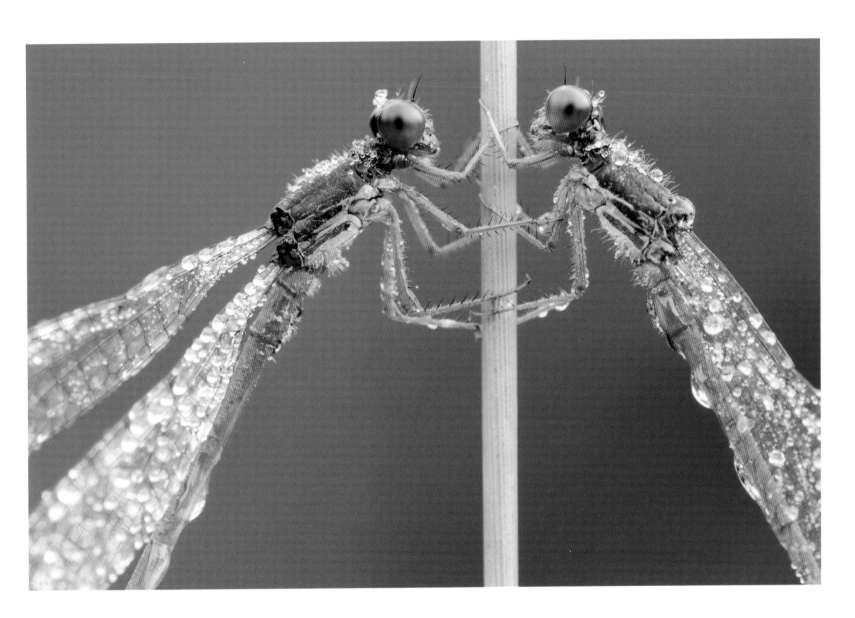

SMALL RED DAMSELFLIES
I captured these damselflies using a relatively large aperture of f/13 to achieve a sharp image. Remember that a smaller aperture will help generate a larger depth of field, but the corresponding shutter will be slower. A large aperture will help generate a faster shutter speed, but the zone of sharpness will be wafer thin. To a great extent, the aperture you select will be dictated by the available light, situation, level of magnification and the effect you wish to achieve.
Nikon D300, 150mm, ISO 200, 1/4sec at f/13, tripod

DEPTH OF FIELD

DEPTH OF FIELD IS THE ZONE OF ACCEPTABLE SHARPNESS RECORDED IN A PHOTOGRAPH. PUT SIMPLY, IT IS THE DISTANCE IN FRONT OF AND BEYOND THE POINT OF FOCUS THAT APPEARS TO BE IN FOCUS.

At large apertures, like f/2.8 or f/4, depth of field is narrow; at small apertures, like f/16 or f/22, it is larger. Normally, depth of field extends approximately one-third in front of the point of focus to two-thirds beyond it. However, when shooting close-ups, this ratio alters, with the zone of sharpness falling more evenly either side of the focal point. Depth of field is inherently shallow when working in close-up and achieving sufficient depth of field is one of the biggest challenges macro photographers face.

Although lens aperture is the overriding control over depth of field, it is also affected by focal length and level of magnification; the zone of sharpness grows progressively narrower at higher magnifications. For example, wideangles produce extensive depth of field, even at relatively large f/numbers; while a telephoto macro has a narrow field of sharpness. Selecting a small f/number to generate a wide depth of field might seem like the obvious step to take. However, doing so won't always be practical or desirable. At small f/stops, diffraction – when light passing through a small hole disperses or diffracts – can significantly soften image sharpness.

Also, shutter speeds can grow impractically long, and a large depth of field won't always guarantee the most pleasing result. When shooting close-ups, there is no golden rule as to which aperture to select, or how much depth of field is required. Every picture-taking opportunity is different and should be treated so.

There will be times when you will want your entire subject in focus; others, when just a shallow depth of field will suffice. Your choice of f/stop should be dictated by the subject matter, situation

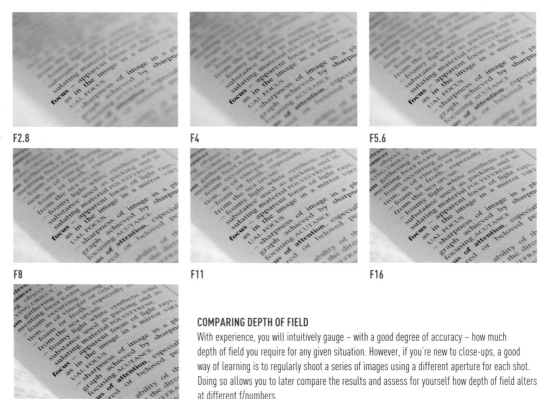

F2.8

F4

F5.6

F8

F11

F16

F22

COMPARING DEPTH OF FIELD
With experience, you will intuitively gauge – with a good degree of accuracy – how much depth of field you require for any given situation. However, if you're new to close-ups, a good way of learning is to regularly shoot a series of images using a different aperture for each shot. Doing so allows you to later compare the results and assess for yourself how depth of field alters at different f/numbers.

and the result that you desire. Another method of extending depth of field is by 'stacking' images (page 180).

SELECTIVE FOCUSING
When you want your subject or focal point to stand out against its surroundings, try selective focusing. This technique typically relies on using large apertures, like f/2.8 or f/4, to intentionally throw everything out of focus other than your

subject or point of focus. At longer focal lengths and at higher magnifications, the effect is even more pronounced. You need to focus with pinpoint accuracy when employing this technique, as depth of field will be paper thin. Results can look striking, with your subject, or point of focus, standing out sharply against attractively diffused bokeh (see box).

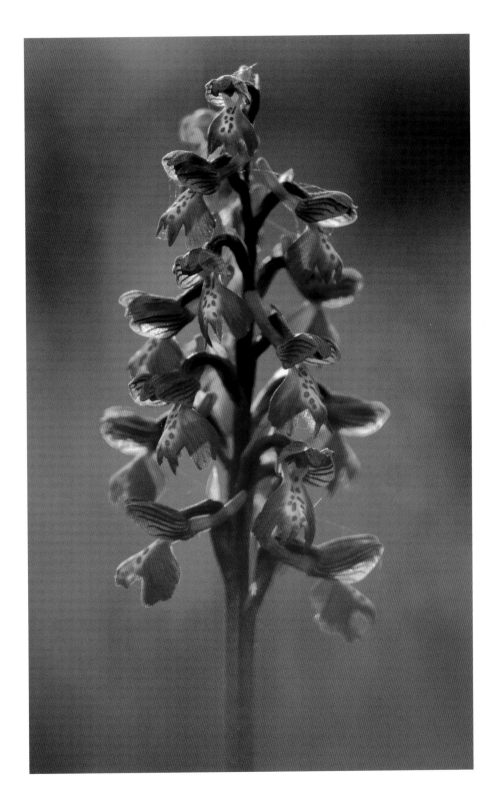

BOKEH

The appearance or feel of out-of-focus areas is known as 'bokeh'. Put simply, it is the character of the blur produced by the lens in a photo. In many close-ups, large areas of the image are out of focus due to the shallow depth of field. Therefore, the quality of a lens's bokeh is important. Ideally, it should be attractive; it shouldn't compete with the main subject. Longer focal lengths, higher magnifications and the size and shape of a lens's aperture all contribute to the look of bokeh. The shape of the aperture is of particular importance. When more blades are used in the construction of the iris diaphragm, a more perfect circular opening (aperture) is created. This produces softer, smoother bokeh. When fewer blades are used, the hole will resemble a pentagon or hexagon shape and the more angular edges produce less attractive out of focus areas. Therefore, when buying a lens, it is worth looking at the lens's specification. Look at the number of blades used in its construction. It's best to opt for a lens with more blades used in the design, and it is better still if they are slightly curved.

PRO TIP

To help you assess whether the f/stop you've selected will provide sufficient depth of field, some digital SLRs have a 'preview' button. When depressed, it stops the lens down to the chosen f/stop to give you a visual preview of how the depth of field will be distributed.

GREEN WINGED ORCHID

I shot this orchid using a large aperture. This reduces the impact of distracting background and foreground detail, creates attractive bokeh (see box), and helps emphasize my subject. When working with a shallow depth of field, parts of your subject will inevitably begin to drift out of focus – legs, wingtips or the tips of petals, for example. To what degree this is acceptable is largely down to the photographer's own discretion.
Nikon D300, 150mm, ISO 200, 1/180sec at f/4, beanbag

COMPOSITION

IF YOU WANT YOUR IMAGES TO TRULY STAND OUT, TECHNICAL KNOW-HOW IS NOT ENOUGH. YOU NEED TO THINK ABOUT COMPOSITION TO MAKE SURE YOUR PHOTOGRAPHS HAVE BALANCE AND INTEREST.

The artistic side of close-up photography can get overlooked. Why? Well, maybe, due to the challenging nature of shooting at magnification, achieving a technically good close-up is considered enough by some photographers. However, the skills of composition are just as applicable to shooting close-ups.

The rules of composition are as relevant to macro as they are to other forms of photography. The 'rule of thirds' – where you imagine the image space divided into nine equal parts by two horizontal and two vertical lines – is particularly useful. By placing your subject, or a key point of interest, at, or near, a point where the lines intersect, the image will typically be stronger. Positioning your subject off-centre in this way will achieve more stimulating results since it invites the viewer's eye around the frame. There are always exceptions, though, and in some instances, placing the subject centrally will create the strongest result. For example, when shooting flower close-ups, placing the centre of the flower bang in the middle of the frame can create wonderfully symmetrical-looking results.

Close-up photographers often intuitively fill the frame with their subject. While this can help maximize impact, avoid doing so just for the sake of it. Don't underestimate the power of negative space. Intentionally leaving a degree of breathing space around your subject can help create a better feeling of context, scale and size. Simplicity is often key to achieving a memorable image. If you try to cram too much detail into your shots, they will grow overly and needlessly complex and the image's impact will be reduced.

Exclude anything from the frame that isn't adding to the shot and always scrutinize backgrounds thoroughly (page 87).

Shape and form can prove excellent compositional aids. In close-up, photographers are able to isolate or highlight miniature detail. Look for strong, sweeping curves, lines and repetitive patterns. Lines cutting centrally through the composition, like the midrib of a leaf, look more dynamic if placed diagonally (page 95). Finally, don't be afraid to break the rules completely (page 93). Try to compose your images as intuitively as possible. Be prepared to be unconventional, try to be original, and keep things simple. Do this, and you will capture powerful close-ups.

DAHLIA
Don't get too preoccupied with the compositional rules. Trust your own instincts and try to compose images naturally. For example, sometimes, placing a subject smack bang in the middle of the frame will produce the best result. When I shot this colourful dahlia, I chose to place it centrally to produce a more symmetrical looking result. To further emphasize this, I later cropped the image into a square format.
Nikon D70, 150mm, ISO 200, 1/6sec at f/16, tripod

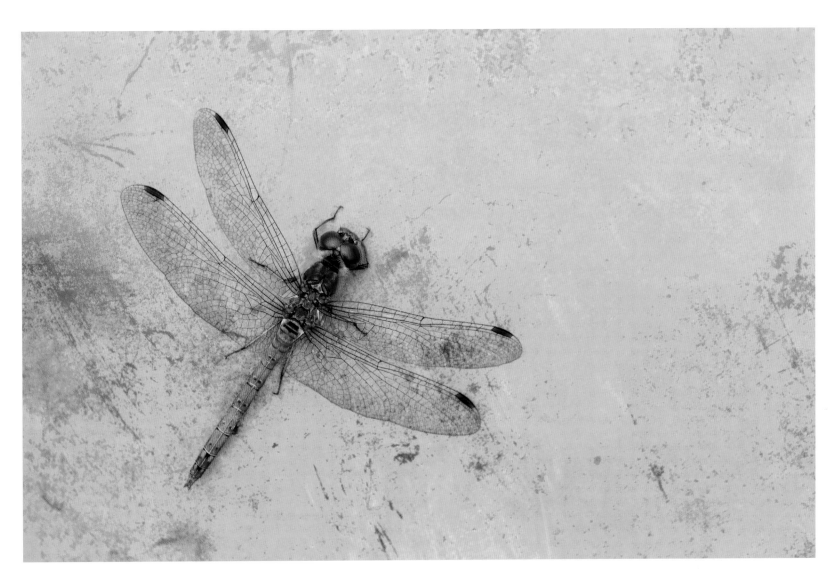

COMMON DARTER DRAGONFLY
Don't overlook the importance of good composition
when shooting close-ups. By placing subjects
off-centre you can often create more stimulating
compositions. A degree of negative space will help
give your subject breathing space and create a better
feeling of scale.
*Nikon D300, 150mm, ISO 200, 1/125sec at f/6.3,
handheld*

ORIENTATION AND PERSPECTIVE

PERSPECTIVE REFERS TO THE RELATIONSHIP BETWEEN OBJECTS OR THEIR SURROUNDINGS
WITHIN THE FRAME, AND ORIENTATION TO THE CAMERA.

Don't overlook the effect of perspective when shooting close-ups. The relative position and size of objects to one another can help create a perception of size, depth and scale.

PERSPECTIVE

Perspective refers to the relationship between objects, or their surroundings, within the frame. It can also be defined as the sense of depth or spatial relationships between objects in a photo.

Lens choice, depth of field and shooting angle can all have an impact on perspective. Short focal lengths appear to stretch perspective and make nearby subjects look more prominent, while pushing more distant subjects further away. If you want to achieve a high level of magnification with a wideangle, you need to position the camera very close to the subject. This way you can capture close-ups with an enhanced perception of depth. Also, due to their larger depth of field, it is easier to place subjects in proper context with their surroundings. In contrast, longer focal lengths, like medium and telephoto macros, foreshorten perspective. Therefore, perspective compression is commonplace when shooting close-ups. This type of foreshortening creates the impression that subjects at varying distances are closer to one another than they actually are.

Shooting angle also has a bearing on perspective and the way in which the subject is perceived. For example, photographers are commonly advised to shoot from eye level when photographing wildlife, such as reptiles, amphibians or insects. Doing so creates an intimate eye-to-eye perspective. However, when practical to do so, more striking compositions can be created by opting for a completely different perspective. For example, you could shoot a subject from a low or overhead viewpoint (page 112). By simply lowering or raising your camera angle, you can dramatically alter the viewer's perception of the subject.

ORIENTATION

Whether you opt for a portrait or landscape style composition will greatly depend on the subject and result you desire. Vertical compositions help emphasize height and can look bold; while a horizontal format appears more balanced and will create a greater feeling of space. Composition is all about arranging the elements in the most logical, pleasing way, so normally the subject, its shape, behaviour and environment will make the decision for you. For example, long, narrow subjects, like orchids or damselflies, will usually suit a vertical composition; while a dragonfly with its wings held open will typically suit a horizontal format. What you should avoid is shooting in one format or the other simply through habit, or laziness. It can be easy to forget to turn the camera on its side – maybe because we are so accustomed to viewing the world through a horizontal format. The orientation of your composition can have a huge impact on the viewer's perception of the subject. Although photographers are often advised to match the shape of the frame to that of the subject, dramatic, eye-catching results are possible by employing the frame unexpectedly.

Don't be afraid to experiment and, when in doubt, photograph your subject using both a vertical and horizontal composition. You can later decide which is best when you download and edit your images.

1

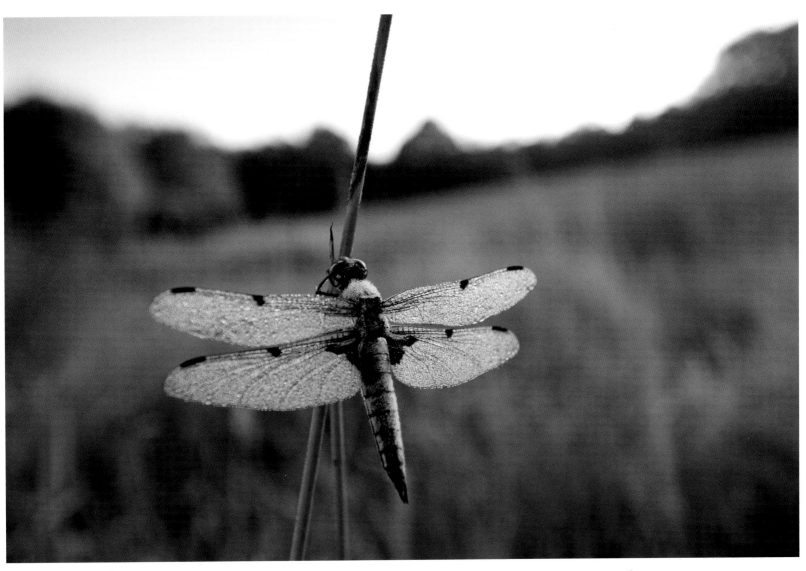

2

FOUR-SPOTTED CHASER DRAGONFLY
Often a subject's shape, behaviour or environment will dictate how you capture it and the orientation of the camera. These two images, of the same insect, were taken just moments apart, but by using a different focal length, and also changing camera orientation and angle, the two photographs look radically different.
[1] Nikon D700, 150mm, ISO 200, 1/320sec at f/2.8, tripod
[2] Nikon D700, 17–35mm (at 35mm), ISO 200, 1/125sec at f/6.3, tripod

IMAGE SHARPNESS

IT IS ONLY LOGICAL TO DO WHATEVER YOU CAN TO MAXIMIZE IMAGE SHARPNESS. IN CLOSE-UP,
YOU'LL FIND YOU CERTAINLY CAN'T GET AWAY WITH LAZY FOCUSING OR TECHNIQUE.

Unlike many other forms of photography, the margins for error are small. Your focusing has to be pinpoint accurate or you risk undoing all your hard work.

In close-up, the point of sharpest focus appears more pronounced through the viewfinder. However, while it might be easier to see, precision is required to achieve it. Given the sophistication of modern automatic focusing systems, you might assume achieving sharp focus would be relatively straightforward. However, in truth, AF, or auto focus, is rarely the best option for macro photography. It can struggle to lock on to small, nearby objects and fine detail, particularly in low light or if the subject is low contrast. Presuming your eyesight allows, focusing manually is normally the better option. This allows you to select and place your point of focus with greater accuracy on, for example, an insect's eyes or the stamens of a flower.

Due to the shallow depth of field, the slightest camera movement will throw your subject out of focus. Ideally you want your camera fixed in position, so employ a tripod whenever practical to do so. A tripod will also allow you to use the Live View function. This allows photographers to employ their camera's high-resolution monitor as a viewfinder, with the camera continuously and directly projecting the image onto the LCD.

Using Live View, photographers can preview the photograph they are about to take. Typically, it provides 100% coverage, unlike many camera viewfinders, which have a slightly reduced image area coverage of around 94–97%. As a result, you can compose images without the risk of any unseen, unwanted elements protruding into the edges of frame. However, for close-up photography, Live View is most useful as a focusing tool. You are able to zoom into the image and magnify small, specific areas in order to check critical sharpness and make very fine adjustments to focus. On some models, you can activate Live View in combination with your camera's depth of field preview button in order to achieve a 'live' preview of the zone of sharpness achieved at any given f/stop. When photographing any static subjects using a tripod, focusing via Live View is highly recommended: no other focusing technique will allow you to position your point of focus with such great precision.

MIRROR LOCK-UP FUNCTION

Using a tripod alone won't always guarantee the sharpest results. Depressing the shutter release button can cause a small amount of movement that, at slower shutter speeds, can soften image quality. Although the effect is often minimal, it appears more noticeable at higher magnifications. Therefore, unless you are shooting handheld, it is good practice to trigger the shutter remotely using a remote cord or device (page 38). Alternatively, you could employ your camera's self-timer. To help maximize image sharpness further, use your camera's mirror lock-up function, if it has one. This is designed to 'lock up' the reflex mirror prior to firing the shutter and eliminates internal vibrations caused by the mirror swinging up, and out of the light's path, just prior to the shutter opening. The internal vibrations generated by 'mirror slap' can degrade the sharpness of very fine detail. When using mirror lock-up, it takes two presses to take the picture: the first press locks up the mirror and the second takes the photo. When the mirror is in the locked-up position, the subject will no longer be visible through the viewfinder. On many digital SLRs, Live View will effectively work in the same way as using mirror lock-up, as when Live View is activated the mirror is in the 'up' position.

WOOD ANEMONE

Presuming your subject is static and you are using a tripod, focusing manually via Live View is recommended, being an extremely precise method of placing focus. In this instance, I did exactly that, zooming into the image and placing my point of focus with extreme accuracy. To maximize image sharpness, also trigger the shutter remotely – using a dedicated remote cord or device – and employ your camera's mirror lock-up facility if it has one.

Nikon D300, 150mm, ISO 200, 1/320sec at f/4, tripod

LIGHTING

Light is a key ingredient in any photograph. The quality, colour,
direction and contrast of light all contribute to the final image.

Light can help highlight, enhance or conceal the appearance of minute detail,
and front, side and backlighting each have their own individual qualities. The
trouble is, light is often in short supply when working so close to the subject.
It can be difficult to avoid your body or camera physically blocking the light due to
your close shooting position, while a degree of light is naturally lost or absorbed
at higher magnifications anyway. Thankfully, the improved high ISO performance
of modern digital SLRs is making it more and more possible to shoot using
natural light alone. Also, it is relatively easy to manipulate or supplement light
when photographing small objects at such close proximity. For example, using a
small reflector (page 64) you can bounce natural light onto your subject in order to
relieve ugly shadow areas. While, personally, I favour the quality of natural light,
for certain close-up subjects – particularly wildlife – sunlight alone won't always
provide sufficient light to freeze a subject's motion or capture fine detail and
colour. Flash is the answer. However, even when using artificial light, the goal
is normally to produce results that appear as natural as possible. This can
prove difficult to achieve when the flash is positioned so close to the subject,
so good technique and diffusion (page 72) are essential to prevent flashlight
looking harsh and artificial.

COMMON DARTER DRAGONFLY
Light has the ability to make or break your photos.
Although the quality of daylight makes it an
unrivalled light source for nature photography,
it can be in short supply at higher levels of
magnification. It is common for macro photographers
to have to supplement the light using a reflector or
flash. However, the aim is normally to still produce
natural looking results. In this instance, macro flash
(page 70) was employed to capture this photograph
of a common darter dragonfly.
*Nikon D200, 150mm, ISO 100, 1/180sec at f/4,
Commander kit R1C1 and tripod*

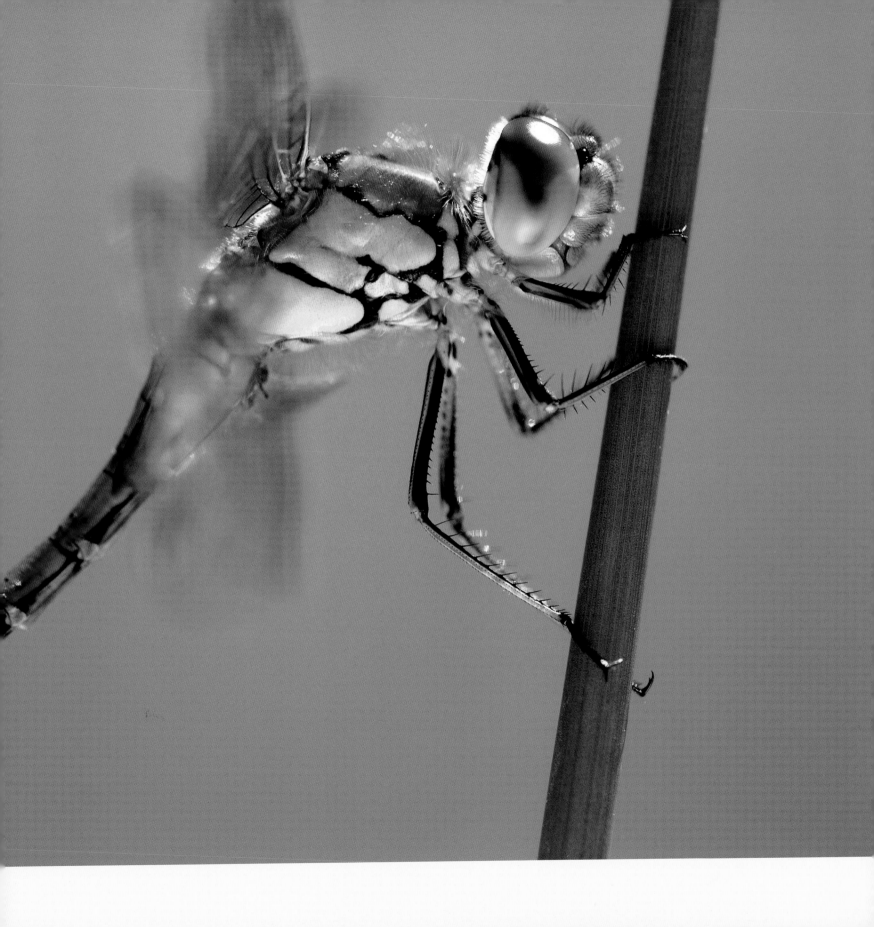

NATURAL LIGHT DIRECTION

BEFORE ATTEMPTING TO PHOTOGRAPH YOUR SUBJECT, YOU MUST CAREFULLY CONSIDER THE DIRECTION
OF THE LIGHT AS THIS WILL HAVE A CONSIDERABLE EFFECT ON THE RESULTS.

Natural light is constantly changing – not only the sunlight's direction and intensity, but also its 'colour temperature' (page 174). You are probably already familiar with the term 'golden hours'. This refers to the time around dawn and dusk, when the light is naturally soft and warm. There is no denying that either the beginning or end of the day is the best time to take photographs outside. However, the level of control close-up photographers have over how the miniature subjects are illuminated means it is possible to take good close-up images at any time of day.

FRONTLIGHTING

When the subject facing the camera is directly lit, it will be illuminated quite evenly. It is a fairly shadowless form of light, and usually easy to predict and manage. While it is good for showing subjects with no particular emphasis, it is a form of light that can produce quite flat, formless results, lacking contrast. It is well suited to emphasizing colours, though, helping make them appear richer and more vibrant.

An added complication is that, due to working close to the subject, it can prove difficult to avoid your shadow casting the subject into shade. You often need to think carefully about how and where to position your camera when relying on front light for close-up work.

SIDELIGHTING

Sidelighting helps to highlight form and texture and define shape and edges. The degree to which it does this depends on the subject

matter and the angle and intensity of light. Arguably, sidelighting is best suited to landscape photography, but it can produce powerful close-ups too, particularly if you make the subject's shadow a feature of the shot. Strong sidelighting can create too much contrast, resulting in the side of the subject that is lit being overexposed or the shadier side of the subject being underexposed, with little detail recorded. Therefore, keep a close eye on the image's histogram. If contrast is too great, you may need to relieve the shadow areas using a reflector or fill flash.

OVERHEAD LIGHT

Overhead light, created by the sun's high position during the middle of the day, can produce rather harsh, unflattering light. It can result in images looking flat and two-dimensional. Unless the subject is horizontal, top lighting isn't well suited for emphasizing texture or form. Strong overhead light is often best diffused, using a diffuser of some variety. Alternatively, it may be beneficial to cast the subject into shade in order to create a more even, attractive quality of light. This is easily done by using your body, a sheet of card, or an umbrella to block the light.

OVERCAST LIGHT

You don't always require strong directional light to capture good images. Bright, overcast light can actually produce some of the most attractive and usable light for close-ups. Clouds act like a giant diffuser, softening the sun's intensity and producing flattering, low-contrast light. When

the light is diffused in this way, you can capture fine detail and rich, saturated colours. You don't need to worry about the angle you are shooting from either, as there will be no harsh shadows to worry about and you will have complete freedom over how to compose the shot. Achieving the correct exposure is also easier in such consistent light, with the camera being able to capture detail throughout the image without any difficulty. Overcast light is very underrated, so don't be deterred if the sun isn't shining.

DOOR HANDLE
Light from any direction has the potential to create stunning close-ups. Although sidelighting is generally considered less useful for close-up work, with the right subject and situation, it can produce striking results. In this instance, I intentionally made a feature of the door handle's long shadow, cast by the low sidelighting.
Nikon D300, 150mm, ISO 200, 1/60sec at f/11, tripod

BLUEBELL
Overcast light is particularly well suited to flowers and plants. Any glare from shiny vegetation is reduced, while some flowers, like bluebells, reflect invisible ultraviolet radiation that can affect how their colour is rendered in photographs taken in bright, direct light.
Nikon D300, 150mm, ISO 200, 1/40sec at f/4, tripod

BACKLIGHTING

WHEN THE PRINCIPAL LIGHT SOURCE IS POSITIONED BEHIND THE SUBJECT, IT IS DESCRIBED AS BEING BACKLIT. WITH PRACTICE, YOU'LL FIND THIS TECHNIQUE CAN BE USED TO DRAMATIC EFFECT.

Backlighting is one of the most dramatic forms of light. Due to its ability to highlight a subject's shape and form, it is my favourite type of lighting for close-ups. However, it can also prove the most difficult to correctly meter.

The best time of day to photograph backlit subjects outdoors is morning and evening, as the sun's position is lower in the sky. Shooting towards the light's direction can enhance the risk of lens flare. However, unless you are using a short focal length, it is normally fairly easy to prevent by attaching a lens hood and selecting your camera angle with care. Backlighting is a difficult light type for TTL metering to read, with systems having a tendency to underexpose results. Switching to spot metering, and taking a light reading from just your subject, can prove a good solution. However, by regularly checking the histogram (page 22) you will soon notice if results are too dark – if they are, apply positive compensation. Illuminating subjects from behind can create attractive rim lighting, ideal for emphasizing fine detail, like the hairy stems of plants and tiny water droplets. It is especially well suited to translucent subjects, like leaves, and the wings of insects.

You don't have to rely on natural light to backlight subjects. By placing off-camera flash behind and slightly to the side of your subject, you can create a similar effect. For close-up photography, a lightbox can also prove a really useful light source. This is a unit with daylight balanced tubular lighting mounted below Perspex or toughened glass. Before the advent of digital cameras, many keen photographers owned a lightbox for viewing slides and negatives. If you still own one, dust it off and use it for shooting close-ups indoors. I regularly use one for shooting small, translucent subjects, such as slices of fruit, plastic, liquids and leaves.

MINIATURE SILHOUETTE

The most extreme form of backlighting is a silhouette – or *contre-jour* photography. This is when the subject is captured as an inky black outline, without colour or detail, against a lighter background – for example, water or sky. A silhouetted subject can make a powerful and striking image. The technique relies on the subject being grossly underexposed, so to achieve the effect, meter correctly for the subject's brighter background.

To work in silhouette, your subject should have a strong, instantly recognizable outline. Although it can be more difficult to identify suitable subjects to silhouette when shooting close-ups, when combined with the right object, results can be truly eye-catching. Keep compositions simple and try to avoid including distracting background elements.

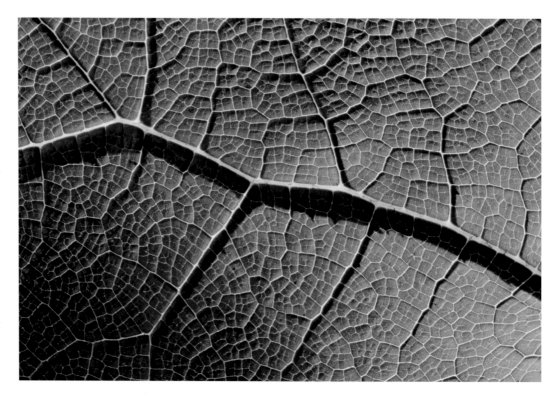

DAMSELFLY

Strong, recognizable miniature subjects can look striking silhouetted. By recording your subject as an inky outline, you will highlight its shape and form. In this instance, I metered correctly for the damselfly's light background in order to render the subject as an inky silhouette.

Nikon D300, 150mm, ISO 200, 1/30 sec at f/11, tripod

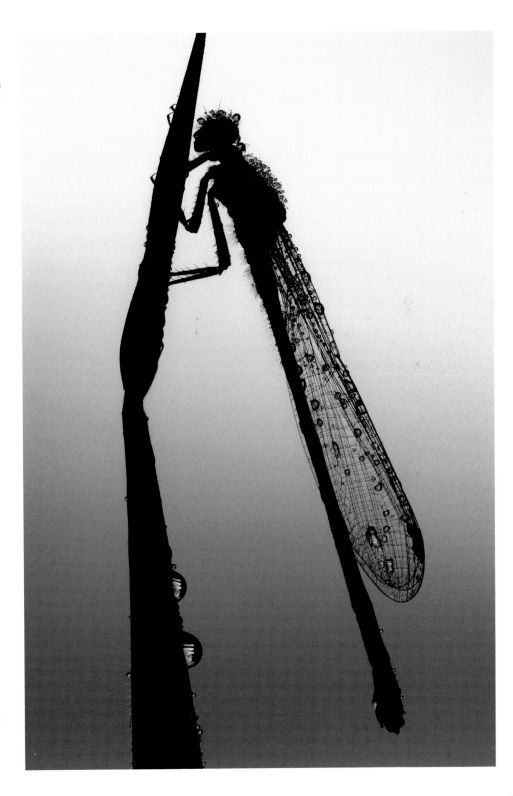

LEAF

Backlighting is well suited to lots of different close-up objects, but particularly translucent subjects like butterflies and leaves. In this instance, the low evening light backlit this leaf, highlighting its intricate design and veining.

Nikon D200, 150mm, ISO 200, 1/4sec at f/11, tripod

REFLECTED LIGHT

A REFLECTOR IS A LARGE REFLECTIVE 'DISC' THAT BOUNCES LIGHT BACK ONTO A SUBJECT. IT IS EXTREMELY USEFUL FOR CLOSE-UP PHOTOGRAPHY, GIVING EXTRA LIGHT AND BANISHING SHADOWS.

For close-up photography, I would argue that a reflector is a 'must have' lighting accessory. It can be angled manually to direct light onto your subject, providing extra illumination and relieving ugly shadow areas. Personally, I never go anywhere without a small reflector tucked away safely in my camera backpack.

When natural light is insufficient, flash (page 66) is the obvious answer. However, when placed so near to the subject, flash has to be applied with great care, and often with a good degree of diffusion, in order to retain a natural feel to close-up images. Therefore, for static subjects, often a better alternative is to simply manipulate the light available using a reflector.

Reflectors are inexpensive and available in different sizes and varying colours. The colour of the reflector is important: white will provide a soft, diffused light; silver is more efficient, but can look harsh; and gold or sunfire will add warmth to images. Many reflectors are produced with a different colour on either side, which gives you a choice depending on the subject and desired effect. Most small reflectors are collapsible, allowing them to be stored away and carried around easily. The larger the reflector, the more light they are able to reflect. However,

for small objects, a 12in (30cm) or 18in (45cm) reflector will more than suffice. It is also easy to make your own (page 101).

One of the biggest advantages of using a reflector is that you can see the effect it has on your subject immediately, before you trigger the shutter. The intensity of bounced light is quick and easy to adjust by simply moving the reflector closer or further away from your subject. Avoid placing it too close to the subject, or you risk the result looking artificially lit. Reflectors are ideal for giving small objects a kiss of light in order to relieve ugly shadows, without losing

the appearance of being naturally lit. They are particularly handy for illuminating the dark underside of subjects shot from a low angle, such as the gills of a mushroom.

PRO TIP

Presuming you are using a tripod, you can usually hold the reflector in place yourself, although a Plamp (page 39) can prove handy for keeping a reflector in position for longer periods.

GILLS

When shooting close-ups, I always carry a 18in (45cm) reflector and favour its white side. A large percentage of the images published in this book were captured with the aid of a reflector; I consider one a 'must have' tool for close-ups. They are particularly useful for supplementing natural light in dark environments.
Nikon D300, 150mm, ISO 200, 1/4sec at f/16, tripod

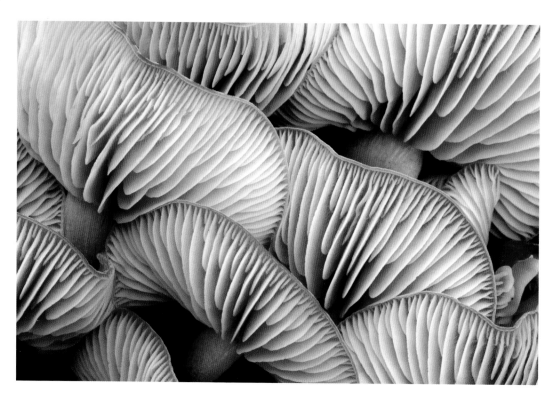

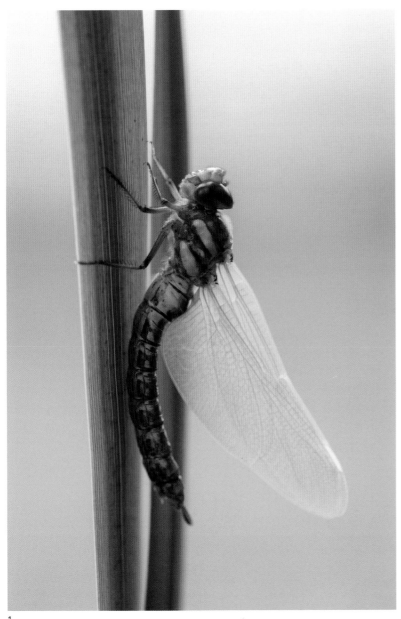

1

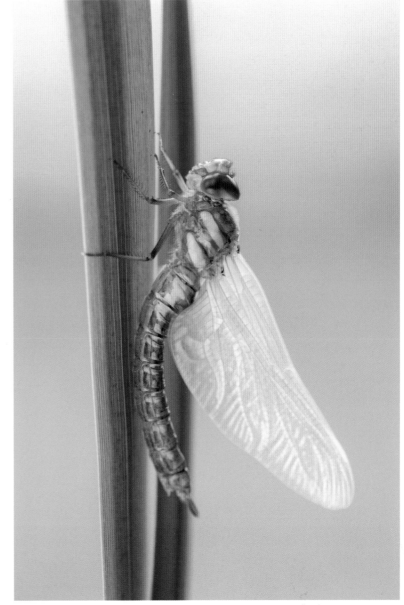

2

BOUNCED LIGHT

By carefully bouncing the light with a reflector, it is possible to illuminate small subjects and lighten dimly lit areas. Typically, results look more natural than if using flash. In this instance, the first image was taken using natural light alone (1), while for the second, I held a reflector adjacent to the subject to fill in the ugly, shadow areas (2).

Nikon D800, 150mm, ISO 100, 1/125sec at f/5, tripod

FLASH LIGHTING

WHILE NATURAL LIGHT IS THE FIRST CHOICE FOR CLOSE-UP PHOTOGRAPHY, WHEN IT IS IN SHORT SUPPLY FLASH IS THE ANSWER. FLASH IS ALSO USEFUL WHEN YOU WISH TO FREEZE A SUBJECT'S MOVEMENT.

Although natural light is often favoured for close-up photography, it obviously has its limitations. Flash allows you to capture results that would be impossible to achieve using ambient light alone.

While the quality of natural light is unrivalled, it can be in short supply when shooting at higher magnification. Flash has a reputation of looking harsh and unnatural, but applied well, in moderation and with suitable diffusion, it provides a number of key benefits. Firstly, since flash allows the selection of a smaller aperture, it provides greater depth of field. This is significant given how shallow the zone of sharpness is at higher magnifications. Secondly, flash can help highlight greater detail and colour in a subject, producing sharper, more vibrant looking results. Finally, if lighting an image entirely with flash, the very short duration of the flash acts in a similar way to a fast shutter speed and will help eliminate motion or camera blur. This is ideal when working in poor light.

Achieving correctly exposed results using flash is straightforward today, thanks to sophistication and accuracy of TTL flash metering – where the camera and flash 'communicate' to achieve the correct level of illumination. Flash light can be provided by a camera's built-in flash unit, a separate flashgun or a ring flash system.

BUILT-IN FLASH

Practically all compacts have a flash, while most SLRs are designed with a built-in, pop-up unit. Although not as powerful or flexible as an external speedlight, an integral flash can still prove useful for fill flash (page 68) and illuminating some close-up objects, particularly when combined with a degree of diffusion and flash exposure compensation. It is important to recognize its limitations, though. Its position is fixed, so it cannot be directed and, due to its relatively low position, there is a high risk that its burst will miss, or only partly illuminate, nearby objects.

EXTERNAL FLASH

An external speedlight offers far greater versatility. They are designed to operate in synchronization with the camera's internal metering and allow photographers to produce correctly exposed flash images with minimum effort. They can be mounted onto the camera via its hotshoe. However, for close-up work, it is better to use flash off-camera, via a flash bracket. This makes it possible to simulate a more natural angle of light and the flash burst can be aimed more precisely. Off-camera flash can be triggered using a connecting cable or slave unit. Although you can set flash output manually, the camera's automatic TTL metering is very reliable, ending the flash burst when the correct level of illumination is reached. However, flash output is affected by your subject's reflectivity and tonal value. Therefore, when photographing very light or dark subjects you may need to dial in positive or negative flash compensation to achieve the right level of exposure (see box).

BUILT-IN FLASH
Most consumer digital SLRs have a built-in pop-up flash. However, in truth, its usefulness for illuminating close-up subjects is fairly limited.

SPEEDLIGHT
External flashguns are more powerful, sophisticated and versatile. Their flash recycle time is faster and the majority of flashguns feature an LCD panel, where settings are displayed and can be easily altered.

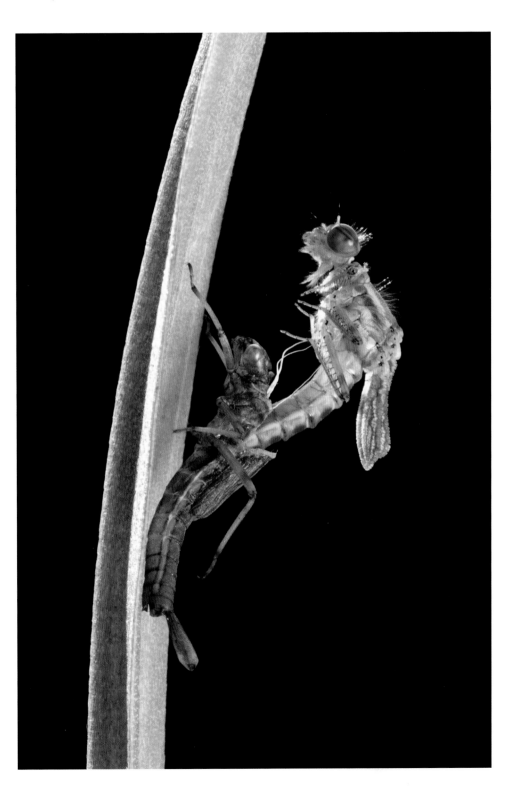

LARGE RED DAMSELFLY
Due to flash fall-off, flashlight can produce an artificially dark, or even black, background. While this can betray the use of flashlight, it can also isolate your subject against a simple, non-conflicting black backdrop.
Nikon D300, 150mm, ISO 200, 1/200sec at f/16, Metz 15MS-1, tripod

PRO TIP

Due to the design of the shutter mechanism, digital SLRs have a maximum flash synchronization speed, known as 'flash sync' or 'X-sync', which you cannot exceed. Some models are faster than others, but typically the flash sync speed is in the region of 1/200sec.

FLASH EXPOSURE COMPENSATION

If you wish to make a subject lighter or darker when using flash, apply flash exposure compensation. It is similar in principle to exposure compensation (page 44) and should be applied if the flash level automatically set by your camera is incorrect. When flash exposure compensation is applied, no changes are made to aperture, shutter speed or ISO; only the level of flash emitted is altered. Positive compensation (+) increases the burst, which makes the subject appear brighter. Negative compensation (-) reduces flash output, which makes the subject darker and also helps reduce ugly highlights and reflections.

FLASH LIGHTING FOR CLOSE-UPS

WHEN USING A FLASH FOR CLOSE-UPS, THERE ARE A NUMBER OF OPTIONS TO CONSIDER, SUCH AS HOW MUCH FLASH TO USE AND WHETHER THE CAMERA'S INTEGRAL UNIT OR AN EXTERNAL FLASHGUN IS BEST.

The first decision is whether to use only a small burst of 'fill flash', with the remaining light provided naturally, or whether to light the image entirely with flash. The next decision is whether to use your camera's pop-up integral flash unit, an external flashgun or a dedicated macro ring flash or twin flash system (page 70).

FILL FLASH

'Fill-in' or 'fill' flash is used to supplement the existing light. This is usually used to brighten, or relieve, deep shadow areas and/or to enhance the subject's colours. This can be provided by your camera's built-in flash. However, due to being so close to the subject, the lens may cast a shadow. Alternatively, if the subject is too far from the lens, the integral flash may not be powerful enough to provide sufficient flash output. Therefore, generally speaking, a dedicated flashgun is a better option. Ideally this should be attached to a side flash bracket, which allows the flash head to be angled over the subject; Custom Brackets, Novoflex and Wimberley are among the providers of flash brackets. Shoot in aperture priority mode (page 20) and set the flash to automatic (for example, ETTL for Canon or i-TTL for Nikon) for the best results. In order to reduce the flash burst, dial in negative flash exposure compensation. The exact amount required depends on the subject, working distance and the result desired, but begin by reducing the burst by either 1 or 2 stops. If the flash output is not sufficient, or is too bright, adjust flash exposure compensation accordingly.

EXTERNAL FLASH

An external flashgun is essential if you wish to light an image entirely with flash. Again, ideally, it should be attached via a dedicated macro flash bracket. The aim is to remove all natural light from the image so that the subject is illuminated only by a very short, but very bright, burst of flash. The photographer has complete control over the choice of f/stop and, by removing motion blur, it is easier to handhold the camera. However, flash diffusion is essential (see box).

A good method to photograph a subject in this way is to set the camera to manual mode (page 20) before selecting the f/stop desired together with a shutter speed equal to the camera's flash sync speed, typically in the region of 1/200sec. With the flashgun set to automatic, results should be well exposed. However, predominately dark and pale subjects may fool flash metering. Therefore, be aware that you may need to apply a degree of negative compensation for dark subjects, and positive compensation for light objects.

FLASH DIFFUSION

The quality of light from a flashgun is largely determined by the amount of diffusion applied to it. Diffusers are designed to reduce a flash's intensity and create more natural-looking results. For diffusion to be successful there are several 'rules' to follow. Firstly, the diffused flashgun should be as close to the subject as possible, ideally just a few centimetres above it. Therefore, applying diffusion is easier with shorter focal length macro lenses – below 100mm – as the shorter working distance provided make it simpler to position the flash head near to the subject. Secondly, the diffuser should be as large as possible so that, from the subject's viewpoint, it acts rather like clouds diffusing sunlight. Finally, the diffuser should be thick enough to remove harsh highlights, but not so dense that it significantly reduces flash output.

There are a number of diffusers on the market designed for external flashguns, and some are for built-in flash units. The LumiQuest III and the Lambency diffuser are both excellent diffusers, although the latter in particular will often still require a degree of additional diffusion to fully remove highlights. This can be done simply, though, for example, by just covering the front of it with kitchen towel.

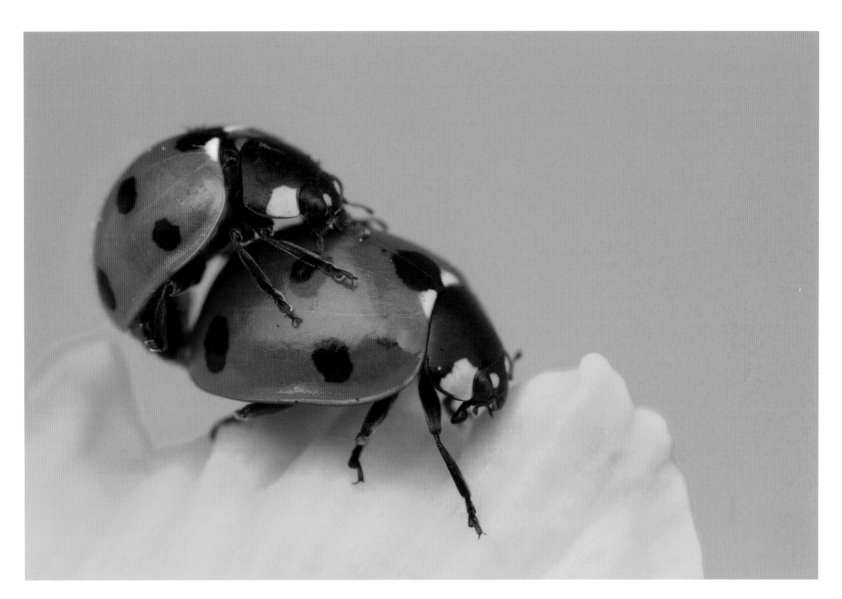

LADYBIRDS
Natural light proved insufficient when photographing these mating ladybirds. Therefore, a burst of fill flash was used, relieving harsh shadows from the subject, while still retaining the colour of the blue sky in the background.
Canon EOS 60D, 60mm, ISO 400, 1/250 at f/8, diffused Canon MT-24EX twin flash, handheld

RING FLASH AND TWIN FLASH SYSTEMS

Light coming from a single source can make it look rather directional and uneven. You can correct this by using a second flashgun on a second side bracket, but this can make your set-up heavy and unwieldy. Instead, many close-up photographers favour a dedicated ring flash or twin flash system. Unlike a conventional flashgun, ring flash is circular, attaching directly to the front of the lens via an adapter, while the control unit sits on the camera's hotshoe. It produces a ring of light, enabling it to effectively illuminate nearby subjects from all directions at once. This type of lighting can prove quite flat and shadowless, though. Therefore, modern ring flashes allow ratio control so that the light from one side of the ring can be stronger than the other. This creates shadow and more natural, three-dimensional looking results. A disadvantage of ring flashes is that it is not possible to change the angle of the light. They can also be very difficult to diffuse and the fact that the ring extends below the lens makes it impossible to rest the lens directly on the ground. This can prove restrictive when trying to photograph ground level subjects. They also tend to produce doughnut-shaped reflections on shiny surfaces on, for example, an insect's eyes, which can look rather unnatural.

TWIN FLASH

Twin flash systems work using a similar principle to a ring flash, but instead of a ring, consist of two small, individual flash heads that are mounted on an adapter ring attached to the front of the lens. The flash heads can be rotated and positioned independently around the ring and their angle can also be adjusted. Ratio control is again possible, allowing one head to be brighter than the other. They are lightweight, compact and arguably the most versatile and useful form of close-up flash. Crucially, it is easier to diffuse twin flash than it is ring flash.

Both ring flash and twin flash units can be used to apply fill flash, but they are better suited to lighting a subject entirely with flash. They are best combined with shorter focal length macros and for high magnification photography.

MACRO FLASH
Ring and macro flash units are designed to allow close-up photographers to evenly illuminate miniature subjects from all directions at once.

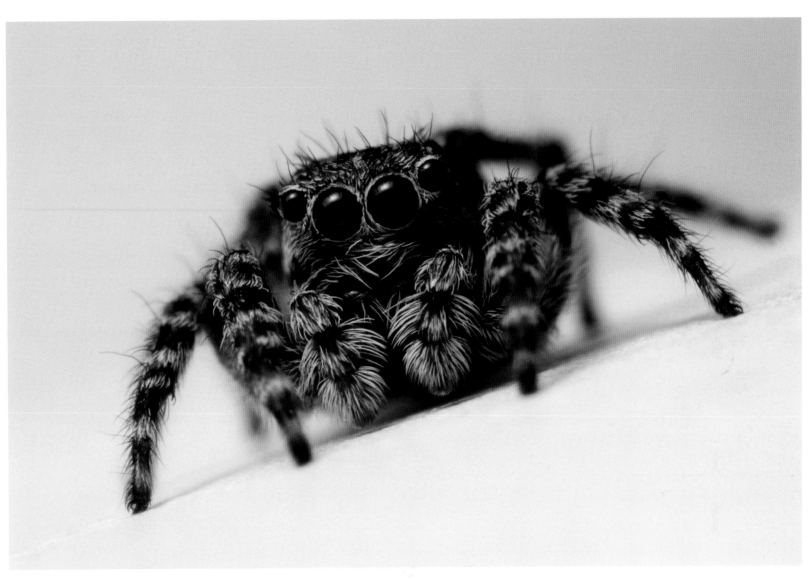

JUMPING SPIDER
Flash can allow photographers to capture sharp, detailed and beautifully lit images of miniature subjects that just wouldn't have been possible using ambient light. This image was lit entirely with flash using a single external flashgun.
Canon EOS 5D, MP-E 65mm, ISO 50, 1/160 at f/14, diffused Canon 580EXII flash, handheld

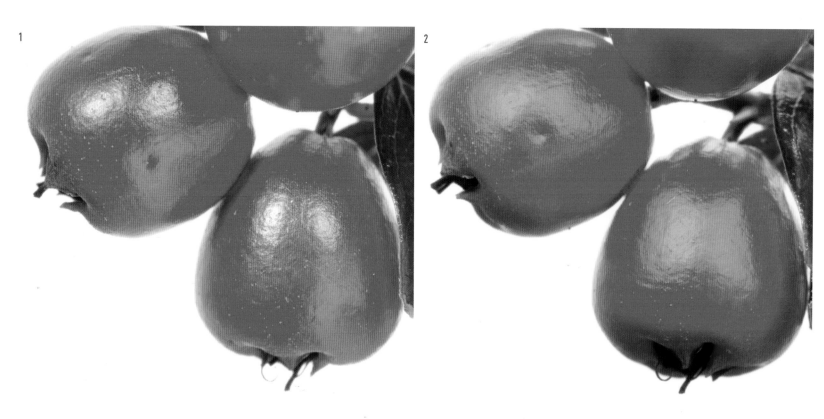

1

2

DIFFUSING FLASH

Unless it is diffused, neither ring flash nor twin-flash will produce attractive light. Unfortunately, there are no diffusers commercially available for ring flash or twin flash systems that perform the task effectively. It is therefore probably best to make your own. Due to their shape and design, ring flashes are difficult to diffuse. The best option is to simply cut and fix rings of kitchen towel or stiff paper to the actual flash ring. Doing so will soften the light, but will not remove the doughnut-shaped reflections. Twin flash units are easier to diffuse and, if you search online, you will discover a number of innovative solutions. One of the best methods is to cut the front domes from two Lambency diffusers and position them in front of the two flash heads using strips of Velcro. An additional layer of kitchen towel or paper

may be needed to fully reduce flash hotspots. If the two domes are attached to each other it will also help to prevent the flash from producing two distinct reflections, although inevitably the shape of the two diffusers can still be seen to an extent on highly reflective surfaces. Nevertheless, when diffused like this, it is possible for twin flash units to produce soft, even and natural-looking light.

HOMEMADE DIFFUSERS ON TWIN FLASH
Diffusion is key to successful flash lit close-ups. This homemade set-up was constructed using the front domes of Lambency diffusers. It might not look pretty, but it does the job nicely!

WITH AND WITHOUT DIFFUSION
You can begin to see the importance of flash diffusion in this image comparison. The first image was taken using a twin flash system without diffusion: hotspots and reflections are obvious (1). For the subsequent image, flash was diffused, and the result looks more natural (2).
Canon EOS 60D, MP-E 65mm, ISO 100, 1/160sec at f/14, Canon MT-24EX flash, handheld

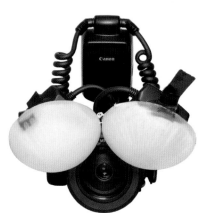

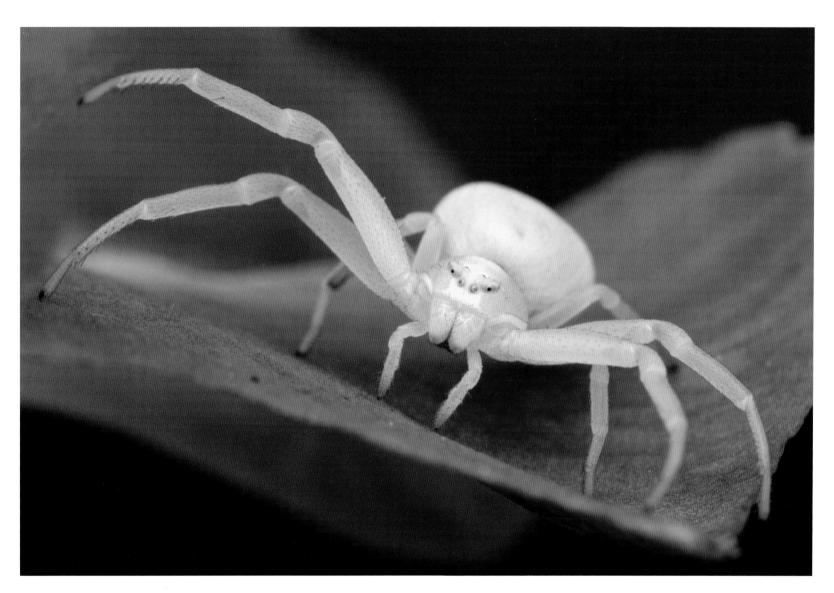

CRAB SPIDER

Flash was essential in order to photograph this crab spider. However, without diffusion, ugly, blown highlights would have resulted on its pale body, which would have ruined the image.

Canon EOS 7D, MP-E 65mm, ISO 100, 1/160sec at f/14, diffused MT-24EX twin flash, handheld

THE OUTDOOR STUDIO

YOU CAN EMPHASIZE YOUR SUBJECT BY PHOTOGRAPHING IT IN ISOLATION FROM ITS BACKGROUND
IN A OUTDOOR STUDIO, WHICH IS REASONABLY EASY TO SET UP.

The subject is photographed against a simple, plain white background, on location, using an outdoor studio. While white backgrounds were favoured by early botanical and bird painters, it is the Meet Your Neighbours project, led by photographers Niall Benvie and Clay Bolt, that made this approach grow in popularity in recent years. The project has also popularized the idea of backlighting the white background in order to highlight the translucent properties of many nature subjects.

At its simplest, an outdoor studio consists of a piece of $\frac{3}{32}$ in (3mm) opaque acrylic (for example, white Perspex); two flashguns (a master and a slave); a tripod to support the camera (if required); and some means of holding the acrylic and one of the flashes in the required position. For example, a lightweight tripod, sticks, crocodile clips and Plamps can all prove useful. The acrylic should be placed in position behind the subject with the rear (slave) flash positioned behind that in order to backlight the subject. The master flash should be camera mounted on a side bracket, or alternatively, a ring flash or twin flash can be used. The master flash will provide all of the front lighting, so it will need to be diffused (page 72). The rear flash (positioned behind the acrylic) does not require diffusion.

Once the basic set-up is in place, it is then a matter of finding the right balance between the light coming from the front flash and that from the rear flash. This can be achieved by setting the flash output manually, or they can be set to automatic with the ratio between the two adjusted to achieve the desired effect. The distance between

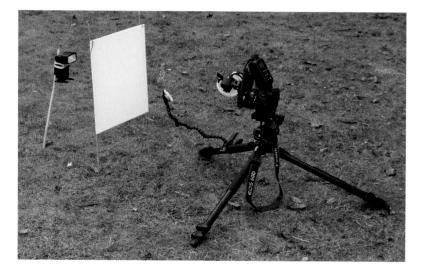

A SIMPLE OUTDOOR STUDIO
An outdoor studio is relatively simple to create and will help you capture striking high-key results, with emphasis on the subject. This image should give you a good idea of how a typical outdoor studio should appear.

the rear flash and the acrylic, and the distance between the subject and the acrylic, can also be adjusted to increase or decrease the brightness. The camera can then be set to manual, the desired aperture chosen, and the subject will be fully lit by the two flashguns; the master flash will automatically activate the slave flash. The objective is for the white background in the final image to be brilliant white. Histograms (page 22) will be skewed to the right and the highlight warning may flash – with the main subject being neither too dark, nor too bright. Particular care needs to be taken to ensure that detail is retained in translucent areas of the subject, such as an

insect's wings. An alternative technique is to lay the acrylic horizontally to form a 'table' with the flash positioned below it. The subject can then be photographed directly on the acrylic.

This type of high-key photography can produce simple yet stunning natural history close-ups. The technique is particularly well suited to plantlife and to wildlife that cannot run or fly away; for example, snails or caterpillars. As always, minimize subject disturbance and, should you decide to reposition a subject, handle it with great care and retain it for a short time only. Once you've taken your photo, always return subjects to where you found them.

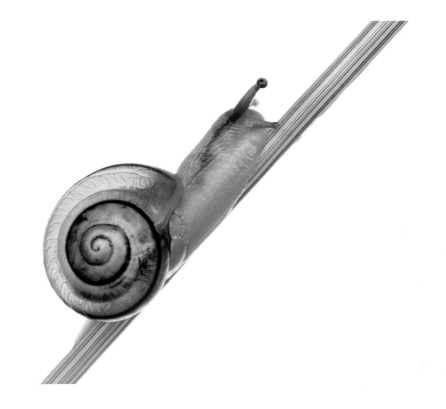

BROWN-LIPPED SNAIL
A backlit white background frees the subject from competing distractions and also helps to illuminate translucent areas such as this snail's shell.
Canon 7D, 60mm, ISO100, 1/160sec at f/16, diffused MT-24EX twin flash and Canon Speedlite 430EXII behind white acrylic, handheld

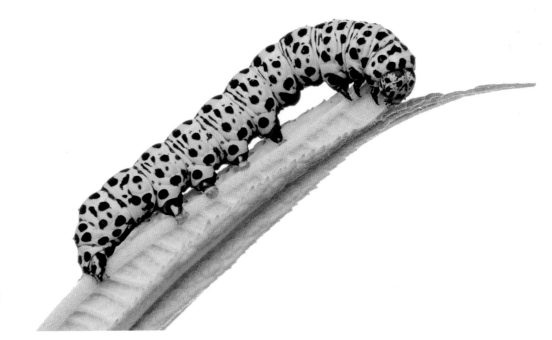

MULLEIN MOTH CATERPILLAR
The markings of this striking caterpillar are emphasized by the simplicity of the plain, white background. This style of photography can suit all types of natural subject.
Canon 7D, 60mm, ISO100, 1/160sec at f/18, diffused MT-24EX twin flash and Canon Speedlite 430EXII behind white acrylic, handheld

CLOSE-UP TOP TIPS

For 20 years or so, I've been peering through either a macro lens or close-up attachment trying to highlight the beauty, texture and intricacy of small things.

As close-up photographers, we have the opportunity to capture minute detail and interest that others easily overlook. On my way to being recognized as a close-up specialist, I've taken a large number of photos, both good and bad. Although, just like any other photographer, I still have a huge amount of learning and improving to do, I have picked up lots of tips and tricks over the years. Hopefully, by sharing a selection of my 'Top Tips', it will not only improve your close-ups, but also help you avoid some of the mistakes I've made over the years...

COLOURFUL WATER DROPLETS
It's incredible how just a few tips have the potential to either markedly improve your images, or simply make life easier when taking photos. Over the next few pages, I share a selection of my 'Top Tips', accompanied by photographs that, hopefully, will further inspire and motivate you to take better close-ups.
Nikon D800, 150mm, ISO 100, 1/2sec at f/16, tripod

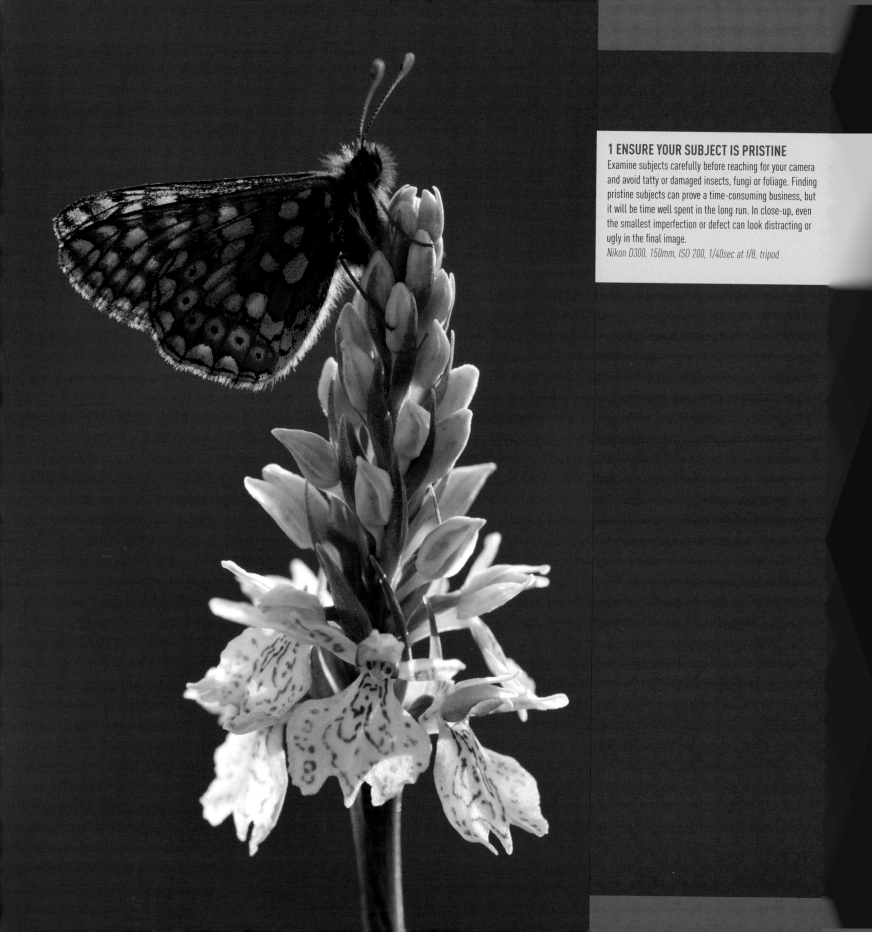

1 ENSURE YOUR SUBJECT IS PRISTINE

Examine subjects carefully before reaching for your camera and avoid tatty or damaged insects, fungi or foliage. Finding pristine subjects can prove a time-consuming business, but it will be time well spent in the long run. In close-up, even the smallest imperfection or defect can look distracting or ugly in the final image.

Nikon D300, 150mm, ISO 200, 1/40sec at f/8, tripod

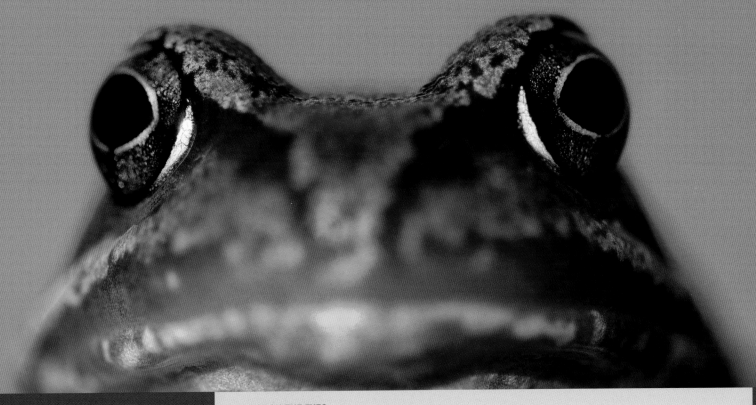

2 FOCUS ON THE EYES

OK, so you've probably read this tip countless times before, but it is so important that I feel it is worth reiterating. Simply, always focus on the subject's eyes. While there are exceptions to the rule, it is rare for an image to succeed if the subject's eyes aren't bitingly sharp. Eyes are engaging and help us to connect with the subject, which is why they are one of the first things we instinctively look at.

Nikon D300, 150mm, ISO 320, 1/640sec at f/3.2, handheld

3 USE A MAKESHIFT WINDBREAK

One of a close-up photographer's biggest enemies is windy weather. Even the slightest breeze can appear vastly exaggerated when working up close. Thankfully, when shooting nearby, static subjects, like flowers, it is often possible to shelter your subject. Try using your body or your camera backpack, placed to the side of the subject, to shield it from the wind. Release the shutter remotely, if required. Another option is to erect some sort of temporary windbreak, using clear polythene and a handful of garden canes, or you could try using a Plamp (page 39) to steady your subject.

Nikon D300, 150mm, ISO 200, 1/20sec at f/7.1, tripod

4 USE A GROUNDSHEET

Photographers are often kneeling down, lying prone on the ground or crawling through undergrowth. To avoid getting muddy or soggy, use a groundsheet, like the Linpix Photography Mat, to help keep you and your equipment clean and dry. Alternatively, wear waterproof clothing or buy garden kneeling pads. If push comes to shove, even a bin liner will do!

Nikon D200, 150mm, ISO 100, 1/6sec at f/16, tripod

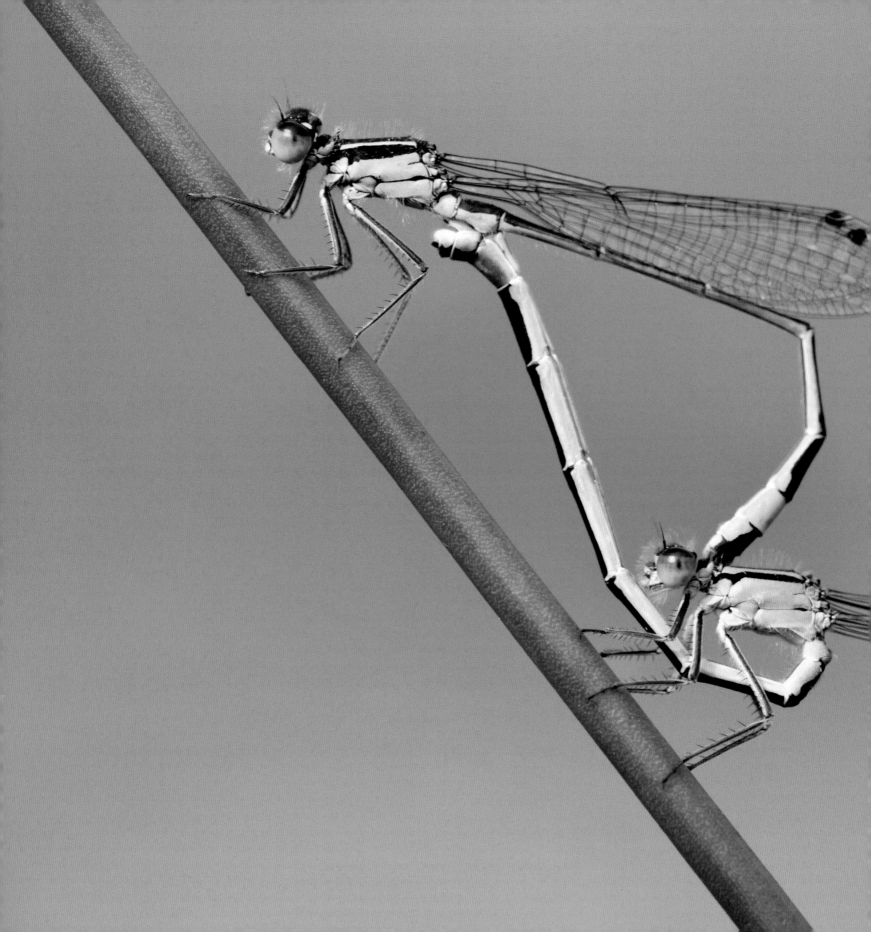

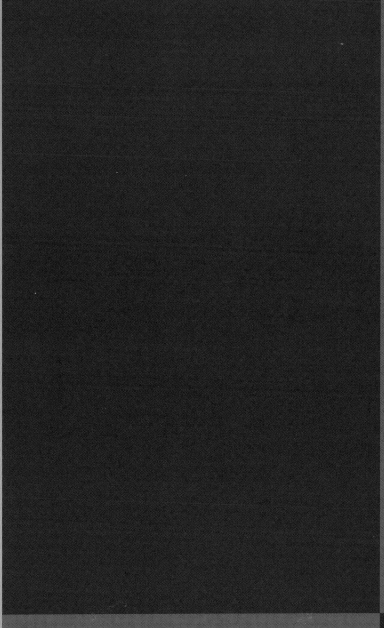

5 CAPTURE BEHAVIOUR

If you want your wildlife close-ups to stand out from the crowd, try to capture interesting or unusual behaviour. For example, a photo of an insect hatching, mating, flying or devouring its prey will have far more impact than a simple, standard portrait. Since knowledge of your subject is essential if you wish to achieve intimate shots of behaviour, research potential subjects thoroughly in order to know where to go and what to look for.

Nikon D300, 150mm, ISO 200, 1/250sec at f/5, handheld

6 PRE-FOCUS YOUR LENS

When photographing flighty or timid subjects that are easily disturbed, it is important to keep your movements to an absolute minimum. Even the movement of your hand adjusting the focus ring may send your subject flying or scurrying away. Therefore, pre-focus your lens in advance and then move slowly forwards until your subject appears sharp through the viewfinder. To help you achieve the level of magnification you desire, try pre-focusing on a nearby object of similar size to that of your subject.

Nikon D300, 120–400mm (at 400mm), ISO 200, 1/200sec at f/9, handheld

7 USE AN ARTIFICIAL BACKDROP

The colour and look of the subject's backdrop can make or break an image. A clean, diffused background will usually complement your subject best, helping it stand out. However, it is not always possible to isolate your subject from its surroundings or throw background detail sufficiently out of focus. In instances such as this, or when you wish to create a more interesting or colourful result, consider introducing an artificial backdrop. Some photographers take photographs of out-of-focus foliage and then print the results to A4 or A3 size to use as backgrounds for flowers and resting insects. For more striking results, use coloured card. For low- or high-key results, place a sheet of rigid black or white card behind your subject. For miniature subjects, almost anything can be used as a makeshift backdrop. In this instance, a bright red jumper created this vivid, contrasting background.

Nikon D300, 150mm, ISO 200, 1/160sec at f/4, tripod

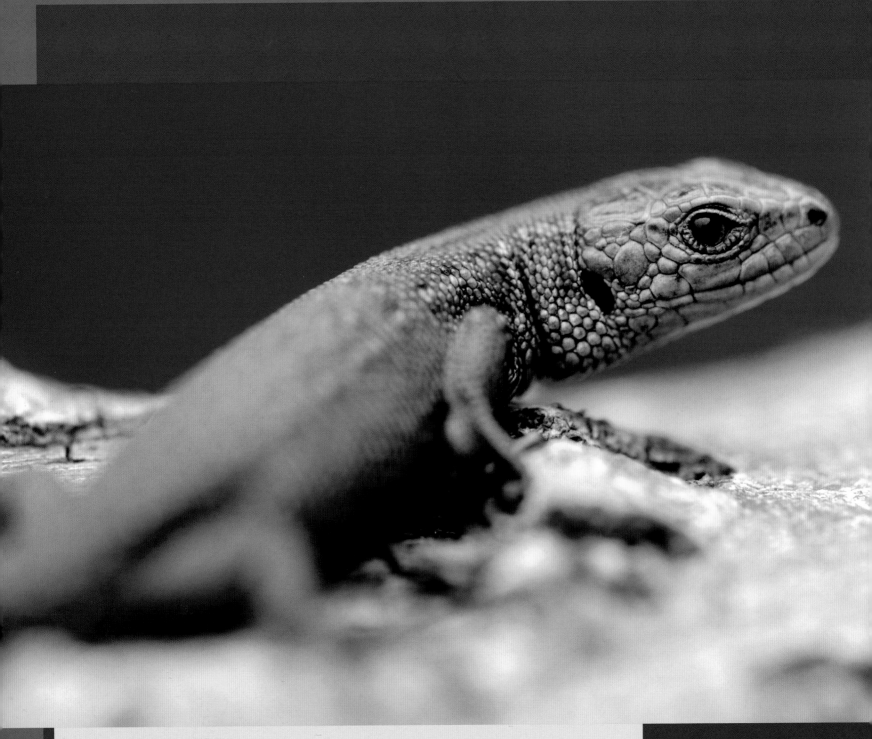

8 APPROACH SUBJECTS CAREFULLY

Insects, spiders and reptiles are particularly sensitive to movement. Therefore, when you are stalking a subject, think about every step you take and each movement you make. Keep your movements slow and deliberate.

Try to avoid disturbing nearby plants and foliage or you may alarm your subject, causing it to hop, fly or scurry away.
Nikon D300, 150mm, ISO 200, 1/80sec at f/3.5, handheld

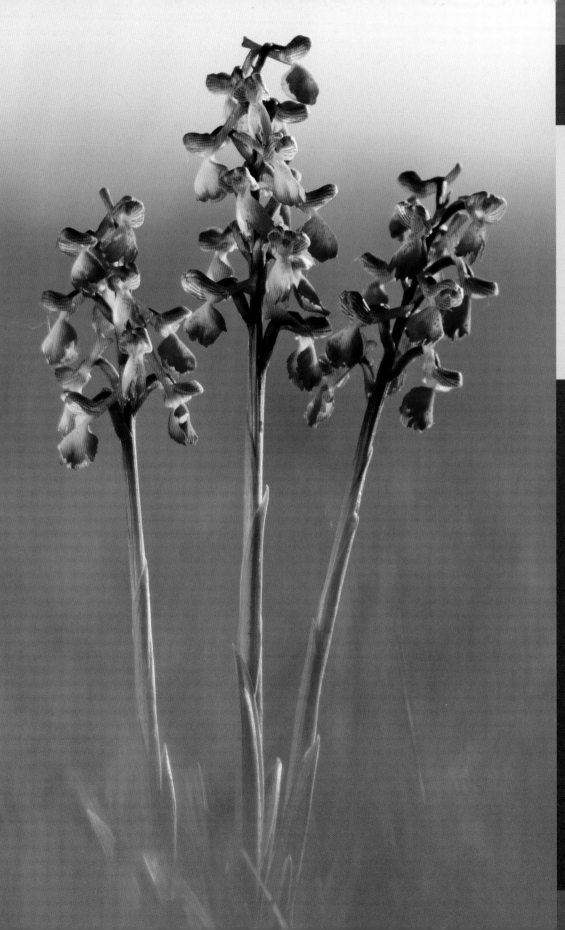

9 CHECK FOR BACKGROUND CLUTTER

What you exclude from the frame is often as important as what you include. A messy backdrop can completely ruin an otherwise good close-up. For example, distracting grasses, or ugly highlights, will draw the viewer's attention away from the intended focal point. Prior to releasing the shutter, get into the habit of allowing your eye time to fully explore the frame. If your camera has a preview button, use it. It will allow you to preview exactly what will be in and out of focus in the final image. Distracting elements can be quickly removed by doing a spot of 'gardening' (page 148), or excluded by altering viewpoint or selecting a shallower depth of field. A simple, clean backdrop will help your subject stand out.

Nikon D300, 70-200mm (at 200mm), ISO 200, 1/500sec at f/5.6, beanbag

10 LEARN TO 'SEE'

One of the key skills to capturing great close-ups is the ability to 'see' the image in the first place. Macro photographers have the ability to reveal a hidden world, highlighting or isolating small, interesting detail, texture, shape and form. You need to rediscover childlike curiosity; if necessary, get down on your hands and knees to see what you find. Learn to closely study objects that you might otherwise walk by or overlook. For example, mossy logs, lichen-encrusted boulders and seaweed-clad rocks can all present a host of opportunities when viewed close up.

Nikon D70, 150mm, ISO 200, 1/8sec at f/11, tripod

11 KISS

'Keep it simple stupid' is a principle particularly relevant to close-up photography. So many images fail due to them being made overly complex. You'll notice that the majority of successful macro images often involve just one or two key elements: for example, shape, texture, light or colour. Don't try to be clever, or cram too much into the frame, just for the sake of it; keep it simple and your images will markedly improve.

Nikon D300, 150mm, ISO 200, 1/25sec at f/5, tripod

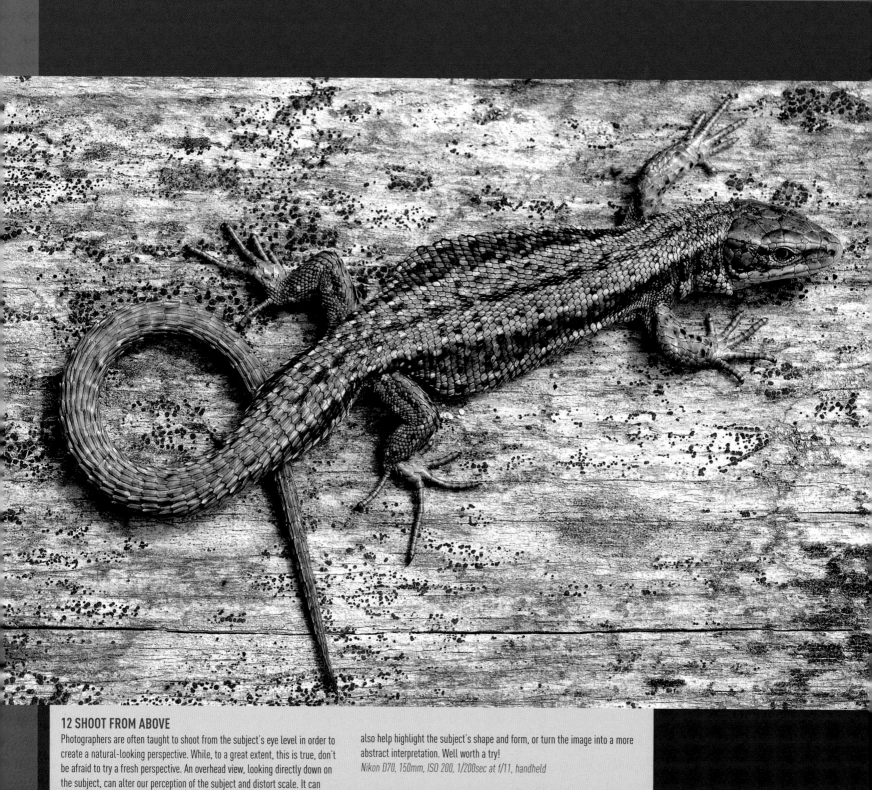

12 SHOOT FROM ABOVE

Photographers are often taught to shoot from the subject's eye level in order to create a natural-looking perspective. While, to a great extent, this is true, don't be afraid to try a fresh perspective. An overhead view, looking directly down on the subject, can alter our perception of the subject and distort scale. It can also help highlight the subject's shape and form, or turn the image into a more abstract interpretation. Well worth a try!

Nikon D70, 150mm, ISO 200, 1/200sec at f/11, handheld

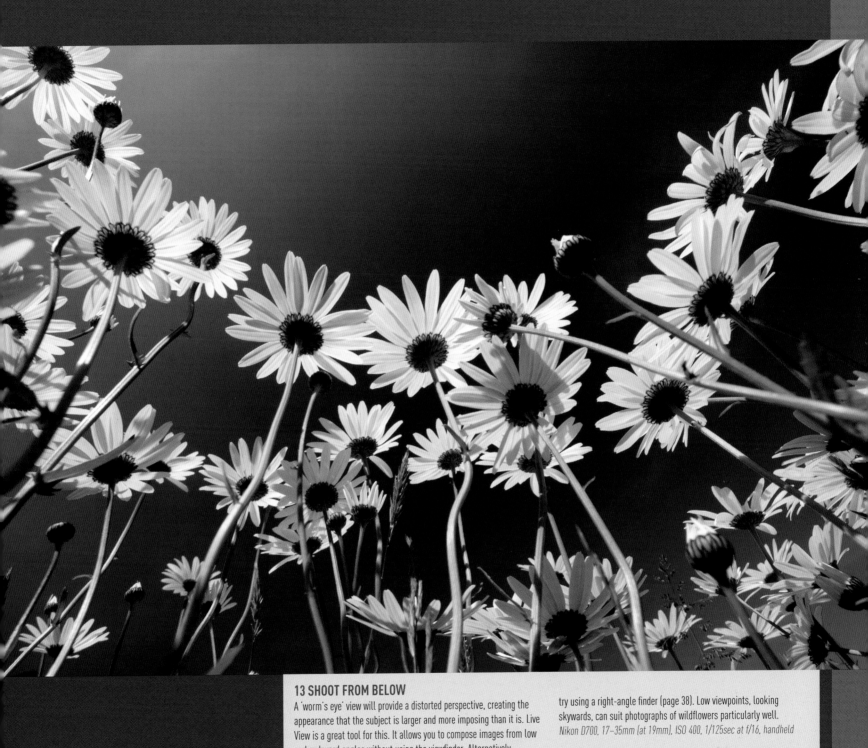

13 SHOOT FROM BELOW

A 'worm's eye' view will provide a distorted perspective, creating the appearance that the subject is larger and more imposing than it is. Live View is a great tool for this. It allows you to compose images from low and awkward angles without using the viewfinder. Alternatively, try using a right-angle finder (page 38). Low viewpoints, looking skywards, can suit photographs of wildflowers particularly well.

Nikon D700, 17–35mm (at 19mm), ISO 400, 1/125sec at f/16, handheld

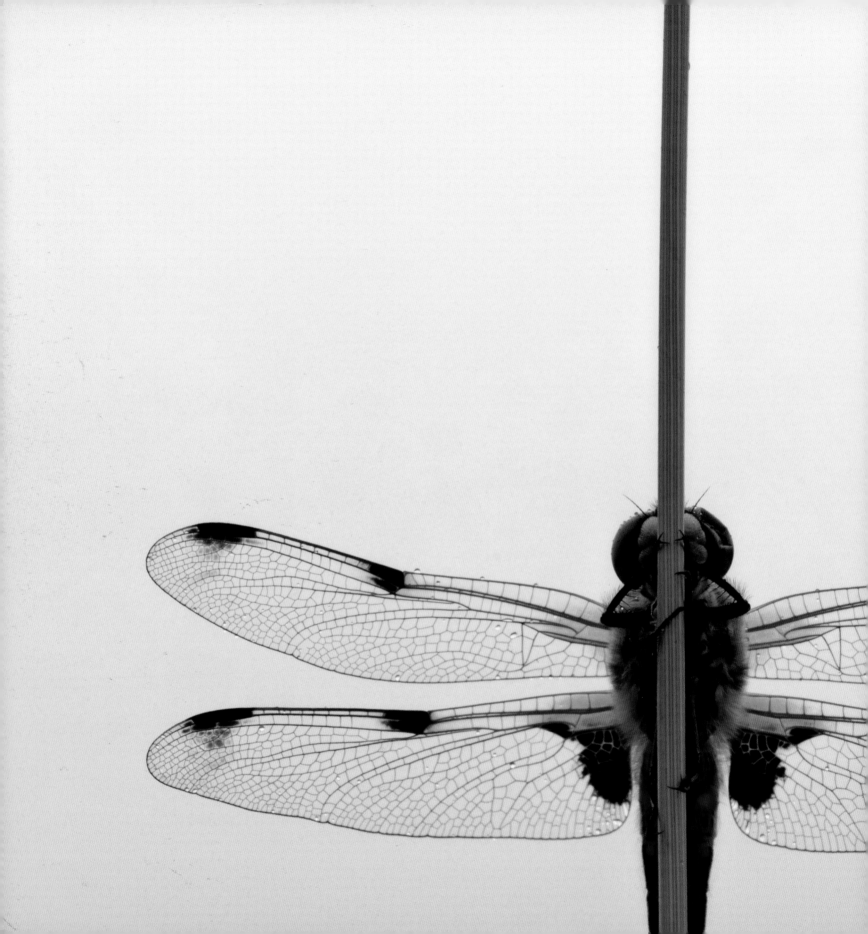

14 BREAK THE RULES

The rules of composition (page 52) are a great starting point when constructing your photographs. These rules exist to help us logically organize the elements within the viewfinder. However, don't be bound by them; following them won't always guarantee the best results. For example, placing your subject centrally, rather than on an intersecting third, can produce more striking, eye-catching results. In this instance, the image shouldn't really work: the reed is central, dissecting the image in two, while the dragonfly is positioned too low in the frame with part of its tail cut off. However, it is for these reasons that the composition actually works. It is bold, eye-catching and unconventional. The key is to always compose instinctively.

Nikon D300, 150mm, ISO 200, 1/8sec at f/16, tripod

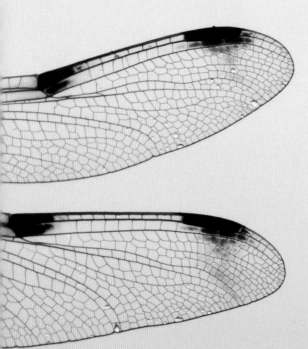

15 LOOK FOR REPETITION

The miniature world is full of patterns and repetitive shapes. Repetition in an image provides structure, order, interest and intrigue. Look for texture, colour and shapes, both natural and manmade, that repeat. Wood grain, bark, chains, lichen, water droplets and sand are among good potential subjects. Using a macro lens or close-up attachment, you can isolate and highlight repetition, creating simple, abstract results.

Nikon D200, 105mm, ISO 200, 1/4sec at f/14, tripod

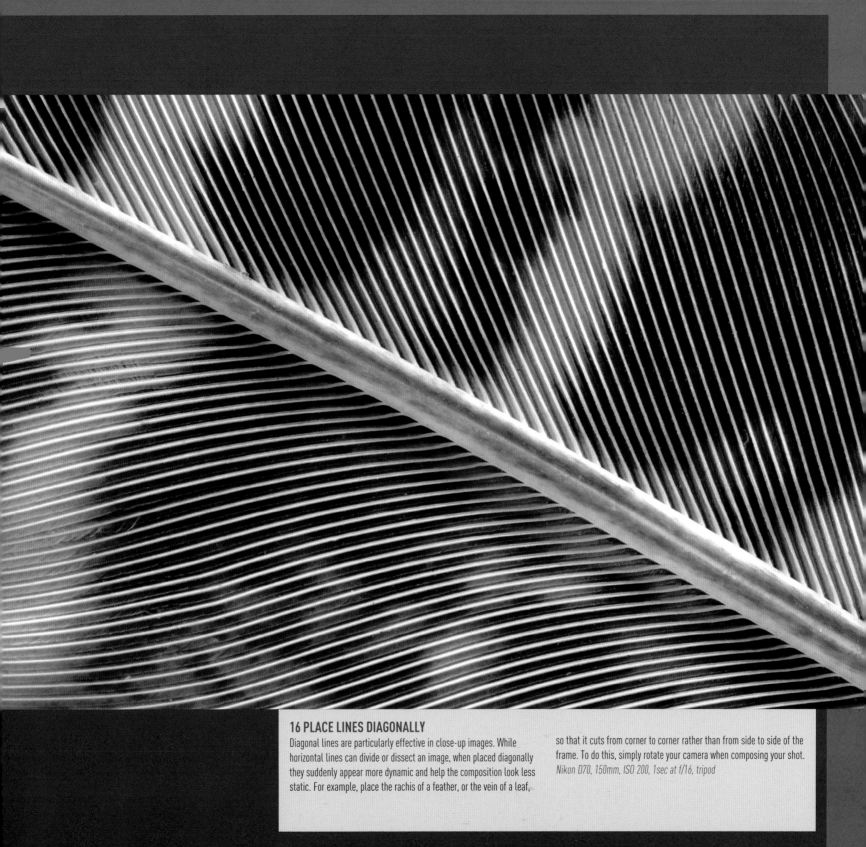

16 PLACE LINES DIAGONALLY

Diagonal lines are particularly effective in close-up images. While horizontal lines can divide or dissect an image, when placed diagonally they suddenly appear more dynamic and help the composition look less static. For example, place the rachis of a feather, or the vein of a leaf, so that it cuts from corner to corner rather than from side to side of the frame. To do this, simply rotate your camera when composing your shot.

Nikon D70, 150mm, ISO 200, 1sec at f/16, tripod

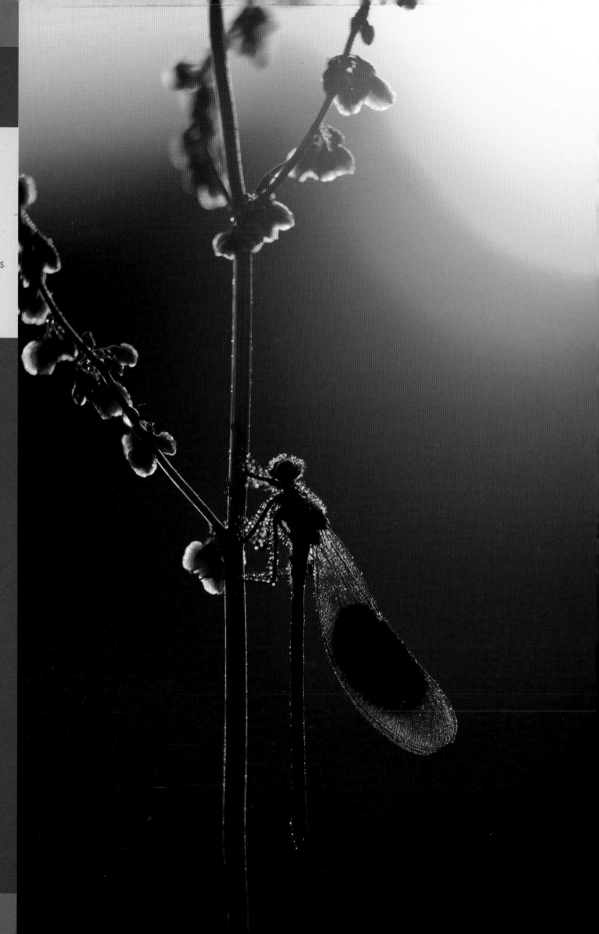

17 ATTACH A LENS HOOD

When shooting backlit or silhouetted subjects, the risk of flare is greatly enhanced. To help prevent ugly flare degrading your close-ups, attach a lens hood. Most lenses are supplied with a compatible hood, but they can be purchased separately. If you don't have a lens hood, try shielding the lens with your hand or a piece of card. Even when a hood isn't necessary, it can still be worthwhile attaching one; a hood will give the front element of the lens a degree of physical protection from the weather and from getting scratched or dirty.

Nikon D300, 150mm, ISO 200, 1/1250sec at f/2.8, tripod

18 SHOOT WHATEVER THE WEATHER

Regardless of the time of year, weather or light, there are always opportunities to shoot great close-ups. For example, after rainfall, foliage will be vibrant and tiny droplets of water will cling to every branch and leaf. In winter, wrap up warm and shoot abstract-looking close-ups of ice patterns and frost-covered vegetation. Dull, grey days can produce beautiful, even lighting – perfect for floral close-ups. Even if the weather is so bad that it stops you going outside, there are countless subjects to shoot from the shelter of your home.

Nikon D300, 150mm, ISO 200, 1/20sec at f/14, tripod

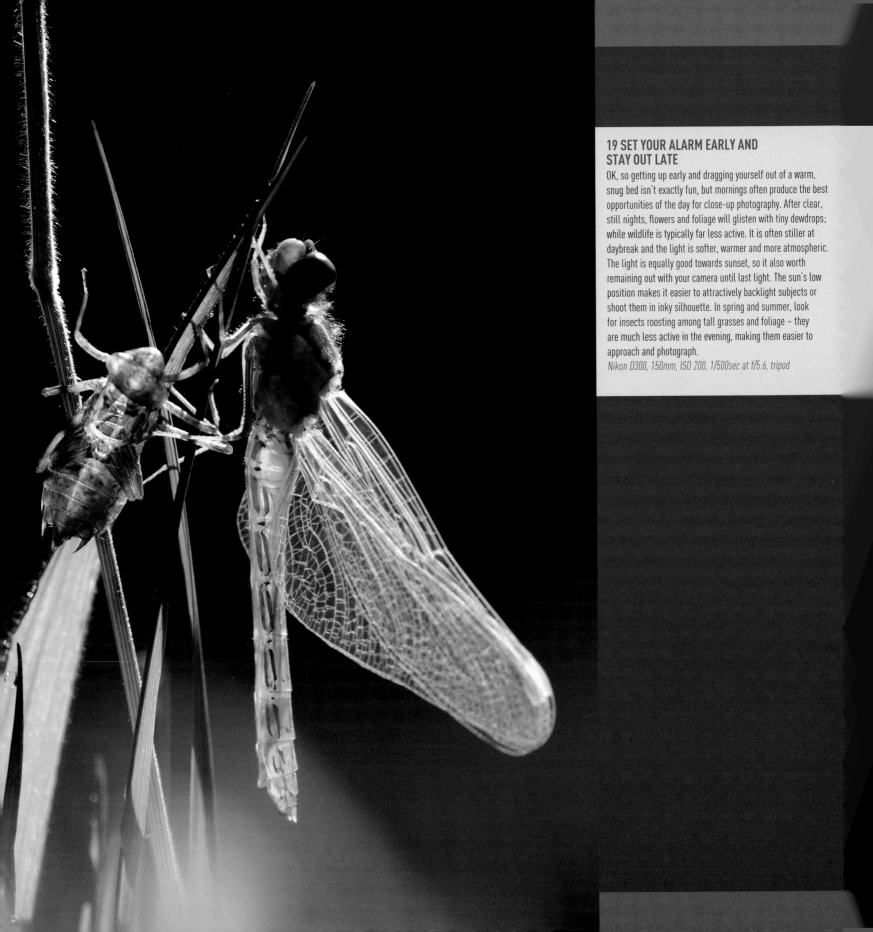

19 SET YOUR ALARM EARLY AND STAY OUT LATE

OK, so getting up early and dragging yourself out of a warm, snug bed isn't exactly fun, but mornings often produce the best opportunities of the day for close-up photography. After clear, still nights, flowers and foliage will glisten with tiny dewdrops; while wildlife is typically far less active. It is often stiller at daybreak and the light is softer, warmer and more atmospheric. The light is equally good towards sunset, so it also worth remaining out with your camera until last light. The sun's low position makes it easier to attractively backlight subjects or shoot them in inky silhouette. In spring and summer, look for insects roosting among tall grasses and foliage – they are much less active in the evening, making them easier to approach and photograph.

Nikon D300, 150mm, ISO 200, 1/500sec at f/5.6, tripod

20 MIND YOUR SHADOW

When shooting close-ups of wildlife, always be mindful of where your shadow will fall.
If you cast your shadow across the subject while moving into position, it will alert it to
potential danger. As a result, it will likely scurry or fly away. Therefore, when approaching
your subject, always glance skywards first so that you are aware of the sun's position.
Then adjust the direction of your approach accordingly.

Nikon D300, 150mm, ISO 200, 1/800sec at f/2.8, tripod

21 CARRY A SOFT BRUSH

Through a close-focusing lens, even the smallest particles of dirt, dust or pollen can prove ugly or distracting. One option is to simply remove them during post-processing using the Clone Tool or Healing Brush in Photoshop. However, this can be a fiddly and time-consuming business. Instead, use a small, soft brush or blower to gently remove any specks of dirt from your subject before taking photos. This will save time in the long run.

Nikon D300, 150mm, ISO 200, 2sec at f/11, tripod

1

2

22 MAKE A REFLECTOR

When photographing miniature subjects, light is often in short supply (1). One of the best ways to supplement natural light is by using a reflector (page 64). You can relieve dark, ugly shadows by bouncing light onto the subject (2). Although compact, foldaway reflectors are available quite cheaply, you can save yourself a few quid by making your own. Simply tape silver foil onto a piece of stiff card. A4 is a good size, being large enough to be able to illuminate small subjects, like plants and flowers, yet small enough to slip into most camera bags without being folded.

Nikon D300, 105mm, ISO 200, f/5.6 at 1/30sec, tripod

23 ATTACH A POLARIZING FILTER

Polarizing filters are well known for their ability to saturate clear blue skies in wideangle views. However, the way in which they can reduce subject glare and reflections makes them equally suited to close-up photography. They are most useful for shooting flowers and foliage, particularly if they are wet after rainfall. Simply rotate the filter in its mount until natural colour saturation is restored. A polarizer will help give your floral close-ups more vibrancy and impact. Due to their two-stop filter factor, shutter speed will be slower as a result of attaching one.

Nikon D300, 150mm, ISO 200, 1/50sec at f/2.8, handheld

24 SELECTIVE FOCUSING

Want your subject or point of focus to stand out against its surroundings? Try selective focusing. Opt for a large aperture, in the region of f/2.8 or f/4, in order to creatively throw everything out of focus other than your chosen focal point. Depth of field is naturally shallow at high magnifications, but using a large aperture will exaggerate this further. Results can look striking, and your subject will stand out sharply against a beautifully diffused background. Pinpoint focusing is required, so using a tripod is recommended.

Nikon D300, 150mm, ISO 200, 1/20sec at f/4, tripod

25 DIFFUSE THE LIGHT

When sunlight is harsh and unflattering, you can diffuse the light to soften its strength and reduce contrast. Certain companies, such as Lastolite, market diffusers. Alternatively, a sheet of translucent, opaque plastic will do the job. I've even seen photographers make diffusers from a coat-hanger and a semi-clear shower curtain! Simply bend the wire hanger into a square or circular shape, cut the shower curtain to fit, and secure it onto the hanger frame using tape. Using a diffuser is straightforward; simply hold it between the light source and your subject to soften the light.

Nikon D200, 105mm, ISO 200, 1sec at f/11, diffuser, tripod

STILL-LIFE PHOTOGRAPHY

The term 'still life' refers to the depiction of manmade or natural inanimate objects, which are arranged and lit creatively by the artist.

Still life is a popular form of photography, and its accessibility is one of its greatest appeals. Depicted by artists for centuries, still lifes usually portray small objects or arrangements, which means they fall within the realms of close-up photography. Since it means you can work indoors, you can take photographs at any time, regardless of the weather or time of day.

You don't need to go far or look very long to find good, suitable subjects. A typical household is full of objects with huge picture potential. One of the key skills to still-life photography is having the ability to identify subjects in the first instance, and also the type of light and setting they will suit. With a little imagination you will soon think of far more original subjects than the stereotypical bowl of fruit or vase of flowers. If you look around your home with a creative eye, you'll see that even mundane, everyday objects can form striking results. Cutlery, stationery, work tools, bottles and jars, flowers, fruit, sweets and toys are all subjects with great potential and can either photographed on their own or combined with other objects.

Contrast, shape and form are all important aspects of still-life photography. Colour (page 114) is often a key ingredient, but the potential of converting to mono (page 118) shouldn't be overlooked either. Black and white can convey a feeling of nostalgia, which is well suited to many still-life subjects. Since the photographer has complete control over every aspect of taking the picture, still life is a great way to hone compositional, lighting and close-up skills. That isn't to say it is easy, though. After all, this is one of the few subjects where you have to 'make' the picture before you can take it.

CUTLERY
Everyday objects that you wouldn't normally consider photographing can be transformed thanks to the three key ingredients of shooting still lifes: lighting, composition and arrangement. In this instance, I positioned a knife and fork on a lightbox to create a bold, still-life silhouette.
Nikon D200, 150mm, ISO 200, 1/4sec at f/11, lightbox, tripod

HOUSEHOLD OBJECTS

WITH A LITTLE INGENUITY, EVEN THE MOST ORDINARY OBJECTS CAN CREATE
EYE-CATCHING RESULTS.

In close-up, you can disguise, highlight or abstract a subject's appearance. Everyday items like cutlery, stationery, coloured paper, bottles, jars, toys and textiles are just a small example of the type of things that, when lit, arranged and photographed well, will make compelling still-life images.

Unsurprisingly, lighting is particularly important when shooting a still life. Its quality and direction will help shape and emphasize the subject and its form. Simple window light (page 123) will normally suffice, but a lightbox is another good light source for small objects. Not only is it perfect for highlighting a subject's translucency, but it is also useful for creating silhouettes or for creating a clean, simple white background in order to produce high-key results. If you rely on room lighting to illuminate your subject, be aware of the colour cast this can potentially cause. Most light bulbs used domestically have a tungsten filament. Tungsten lighting emits more red light than ordinary daylight, having a colour temperature of approximately 3,200K. This will create an orange cast in still-life images, which is rarely desirable or flattering. If you set white balance (page 16) to auto or its incandescent setting, the cast should be neutralized. If you shoot in Raw (page 172), it is easy to fine-tune colour temperature during processing.

Many still-life images don't require a particularly high level of magnification and a standard lens combined with close-up attachment will normally suffice. A tripod is essential, though. It will allow you to tweak your

BOTTLES
You can glean a great deal from simply studying still-life images published in books, magazines and online. Notice how lines, repeating shapes, symmetry, contrast and colour usually form an integral part of the image. Lighting is also key. I love backlighting and often use a lightbox as the primary light source for my indoor close-ups – it is perfect for creating high-key results of translucent subjects, like glass.
Nikon D300, 105mm, ISO 200, 1/4sec at f/11, lightbox, tripod.

set-up until you achieve just the right look and balance. You can do this in the knowledge that your camera's position is fixed and your composition won't alter. If you intend to take a lot of indoor close-ups, buying a dedicated still-life table or coving (a curved white background that makes it easy to shoot objects against a neutral backdrop) may well prove a good investment. They are ideally suited to this type of photography and available in a range of designs and sizes, from small tabletop set-ups to large professional

studio tables. The 'Magicstudio' range by Novoflex is ideally suited to still-life work. However, if you don't want the extra expense, a dinner or coffee table can easily be adapted.

When you begin arranging your still life, start modestly. Often less is more when shooting this style of photography and simplicity is best. Look at the way light affects the shape and form of your subject. Keep 'building' your arrangement, making fine adjustments until you are satisfied with the result.

SCISSORS

For still-life photography, the best advice is to keep arrangements simple. Don't try to be too clever or overly complicate things. Look around for household objects with strong, instantly recognizable shapes that, when arranged and lit well, will create striking close-up photographs. In this instance, kitchen scissors made an ideal subject, lit simply on a lightbox, with plastic envelope stiffener to soften their shape slightly and add interest.

Nikon D300, 105mm, ISO 200, 1/10sec at f/11, lightbox, tripod

FOOD

When shooting close-ups, it is often your creativity and not the subject matter itself that matters most. We all buy, prepare and consume food, so it is no great trouble or cost to photograph it first. The colour, design, shape and textural quality of fruit, vegetables and confectionery are particularly suitable for close-up photography.

Food provides a continuously changing and large variety of photographic subjects. A high level of magnification allows you to exclude distracting background elements and highlight or abstract detail, colour and texture. Fruit and vegetables in their natural form are particularly photogenic. The surface and texture of fruit such as, oranges, strawberries and pineapples are interesting, but often it is the inside of fruit that is more appealing. Thin slices of orange, lemon, kiwi and lime are beautifully translucent and photograph well backlit. You'll find that a lightbox is useful here. Be artistic with your arrangements. For example, try overlaying fruit segments or create large, repeating patterns. As with most other close-up subjects, only photograph things free from blemishes and marks. Supermarkets are good places to look for more unusual, exotic subjects, such as starfruit, pomegranate and colourful berries.

Confectionery is another excellent close-up subject. You can have a lot of fun photographing colourful, interestingly shaped sweets – and enjoy eating them afterwards too! Jelly beans, fruit gums, boiled sweets and smarties will all create bright, colourful close-ups. Arrange them in a pattern or repeating formation, with maybe just one missing, so that you create a deliberate focal point. Sweets like jelly babies, pastilles and boiled sweets are translucent enough to be backlit, while an overhead viewpoint often works best if you wish to emphasize colour, shape and repetition. A low viewpoint, combined with a shallow depth of field, can also produce interesting results. When possible, try to be imaginative and original with your approach. For example, you could try high-speed photography of fruit dropping into water or milk, using the technique outlined on page 124; or photograph sweets refracted in water droplets (as shown here). The only limitation is your imagination.

SMARTIES
Being so bright and colourful, sweets are good close-up subjects. Having arranged these smarties in a pattern, rather than photograph them directly, I decided to shoot their refracted image. I positioned a piece of glass above them and, using a dropper, created a series of tiny water droplets in order to reflect the image of the sweets.
Nikon D300, 150mm, ISO 200, 2sec at f/16, tripod

RED HOT CHILLI PEPPER
I shot this image for a photo magazine. The idea behind it was to play on a chilli pepper's reputation for being hot. I skewered the pepper to hold it in position before taping an incense stick to the back of it. When lit, the incense stick emitted a thin stream of smoke, giving the impression the pepper was smoking. Later, in post-processing, I used the Clone Tool to remove the skewer from shot.
Nikon D300, 150mm, ISO 200, 1/250sec at f/8, SB800 speedlight, tripod

COLOUR

COLOUR CAN PROVE ONE OF THE MOST EFFECTIVE ELEMENTS IN A CLOSE-UP IMAGE.

Colour is everywhere and, in frame-filling close-up, it is possible to reveal, isolate and highlight a subject's colour. Have a look around your home and you will find a wide range of brightly coloured objects, such as fruit and sweets, pens, pencils, drinking straws, card and paper. Arranged, lit and photographed creatively, objects like this will create still-life images bursting with colour impact.

It is easy to take colour for granted, but it can have a huge influence on your photographs. If colour is the principal subject matter, the brighter the better. If the image space is overflowing with colour if it fills the frame, the effect will be maximized. Filling the frame, so the image space is effectively overflowing with colour, will often help maximize impact. Some understanding of colour theory may help you with how you arrange subjects. Some colours, particularly red and yellow, appear to advance towards you, and are regarding as advancing colours. Others, such as blue and green, are receding. Therefore, if you have a foreground element that is red, it can help add a feeling of depth to your photo.

How you should or shouldn't combine colours is tricky to answer – much will depend on the effect you wish to achieve. While there are no hard and fast rules, a little forethought about colour harmony is wise. Complementary harmony occurs when any colour is combined with the colour directly opposite it on the colour wheel. Red and cyan are an example of this. However, like all photographic rules, sometimes the best thing to do is break them. If you combine colours instinctively and opt for bold, garish colours that conflict and

clash, you can sometimes produce more eye-catching and compelling results. Being aware of the effects of colour, and using it consciously, can prove an effective tool in still-life photography.

Even, shadowless light will often suit images of colour. A Cubelite, or collapsible light tent, made, for example, by Lastolite, can prove handy. If the subject is surrounded by white, reflective material, a burst of flash will bounce around and illuminate objects evenly. The camera can be positioned via a Velcro opening. Alternatively,

you can create a makeshift light tent by using translucent acrylic, tracing paper or even a white sheet draped over a frame. Using ring flash (page 70) is another option. If you can't justify the cost of a dedicated macro flash, there are adapters available that convert ordinary flashguns into a makeshift ring flash by redirecting the flash burst. These use a system of internal prisms and reflectors to a circular unit fitted around the lens. Using an LED lighting unit is another option for illuminating this type of still life.

COLOUR THEORY
A colour wheel is designed to show the relationship between primary, secondary and tertiary colours. There are a number of colour combinations that are considered particularly pleasing. For example, colours opposite one another on the wheel are harmonious. A little understanding of colour theory can certainly prove beneficial when colour is your photograph's key ingredient.

DRINKING STRAWS

Brightly coloured objects, like pens, felt tips, card and drinking straws can create striking results when arranged and photographed well. I carefully arranged these drinking straws on a lightbox to create symmetry and an interesting pattern. However, colour is the ingredient that really gives this shot impact.

Nikon D300, 150mm, ISO 200, 1/30sec at f/9, lightbox, tripod

PENCILS

Look around your home and you will find no shortage of colour. Filling the frame so that colour literally overflows out of the image will often maximize the image's visual impact. Lighting can be simple. Even, shadowless light will help keep the emphasis on the subject's bright hues. Simplicity often work best; in this instance, I placed a number of coloured pencils next to each other and shot them from overhead.

Nikon D70, 105mm, ISO 200, 1/10sec at f/11, tripod

CROSS-POLARIZATION

BY SANDWICHING A CLEAR, BACKLIT PLASTIC OBJECT BETWEEN TWO POLARIZING MATERIALS,
YOU CAN CAPTURE BRIGHTLY COLOURED, SURREAL LOOKING CLOSE-UPS.

Once you have learnt how to cross-polarize you will never look at plastic objects in quite the same way again. The cross-polarized effect generates a weird kaleidoscope of vibrant colours within the plastic's surface. At first, results might look like Photoshop manipulation, but in fact, the effect is all achieved in-camera.

The way in which some plastics are produced generates stresses. To the naked eye, they are invisible, but through cross-polarized light the areas of stress become obvious. The stresses appear as multi-coloured patterns in clear plastics. This psychedelic effect is the result of diffraction of white light into the colours of the spectrum, in which the most dramatic and intense colours occur at the points of greatest stress. Some plastics work better than others. The best results are often achieved with cheaply made objects that shatter easily, like throwaway cutlery, plastic stationery sets, and other objects that you can find in supermarkets.

To create the cross-polarized effect, you first need to cover your light source with polarizing material. A lightbox is perfectly suited to shooting small, cross-polarized subjects. You can buy sheets of polarizing film, but another option is to simply use a polarizing filter, although as you

will see you will need two of them. The filter can be placed on the lightbox, with your plastic object positioned gently on top of it. However, due to the limited diameter of a filter, you will only be able to photograph very small objects. Next, position your camera directly above your set-up. A tripod is essential and you need to select a macro lens or close-focusing attachment so you can fill your frame. Attach a circular polarizing filter to the front of your lens to allow you to sandwich your backlit subject between two polarizing materials. Now the fun begins. Look through the viewfinder and rotate the polarizer on your lens. Depending on how you rotate the filter, you will see the colours intensify or fade. Also, the background will either lighten or get increasingly dark.

When the light is fully polarized, the background should be rendered completely black. Results can look dramatic and eye-catching. Your camera's TTL metering shouldn't have any problems achieving the right exposure but, as always, study histograms (page 22) to ensure correctly exposed results. An aperture in the region of f/8 or f/11 should provide adequate depth of field for relatively flat objects, like clear plastic CD cases. Very little post-production should be required – maybe just a slight tweak to contrast (page 176).

histograms (page 22)
(page 176)

PRO TIP

If you don't own a second polarizing filter or polarizing film, try using a computer monitor or tablet instead. They are polarized so will perform just like a polarized lightbox. Set the screen to white and stand your plastic objects in front of it.

KNIFE AND FORK
Cheap, throwaway plastic cutlery has plenty of stresses within its makeup, making it an ideal subject to photograph in cross-polarized light. Their interesting shape and form also suit being photographed in close-up.
Nikon D300, 18–70mm (at 70mm), ISO 200, 1sec at f/14, +4 close-up filter, tripod

BLACK AND WHITE

COMBINED WITH THE RIGHT SUBJECT AND LIGHTING, BLACK AND WHITE PHOTOGRAPHY IS CAPABLE OF INJECTING MOOD, DRAMA AND EVEN AN AURA OF NOSTALGIA INTO YOUR STILL-LIFE IMAGES.

A powerful medium, the appeal of black and white photography has certainly passed the test of time. Today more and more photographers are dabbling with monochrome since it is so quick and straightforward to convert digital images from colour to black and white.

Not all still-life images will benefit from being converted to black and white but it will significantly enhance and improve those that it suits. Removing colour from a photograph helps eliminate distractions and place emphasis on shape and form, composition and light. Some photographers have the ability to visualize how a particular image will look devoid of colour. Personally, I don't 'see' in black and white particularly well, so to help me preview how my subject will appear as a series of monochromatic tones, I will often temporarily change my camera's picture style to monochrome. This enables me to see the subject projected in black and white via Live View (page 56).

However, if you shoot in colour rather than black and white, and then convert it, it is actually a better option since a colour image captures more tonal levels. Also, shooting in colour gives you more options: you can save the image as colour, black and white or both.

Due to black and white's ability to convey a sense of age or nostalgia, the still-life subjects it typically suits best are old mechanisms, clocks, tools, glass, cutlery and textiles. Not every still-life image has to be set-up and arranged indoors. Black and white is particularly well suited to 'found' still lifes – inanimate objects that you chance upon, rather than pre-arrange. Rusty chains, machinery, the weathered hull of a boat

and other old and decaying objects are just a few examples of the type of 'found' still-life subjects that typically suit mono conversion.

Without colour, a photograph has to rely entirely on contrast, shape and tone for its impact. Therefore, light and shade is an important ingredient. Directional lighting – particularly sidelight – will help define a subject's form, design, texture and miniature detail. However, lighting should remain subtle and sympathetic. Diffused window light, for example, will create this lighting effect.

If it is a feeling of age you wish to convey in a black and white still life, you can add the look of film grain to results. This is best done in Photoshop, where you have a number of options and the effect can be applied precisely. The quickest and simplest methods is to click: Filters > Artistic > Film Grain.

JIGSAW
I photographed this jigsaw backlit on a lightbox. Removing a single piece added interest and a key focal point. There was little colour in the original, so converting the image to mono seemed a logical thing to do. Combined with the right subject matter, the bold contrast between black and white can create really striking close-ups.
Nikon D70, 105mm, ISO 200, 1/125sec at f/8, lightbox, tripod

PRO TIP

Due to the way black and white emphasizes fine detail and texture, conversion to monochrome can also suit many natural subjects, particularly things like bark, feathers and tiny water droplets.

ROPE

Not every still life has to be set up. 'Found' still
lifes refer to photographs taken of subjects that
the photographer has chanced upon, rather than
pre-arranged. In this instance, I noticed this old
rope coiled up on a jetty. Conversion to mono helped
emphasize shape and texture.

*Nikon D600, 150mm, ISO 100, 1/250sec at
f/2.8, handheld*

FLOWERS

OF ALL THE STILL-LIFE SUBJECTS THERE ARE, FLOWERS ARE ONE OF THE MOST POPULAR.
GIVEN THE VARIETY OF STRUCTURE AND COLOUR, IT IS NOT DIFFICULT TO UNDERSTAND WHY.

Flowers create vibrant, colourful and interesting close-ups and require only a basic tabletop set-up. In terms of the technique and equipment that are required, photographing cut, cultivated flowers isn't too dissimilar to shooting wildflowers and plantlife (page 146). However, in the comfort of your home you don't have to contend with the elements and you will have greater influence over lighting, composition and background.

When photographing wildflowers, not only do you have to contend with wind movement, but you also have a small window of opportunity. Each flower type blooms for just a short period, at a certain time of the year. When photographing cultivated flowers, you have far more choice and control and can photograph popular, photogenic varieties at any time, throughout the year.

You can grow flowers in your garden to photograph or simply wander into your local florist and select the flowers you wish to shoot. You should buy stems that are pristine and flawless since the smallest imperfection is highlighted in close-up. It is a good idea to ask the florist if you can examine or even handpick the flowers yourself. Look for flowers with particularly striking detail, colour or form: gerberas, dahlias, lilies, tulips and roses are among the most popular and photogenic types.

As with most indoor close-up subjects, you need very little room to arrange your set-up. Window light (see page 123) is a great source of illumination for this type of image, and a table placed adjacent to a lit window will normally suffice. A reflector might also prove useful, for bouncing some extra light onto the side of the flower furthest from the window. Keep cut stems in water to help prevent them wilting.

Close-up photographers will probably want to avoid the clichéd 'flowers in vase' image, preferring to crop in much tighter in order to concentrate more on the flower's design, colour, petals and stamens; filling the frame is a great way to highlight a flower's beauty. There is nothing to say the entire subject has to be recorded sharply. Employing a shallow depth of field (page 50) will often create more artistic results. Therefore, try opting for your lens's maximum aperture and isolate shape and form. For example, focus on the flower's stamens or the very tip of a petal. Due to the shallow zone of sharpness, everything but your focal point will be rendered soft. This type of selective focusing (page 50) is great for helping direct the eye to your chosen focal point.

GERBERA
Flowers are great still-life subjects for honing your close-up skills. Only a simple, tabletop set-up is required. In this instance, I placed a single gerbera stem in a vase and positioned it on a coffee table next to patio doors. The day was overcast, so the lighting naturally diffused. I then explored different angles, trying various levels of depth of field, before capturing this shot.
Canon EOS 50D, 60mm, ISO 100, 1/200sec at f/2, tripod

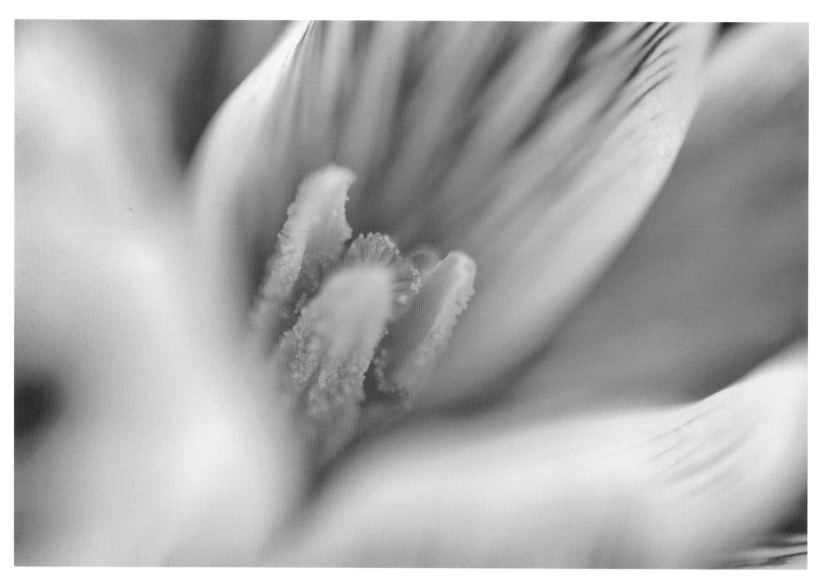

SHOOTING ANGLES

Explore different shooting angles: parallel, overhead and low viewpoints can all work well when photographing flowers. Also, consider the look of the flower's background. Keep it simple. When working indoors, it is easy to alter the subject's background by simply positioning sheets of different coloured card or fabric behind your set-up. Often, a simple black or white backdrop will work best, but don't overlook the possibility of using bright, contrasting backdrops to create extra impact or a colour clash. Keep the background positioned a minimum of 1ft (30cm) behind the subject, to ensure it is recorded as a simple, soft wash of colour.

To reduce any glare from reflective petals, attach a polarizing filter (page 102). To add interest and scale to your flower images, consider spraying them with tiny water droplets.

CROCUS

A low shooting angle, combined with a shallow depth of field, can often suit floral close-ups, allowing you to isolate or highlight very specific parts of the flower, or key detail.
Nikon D300, 150mm, ISO 200, 1/50sec at f/4, tripod

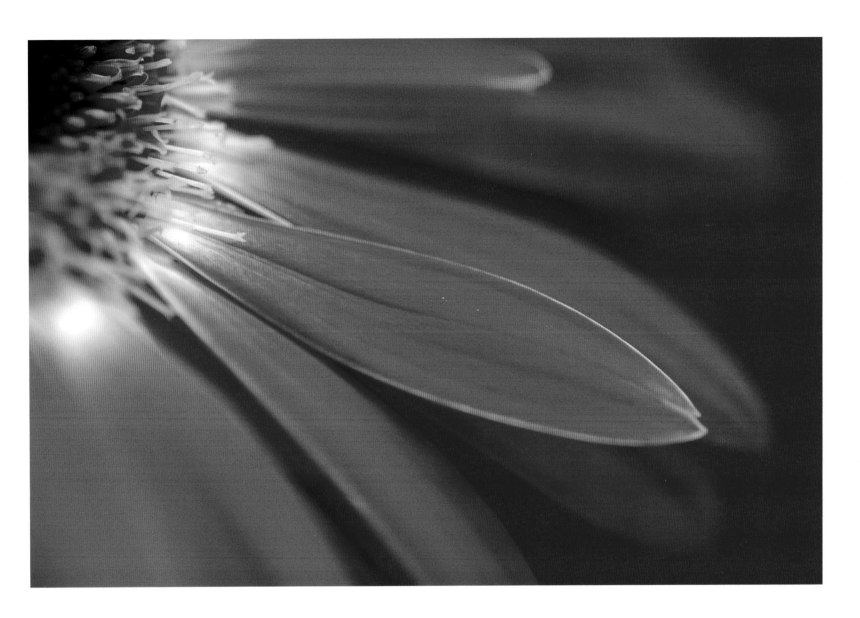

WINDOW LIGHT

Still-life photography is often associated with complex lighting and elaborate, multiple flash set-ups. However, for the majority of inanimate, indoor subjects, simple window light is hard to beat. The colour, intensity and direction of the light flooding through a window will naturally alter depending on the weather, time of day and direction the window faces. You need to consider this when you decide exactly which window to use as your light source. Soft, diffused light is best. This will be provided naturally on cloudy, overcast days, but in bright conditions, it is possible to diffuse window light by hanging a net curtain or some muslin over the glass pane. You can even tape coloured gels to the window to alter the light's colour if you wish.

PETALS
Most close-up photographers will probably wish to avoid the traditional 'flowers in vase' still-life image and instead feel the urge to move in closer to their subject in order to isolate design, detail, stamens or colourful petals.
Nikon D70, 105mm, ISO 200, 1/13sec at f/2.8, tripod

WATER DROPLETS

WHILE IT MAY NOT BE A TRADITIONAL STILL-LIFE SUBJECT, WHEN PHOTOGRAPHED AT HIGH SPEED
AND IN CLOSE-UP, WATER CAN TAKE ON AN ABSTRACT AND SCULPTURAL LOOK.

Photographing water at high speed is fun to try, requiring a surprisingly low budget and simple set-up. With good timing and a few simple props, results can be eye-catching. This is a great technique to practise when you're stuck indoors.

You can capture fascinating water abstracts when you photograph tiny droplets striking the water's surface. Only a relatively basic set-up is needed: you need off-camera flash and a handful of household items. You can photograph drops of water falling into a sink, but this will limit how you set up and light your image and can also restrict your shooting angle. Instead, it is better to use a large, shallow, black or glass dish placed on a tabletop to catch falling drops of water. Suspend a plastic bag, filled with water, approximately 1ft (30cm) above the dish. I do this using a second tripod, with its centre column placed horizontally so I can easily hang the bag from it. Position your camera on a tripod in front of the dish and, ideally, use a macro lens in the region of 100mm. By using a longer focal length you can work from slightly further away, reducing the risk of your camera or lens getting splashed.

Place a coloured background, such as a sheet of card or material, directly behind the dish. Place your flash off-camera, firing it via a wireless set-up or flash cord. Try placing it just to the left or right of where your water droplet will fall and facing directly towards your background. The aim is for the flash burst to bounce off the background in order to create the colour and reflections you will see in the final image; the flash burst shouldn't be directed at the droplet itself. Select manual (M) exposure mode and opt for a smallish aperture, in the region of f/11, to help generate sufficient depth of field. Select a shutter speed equal to your camera's flash sync speed – typically 1/250sec. Adjust the power setting of your flash to 1/64 or 1/32 – this shortens the flash duration, effectively generating a faster shutter speed, capable of suspending the water's motion.

Now make a tiny hole in the bag using a pin to create a constant supply of dripping water. You now need to focus precisely on the point where the droplets strike the water. The quickest and most reliable way to do this is to briefly place a pencil in the water at the exact point where the water is falling and then focus manually on this point. Using a remote cord, you are ready to take photos. Try to time when you trigger the shutter for when the droplet strikes the water.

Be prepared to shoot large numbers of images to get just a handful of perfectly timed results. You may find you have to tweak your set-up to get exposure right – for example, you may need to position the flash closer or further away, alter the flash's power setting or increase ISO sensitivity. The effect and look of your water sculpture will vary with each frame. Try experimenting with different coloured backdrops and liquids. For example, milk can create interesting results.

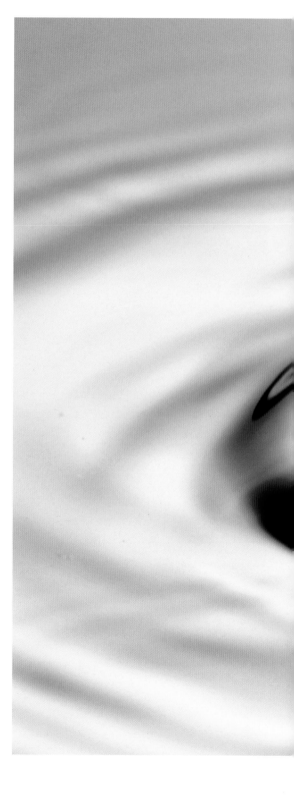

WATER DROP
Water is a great close-up subject. You can achieve beautiful, surreal and sculptural images of water drops as they strike the surface. A degree of trial and error is required to achieve the effect you desire.
Nikon D300, 105mm, ISO 200, 1/200sec at f/11, SB800 speedlight, tripod

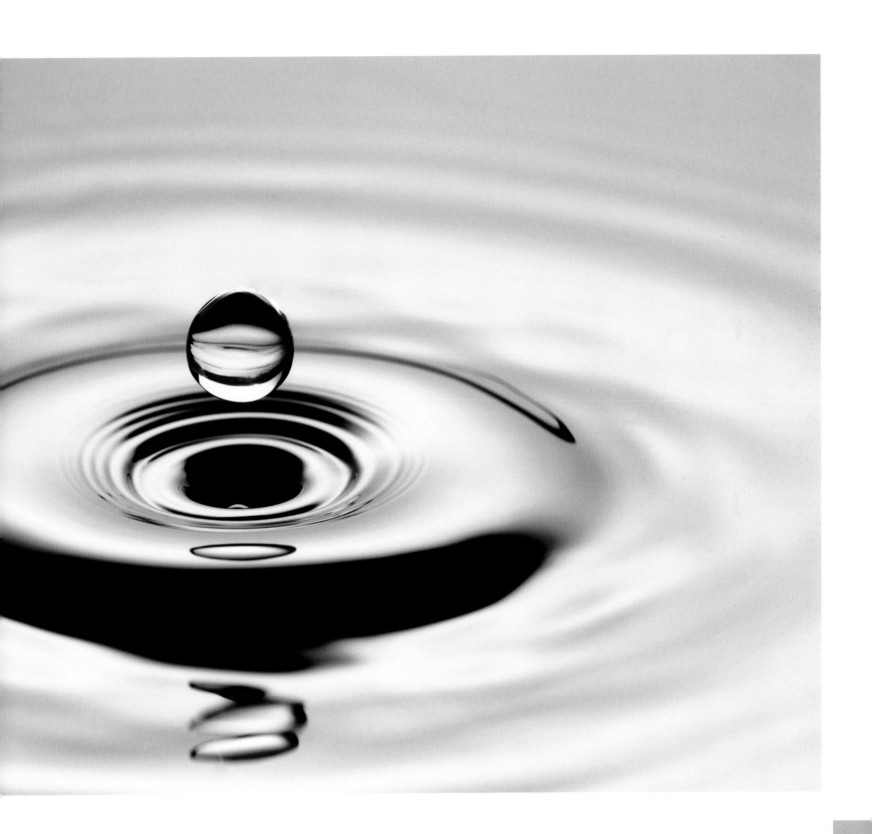

NATURAL-HISTORY SUBJECTS

Beneath our feet is a fascinating miniature world of mini-beasts and plantlife. For many close-up photographers, natural history is the subject they enjoy most; for some, it is the only reason they've invested in close-up kit.

Armed with a macro lens or close-up attachment, it is possible to capture frame-filling images of insects and bugs, flowers and plants that reveal extraordinary detail, colour and design. Large insects, like dragonflies and damselflies, are particularly photogenic. When seen close up, they can appear almost alien-like, with big, disproportionate eyes, large mandibles and long antennae.

However, nature photography is one of the most challenging and difficult disciplines to master. Good technique and fieldcraft are essential in order to succeed. This chapter aims to arm you with the skills and know-how to capture great close-ups of nature.

Working with wild subjects can prove highly frustrating and you will require oodles of patience and lots of practice. However, the hard work will prove worthwhile when you capture amazing images of subjects that most other people would simply pass by. Unlike larger wildlife, such as birds and mammals, you rarely have to travel far to find great subject matter. Many bugs can be found as close to home as your own back garden, while local parks, woodland and wetlands are also good spots to look for insects, wildflowers and fungi.

Through a close-focusing lens, an amazing, often unseen world is revealed. It's time to get down to ground level, search the undergrowth and capture great nature close-ups.

COMMON BLUE DAMSELFLY
Close-up photographers have the ability to highlight the beauty and design of miniature subjects, like this tiny damselfly. In frame-filling close-up, intricate detail and colour is revealed. However, good fieldcraft and technique are required when photographing natural, or easily disturbed, subjects.
Nikon D300, 150mm, ISO 200, 1/8sec at f/8, tripod

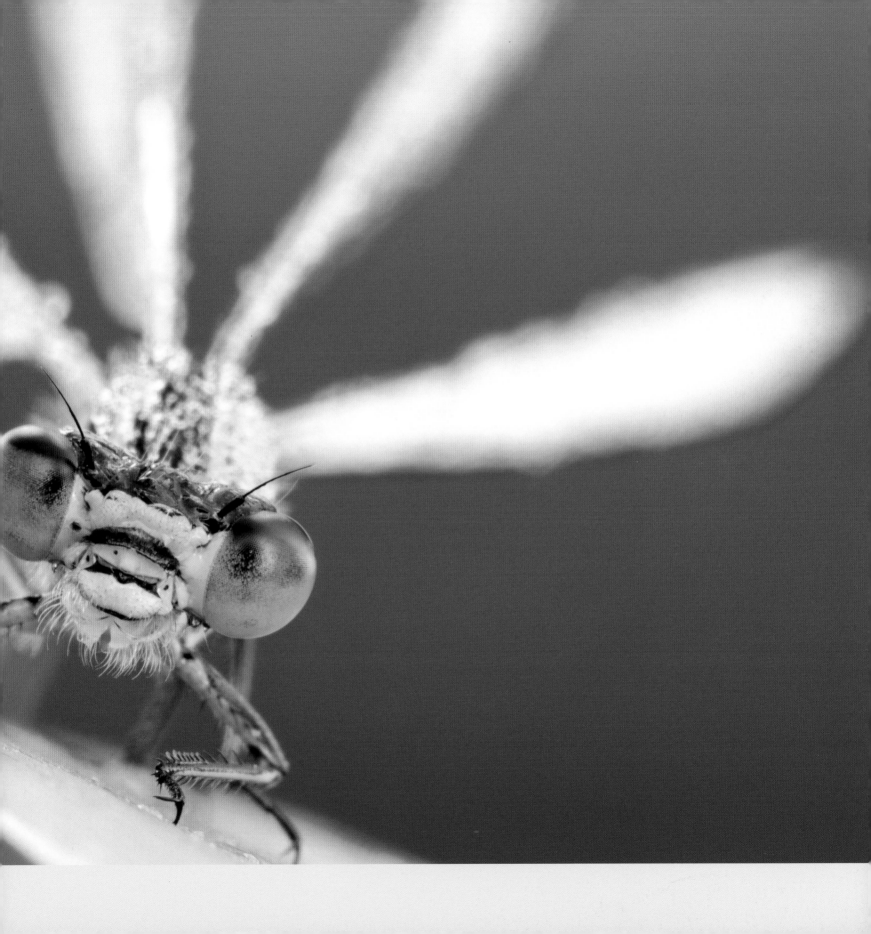

BUTTERFLIES

BUTTERFLIES ARE APPEALING AND HUGELY PHOTOGENIC CREATURES. HAPPILY THEY ARE
ALSO VERY ACCESSIBLE SUBJECTS, INHABITING ALMOST EVERY TYPE OF ENVIRONMENT.

There is somewhere in the region of 20,000 species of butterfly worldwide, and due to their colourful and varied markings, few close-up enthusiasts can resist their allure. However, insect photography presents a wide range of challenges so if you want to produce good results, fieldcraft and good technique are necessary.

If you want to know when and where to look for a type of butterfly, first learn about it. Does it prefer heath, forest or grassland? In which month do adults emerge? A butterfly's lifespan may be only a few weeks, so the window of opportunity can be short. Arm yourself with as much knowledge as possible before visiting suitable habitats.

Typically, the best time to locate butterflies is during the middle of the day when they are busily flying, feeding and breeding. However, this is also when they are at their most active, making it tricky to get close enough to take good photographs. Stalking is the only option. Follow (rather than chase) butterflies as they fly around, and then move into position when they stop to feed or bask in the sun. You will have no control over where the insect might land, the light's quality or the background, but with practice stalking can provide a good degree of success. The further away from the insect you can remain, the less likely you are to disturb it. So, to maximize your chances of success use a telemacro upwards of 100mm, as this will provide a larger working distance. Also, always be aware of your shadow. If it is cast across the subject during your approach, then it will almost certainly frighten the butterfly away. Tread carefully too; if you disturb nearby grasses, flowers or foliage, the insect will fly.

Butterflies can be photographed in all types of ways or angles: for example, head-on for quirky portraits, or from one side to show the marking on their underwings. The most popular angle is from above when the insect's wings are open and flat. Depth of field is shallow at high levels of magnification, but you can maximize what is available by keeping your camera parallel to the butterfly's wings. This is because there is only one geometrical plane of complete sharpness and normally you will want to place as much of your subject in this plane as possible.

To ensure your subject stands out against its surroundings, select an aperture no smaller than necessary. In other words; an f/stop small enough to keep your subject sharp throughout, but still large enough to throw background detail pleasantly out of focus. The optimum aperture will vary from one situation to the next, but typically f/8 is a good starting point. Some butterflies will bask with their wings at a 45° angle, but this can look awkward in photographs and an impractically large depth of field is required to render the wings sharp throughout. Instead, it is normally best to wait until the butterfly opens its wings fully, or closes them shut, before taking photos.

MARBLED WHITE
A frame-filling approach won't always produce the strongest result. A degree of negative space (page 52) can help create a better sense of scale. If your subject is resting on an attractive flower or grass, including it as part of the composition will often create less static, generic-looking images.
Nikon D800, 150mm, ISO 200, 1/100sec at f/7.1, tripod

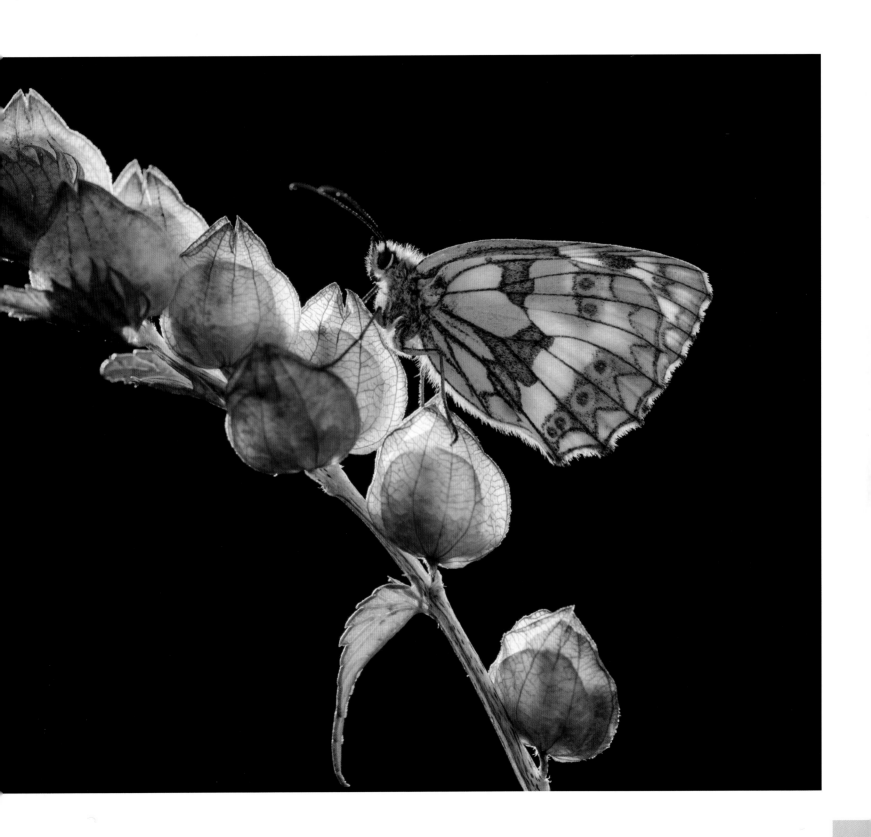

TIME OF DAY

Arguably a better, more controlled method of photographing butterflies is to photograph them during early morning and late evening when they are generally far less active. At this time of day, they can usually be found roosting among foliage or on tall grasses. Search carefully and be mindful of where you tread.

Still days are best since even the slightest breeze will sway subjects about, making it difficult to focus or compose an image accurately. Having located a subject, move into position slowly. On cool mornings, before the insect is warm enough to fly, it may be possible to employ the support of a tripod. This is hugely advantageous, aiding pinpoint focusing.

Before releasing the shutter, allow your eye time to scan the background for any distracting elements, like grasses or out-of-focus highlights. Such things can often be easily excluded by simply adjusting your shooting position slightly or through the selection of a larger aperture. Alternatively, if the insect is dormant, it may be possible to carefully remove distracting background vegetation using scissors, or by gently flattening vegetation by hand.

As with any close-up image, lighting can make or break the shot. With butterflies, backlighting can prove the most effective light type, highlighting the shape of wings and giving them an attractive glow and translucency. A small degree of fill flash (page 68) can be useful in dull weather to lift ugly shadows, or you can use a reflector if the insect is static.

Butterfly photography can prove frustrating at times; the insects can fly away just as you are about to trigger the shutter. However, with preparation and patience, you will soon capture great butterfly images.

PRO TIP

To help hone your skills, visit a tropical butterfly house. This enables photographers to get close to a large variety of different butterflies that they might not normally see. Captive butterflies will often sit still for long periods, allowing you to practise technique. For example, experiment with different shooting angles, depth of field and the level of magnification.

SMALL PEARL-BORDERED FRITILLARY
By researching a species, you will know where and when to look for it. I discovered this fritillary late one evening at a local nature reserve and, at this time of day, was able to photograph it with relative ease. I positioned a small reflector nearby to help illuminate its under-wings. Backlighting suits the translucency of a butterfly's wings, highlighting wing shape and detail.
Nikon D300, 150mm, ISO 200, 1/80sec at f/9, tripod

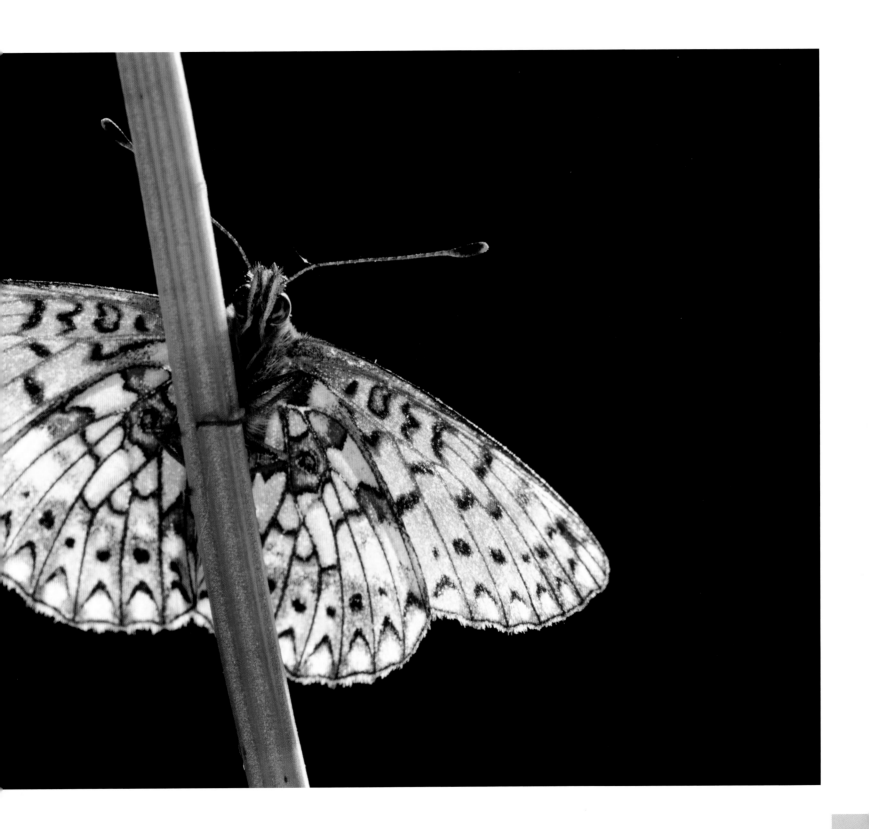

DRAGONFLIES AND DAMSELFLIES

OVER 300 MILLION YEARS AGO, AND LONG BEFORE DINOSAURS ROAMED THE EARTH, DRAGONFLIES WERE PATROLLING THE SKIES. TODAY THESE SCULPTURAL CREATURES MAKE EXCELLENT CLOSE-UP SUBJECTS.

Dragonflies are one of our most impressive and photogenic winged insects. The majority of their lives are spent underwater as aquatic larvae. Then in spring and summer, nymphs climb out of the water and emerge into colourful, flying insects. Both dragonflies and their smaller relatives, damselflies, have widespread appeal to photographers; few insects look more impressive in close-up.

Dragonflies and damselflies enjoy wetland habitats, particularly marshes, swamps, lakes, ponds and streams. The two insect types are easily distinguishable. Damselflies are typically smaller and more slender, close their wings together above their bodies and their eyes are apart (in most dragonflies, the eyes touch). As with any natural subject, learn a little about the subject first. Visit suitable environments, and spend time observing their activity. For example, dragonflies are highly territorial; they often patrol the same stretch of water and visit the same place of rest again and again. The photographer needs to identify resting places, such as overhanging branches or reeds, and then wait nearby, camera ready, for the insect to return. Stealth and patience is required; by wearing drab clothing and watching and waiting, you will enhance your opportunities.

Typically, dragonflies begin flying at temperatures of around 55–59°F (13–15°C). This means that during early morning and late evening, when temperatures are lower, they are less active. This is a good time to visit wetland habitats and carefully search for resting insects clinging to tall grasses or perched on branches. Some damselfly and dragonfly types will even

'roost' close together. Morning is a particularly good time for dragonfly photography, as tiny droplets of dew will form on the insects' wings and bodies during cool, clear nights. Droplets will add interest and scale and sparkle in the morning light. While insects are less active at either end of the day, do take care not to disturb them or the surrounding vegetation.

Look for insects resting high up with a clean, uncluttered background. This is important, as the wings of dragonflies and damselflies are transparent and their intricate veining will be lost against a messy backdrop full of twigs, sticks, grasses or gravel. A large working distance will help to reduce the risk of disturbing subjects. A macro lens with a focal length of at least 100mm is best; alternatively try using a 200mm or 300mm telephoto with a degree of extension. Ideally, attempt to keep your camera parallel to the plane of the dragonfly in order to capture as much of the subject in focus. However, when it is impractical to do so, ensure you focus sharply on the insect's disproportionately large eyes – if they aren't razor-sharp, the image will be ruined.

BROAD-BODIED CHASER DRAGONFLY
Your viewpoint is important. Dragonflies with wings held open and perpendicular to their bodies suit being photographed from directly overhead, as this angle helps reveal the intricate patterning of their wings. However, don't overlook shooting from a side-angle, as this will highlight the insect's body shape; while a head-on view will emphasize their large eyes.
Nikon D300, 150mm, ISO 200, 1/160sec at f/9, handheld

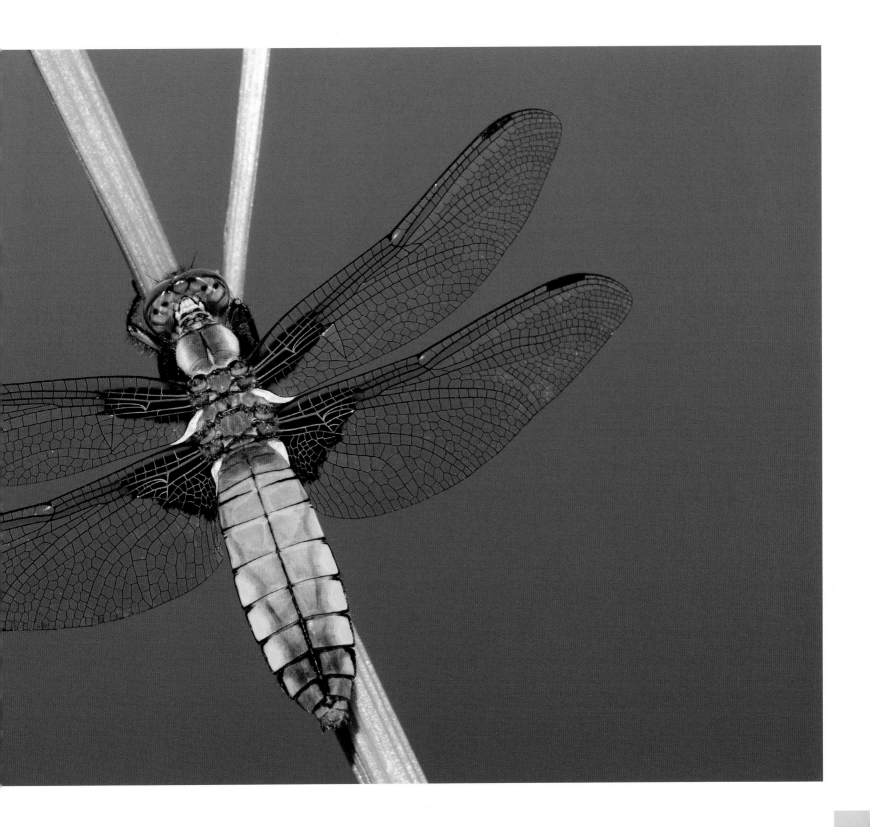

CAPTURING BEHAVIOUR

Shots of dragonflies or damselflies hatching, mating, laying eggs, or in flight appear less static. Larvae typically emerge during mornings, climbing out of the water and attaching to reeds or grass near the water's edge, before hatching. They are highly vulnerable at this time, so photographers must take care not to knock or move them. Finding one in a position suited to photography isn't easy but, once located, it is possible to capture a sequence of images at the various different stages of development.

During the heat of the day, the water will be alive with dragonflies and damselflies hunting, mating and laying eggs. Dragonflies often mate on the wing, but paired damselflies will rest on vegetation near the water's edge. When male and female are in tandem, they form a 'wheel' or 'heart' shape. Keeping both insects acceptably sharp throughout will typically require an aperture of f/11 or f/16.

When laying eggs, female dragonflies will often land on lily pads or weeds and dip their tails beneath the water. Shoot from the water's edge, lying on the ground in order to achieve a low, natural viewpoint. Unless insects are very close to the water's edge, a macro lens won't be powerful enough. Instead use a long telephoto in the region of 300–400mm.

A dragonfly's aerial agility and quick reflexes make it a challenging subject in flight. Be prepared to take huge bursts of images, with a low ratio of success. Target larger species, like hawker dragonflies, when attempting these shots. The best opportunities will come when they hover, as this allows extra time to focus. Alternatively, try pre-focusing on a favourite perch and then fire a short burst of images – using the camera's continuous shooting mode – just before the insect arrives or as it departs. Prioritize a shutter speed of at least 1/1000sec for flight, while a teleconverter (page 27) can be useful for increasing the pull of your lens.

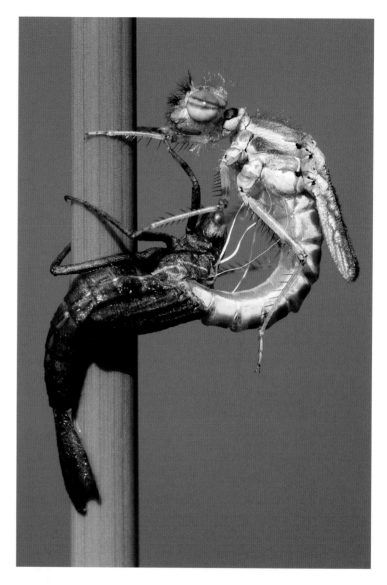

LARGE RED DAMSELFLY
To help your insect images stand out, try to capture some element of behaviour. In this instance, I photographed a damselfly as it emerged from its nymph case. Often, the biggest challenge is locating an insect in a position suited to photography.
Nikon D70, 150mm, ISO 200, 1/30sec at f/13, tripod

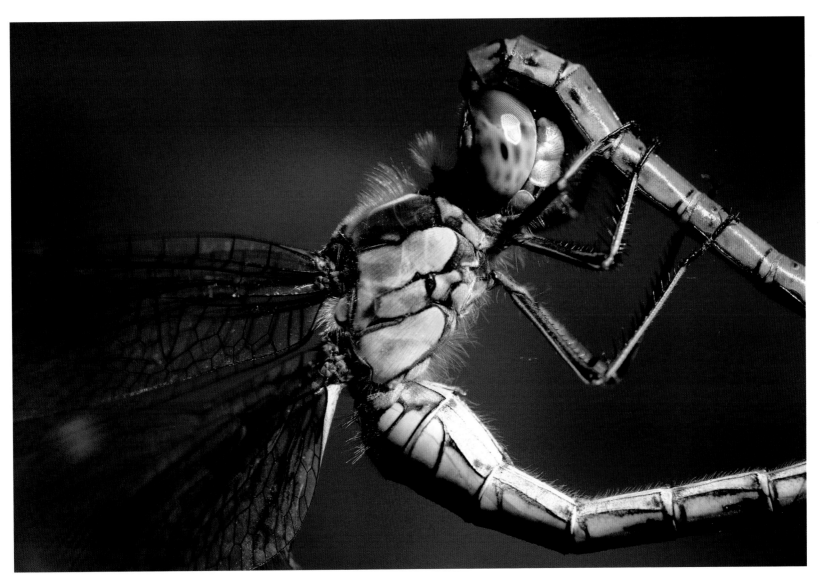

PAIRED COMMON DARTER DRAGONFLIES
When damselflies or dragonflies pair, they will often rest among vegetation close to the water's edge. Watch to see where they land and then approach carefully. Normally, you will want to include both male and female within the frame, but in this instance – to create a more unusual composition – I photographed the female alone.
Nikon D200, 150mm, ISO 200, 1/250sec at f/5, handheld

AMPHIBIANS AND REPTILES

ALTHOUGH ANIMALS LIKE FROGS AND TOADS, SNAKES AND LIZARDS CAN PROVE CHALLENGING SUBJECTS TO GET CLOSE TO, THEY ARE HUGELY PHOTOGENIC, MAKING IT WELL WORTH THE EFFORT.

While amphibians and reptiles are very different animals, when taking photos, many of the technical and aesthetical considerations are interchangeable. First of all you need to locate the subjects.

AMPHIBIANS

Newts and salamanders are a challenge to photograph because they spend so much of their lives underwater. Only experienced naturalists should attempt to collect species for photography. A small nylon net with a not-too-coarse grain can be used. You can buy a standard-sized aquarium or construct your own using high-optical glass for the front of the tank and thicker glass for the base and sides. You can also use glass to restrict your subjects to the front area of the tank. Collect appropriate pond vegetation to create natural-looking backdrops. Use collected rainwater or tap water that has been boiled the day before and left to cool.

Water will quickly become de-oxygenated, so retain subjects for only short periods. Select an aperture of f/11 or f/16 to generate a generous depth of field and illuminate the subject from above using a single flashgun. If you do intend photographing amphibians in captivity, do your research first to ensure any stress to the subject is kept to a minimum. Always return subjects to where they were found as quickly as possible.

Frogs and toads look as natural and photogenic on land as they do underwater. It is easiest to find them when they return to water to spawn. During the breeding season small pools and garden ponds often provide the best sites. One technique is to simply kneel by the water's edge and wait for individuals, or mating pairs, to poke their heads above the water's surface to breathe.

While natural light is preferable, artificial light is often the only way to achieve sharp and bright results. In rainforests, or among dense vegetation, for example, the ambient light is dim and foliage can create an unnaturally green colour cast. In this situation, flash may be required in order to record vivid and accurate colours. Flash will also add a catchlight to the subject's eye. However, diffuse the flash burst to help avoid distracting hotspots forming on the amphibian's shiny skin.

When composing images, an eye-level viewpoint often works best. To create stronger, more stimulating compositions, keep eyes off-centre, rather than in the middle of the frame.

FROG SPAWN
Photographing the various stages of an amphibian's life cycle, such as the eggs or spawn of frogs, can look fascinating in close-up. In this instance, I photographed a clump of frogspawn backlit on a lightbox before quickly returning it to the pond from where it was collected. Doing so created a high-key and abstract-looking result.
Nikon D700, 150mm, ISO 200, 1/5sec at f/11, tripod

REPTILES

Reptiles vary hugely in size and design. Snakes and lizards are particularly photogenic, but it is important to underline that some reptiles are venomous and only experienced naturalists should ever attempt to photograph dangerous animals. The majority of reptiles are harmless, but they are shy and often difficult to get within picture-taking range. Many images of reptiles are shot courtesy of temporarily housing them in a vivarium. However, this isn't something I personally encourage. I prefer, when possible, to capture images in the field, using good fieldcraft and technique.

Of all reptiles, snakes are particularly photogenic. Their large, bright eyes, forked tongues and skin markings look striking in close-up. A telephoto lens will allow you to work from a distance and minimize disturbance. Snakes and lizards are cold-blooded and will typically be at their least active early in the morning, as they bask in the sunshine. This is the best time of day to visit suitable habitats. Research locations beforehand, visiting them regularly in order to identify spots where reptiles are accustomed to bask. A low viewpoint will often create the most intimate-looking results. If using a long focal length, depth of field will already be shallow and by shooting from ground level you will ensure foreground and background detail is quickly thrown out of focus, which places extra emphasis on the subject itself. An overhead viewpoint can also work well with reptiles, highlighting the animal's length, shape and form, particularly if it is resting on an attractive or contrasting backdrop, such as sand or bark.

While you might be lucky enough to stumble upon subjects, many reptiles are timid, well camouflaged and will quickly scurry away if disturbed. Many species are territorial, though, so will often return again and again to the same rocks, clearing, sandy area or log pile. Therefore, regularly return to places where you have seen them before; or even wait patiently nearby with your camera ready. Lastly, remember to wait for the right moment – an image of a snake with its tongue out, or of a lizard devouring its prey, will give your images far greater impact.

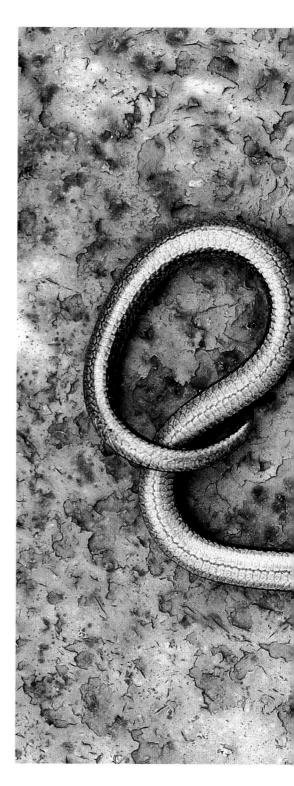

SLOW WORM
The long, narrow shape of snakes and slow worms means that they don't often suit being photographed when fully outstretched, as too much empty space is created within the frame. Instead, they often photograph best being shot from ground level when coiled up. Don't be afraid to explore different viewpoints, though. In this instance, contrary to the general rule, an overhead angle created the most striking composition of this slow worm basking on a rusty sheet.
Nikon D70, 105mm, ISO 400, 1/125sec at f/11, handheld

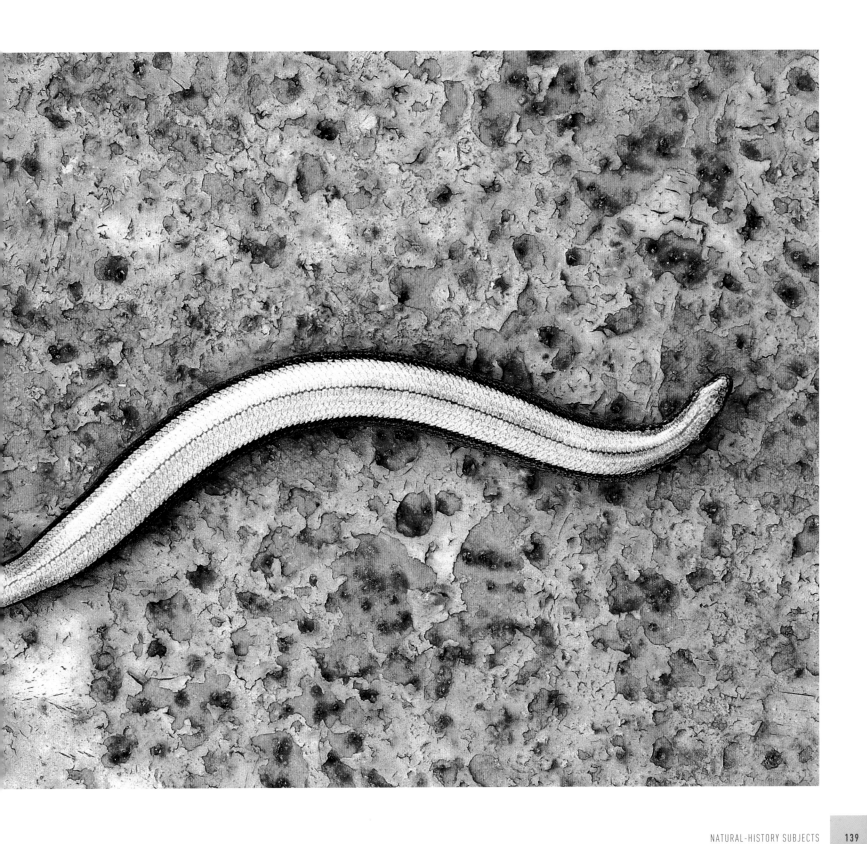

YOUR GARDEN

ONE OF THE GREAT APPEALS OF CLOSE-UP PHOTOGRAPHY IS THAT YOU DON'T NEED TO TRAVEL VERY FAR
TO FIND FABULOUS, MINIATURE SUBJECTS WAITING TO BE PHOTOGRAPHED.

You might be surprised at what is residing in your backyard: ladybirds, lacewings, snails, beetles, bees, hoverflies, woodlice, grasshoppers and moths are among the mini-beasts going about their daily business just outside your front door. Working close to home has many advantages; through regular study and observation you not only learn what to look for, but also where and when. Also, it is easier to adapt your photography around family or work commitments when taking photos in your own garden.

Most gardens already support a wide range of wildlife, but if you want to encourage nature into your backyard for photography, grow endemic and nectar-rich plants and don't be overly tidy or use pesticides. Also, if you have room, build a small pond and you will entice all types of miniature wildlife into your garden.

Your garden is a great place to hone your close-up skills. Admittedly, mini-beasts, like snails, might not be the most glamorous subjects, but if you are new to shooting close-ups of nature, they really are ideal animals for practising technique. Look among rocks, crevices in walls, under plant pots or in similarly dark, damp places and you will undoubtedly uncover a host of small subjects suited to being shot at magnification. Although I discourage photographers from moving or handling subjects, snails are quite easy to relocate without risk of damage. However, always handle with care and quickly return them to where they were originally found. Moving your subject allows you far more control over the look and feel of the final image. For example, when photographing snails, try

using suitable props, such as a flowerpot or trowel, in order to place your subject in context with its garden environment. It can be worthwhile positioning your set-up on a garden table or chair in order to allow you to take photos from a more comfortable height.

Consider lighting beforehand. Are you going to use natural or artificial light? Reflected light (page 64) can work very well in the garden, and you can often persuade a friend or family member to hold the reflector for you while you concentrate on taking photos. Obviously, you shouldn't detain your subject longer than necessary, so before introducing your subject, take a number of test shots first, in order to be sure you've got your set-up looking just right.

Many garden residents, such as snails, woodlice and ladybirds, are slow moving. This means that you generally have more time to consider focusing, viewpoint and composition. However, being so small, a high level of magnification is normally required – in the region of 1:1 life-size. As a result, depth of field will be wafer thin, so employ a small f/number in the region of f/11 or f/16 and focus precisely. If, through selecting a small aperture, the corresponding shutter speed is impractically slow, consider increasing your ISO setting (page 18) or using artificial light to generate a faster exposure.

Working close to home allows you to react quickly to sudden or unexpected changes in the light or weather. For example, after a shower, pop out into your garden and look for insects sheltering under leaves and flowers. Summer is a particularly good time of year for garden wildlife,

as flowers in bloom will attract butterflies, bees and hoverflies. Visiting insects will rarely stay still long, though; they constantly move about and make it difficult to take good photos. Position yourself close by so that when the insect lands on the flower, you can work quickly. When photographing nature, subjects are rarely completely still, so expect your ratio of success to be much smaller. Remember, even the smallest movement in close-up appears greatly magnified. So don't be afraid to take a larger series of images to guarantee at least one or two perfectly sharp, well-composed results.

SUBJECT WELFARE
Natural history isn't like other macro and close-up subjects. When photographing living things, their wellbeing should always be top priority. Photographers have a responsibility to their subject; photography should not be undertaken at the risk of damaging or distressing your subject, or consequential predation or reduced reproductive success. Handling subjects should be avoided if possible. Small animals, like insects and amphibians, are particularly delicate and easily damaged – only handle them if you are experienced at doing so. Hatching or cold, torpid insects are especially vulnerable, so be careful where you tread. Detaining and then refrigerating invertebrates in order to reduce their activity for photography is widely considered unethical practice. Good nature close-ups should be the result of your photography and fieldcraft skills.

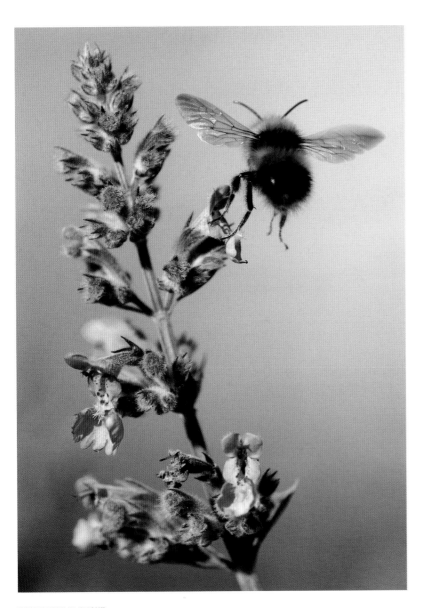

BUMBLEBEE IN FLIGHT
To encourage nature into your backyard, grow
nectar-rich plants like lavender and buddleia.
Doing so will entice bees, butterflies and hoverflies.
I captured this particular shot after spending an hour
or so sitting by a bed of lavender, photographing
bees as they came and went.
Nikon D300, 150mm, ISO 200, 1/1250sec at f/4,
handheld

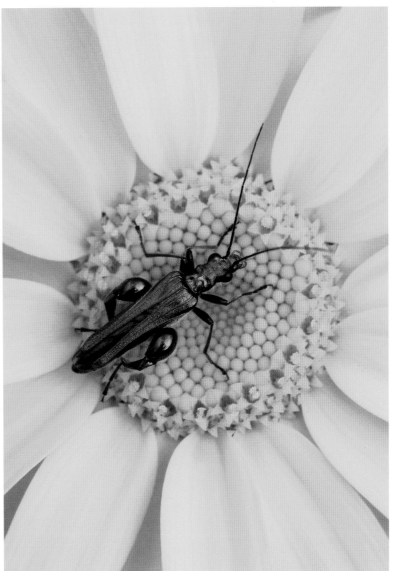

THICK-LEGGED FLOWER BEETLE
Colourful garden flowers create an ideal backdrop
for insects and other small creatures. For maximum
impact, fill the frame. An overhead angle often
works well when taking photos of insects basking or
feeding on flowers. To help entice nature into your
garden, don't be too tidy and try to retain an area
where wildflowers and grass can grow.
Nikon D300, 150mm, ISO 200, 1/40sec at f/14, tripod

SPIDERS

IN CLOSE-UP, THE PRIMITIVE, EIGHT-LEGGED SPIDER CAN BE FULLY APPRECIATED IN ALL ITS GLORY. EVERY TINY HAIR ON THE BODY AND LEGS IS REVEALED IN AMAZING CLARITY.

If you suffer from arachnophobia, you may wish to flick to the next page. A fear of spiders is common, but arachnids are actually very photogenic creatures. Spiders range greatly in look and size, with the largest having a leg span in the region of 1ft (30cm). Some are brightly coloured or beautifully patterned, while spiders' webs can prove equally photogenic in close-up.

Good images of spiders will normally come either as a result of chancing upon subjects or by careful planning. Typically, it is easiest to locate and photograph web-making spiders, as the webs reveal their whereabouts. With a spider suspended in its silk web, it is normally possible to capture images from either side of the web – either capturing the markings on its back or its underneath and mouthparts.

Spiders are sensitive to the tiniest vibration; knock the web or the foliage it is suspended from and it will likely scurry away. Stealth and care is important when getting into position, particularly if you are using a tripod. Carefully place your camera so that the sensor plane is parallel to your subject. This enables you to maximize the available depth of field. If you position the camera poorly, parts of the spider's body or legs will drift out of focus.

As always, background detail is important. Keep it clean and simple, ensuring nothing competes with your subject for attention. When the sun is low in the sky during morning and evening, you might be able to select an angle that allows you to attractively backlight, or even silhouette (page 62), the spider against the sky or the sun. Spiders such as hunters, jumpers and weavers are often best shot from a low, eye-level viewpoint. This type of head-on angle will highlight the spider's impressive fangs and eyes (many spiders have eight eyes) and you can create striking portraits.

With this type of approach, it is not essential for all of the spider's body and legs to be recorded in sharp focus; as long as the eyes are bitingly sharp, it won't matter if the body and legs drift slightly out of focus. Since some spiders remain motionless for long periods, you could choose to focus stack (page 180) if you wish to capture an extended depth of field.

RAFT SPIDER
I captured this striking image of a raft spider at eye level. When photographing spiders on the ground or on water, this viewpoint will often create the most striking and natural result. However, if the spider is contrasted against a suitably colourful or interesting backdrop, an overhead view can also work well.
Nikon D300, 150mm, ISO 400, 1/125sec at f/5, handheld

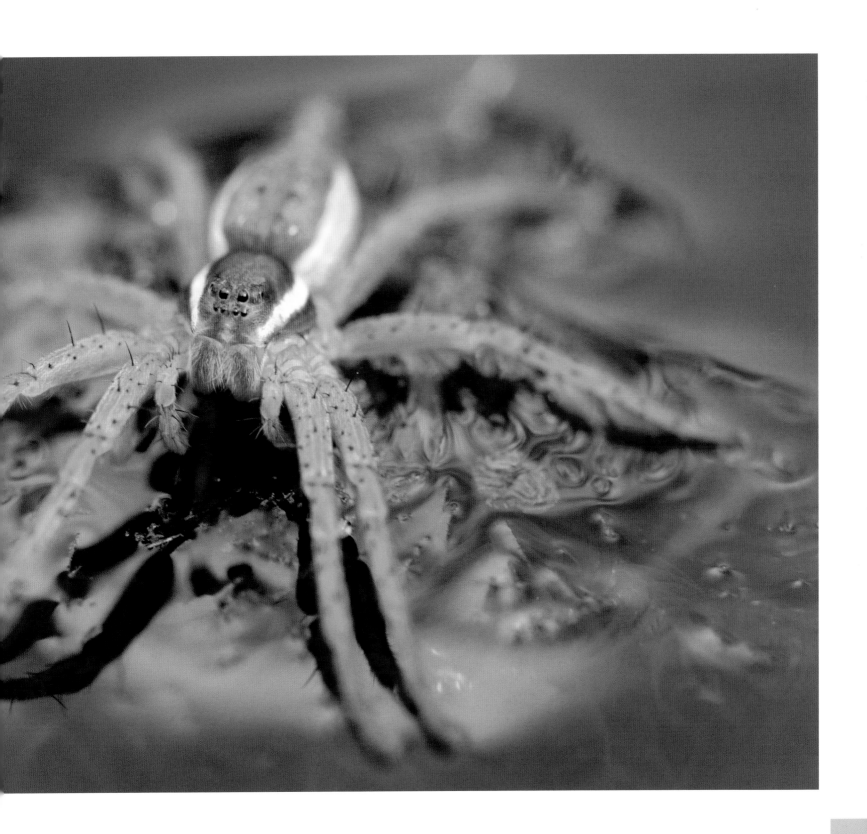

HOW TO PHOTOGRAPH A WEB

The delicate structure and shape of a spider's web makes it almost as appealing to close-up photographers as its creator. By isolating the web alone, photographers can create striking, abstract-looking results. It is amazing just how varied each web can be and, combined with the right backdrop, light and weather, great close-up images are almost guaranteed.

The weather conditions are an important consideration – due to their lightness, webs easily get wind blown. Ideally, opt for a still, windless day. If it is breezy, consider using an umbrella to help shelter the web. Look for a pristine web that is in a position where you can easily isolate it from its backdrop. Tall grasses and small bushes are among the best places to search. Select your viewpoint carefully. A web can look completely different from one side to the other, so explore various viewpoints and opt for the one where the light catches it best and the background is most flattering. Normally, it's best to employ a large aperture, in the region of f/2.8–f/8, to keep background detail nicely diffused. Depth of field will be shallow, though.

To help place your point of focus precisely, use a tripod (taking great care not to knock or damage the web when placing the legs) and focus using Live View (page 56). After still, clear nights, webs will be sparkling with dew, making them both easier to find and more attractive to photograph. Therefore, rise early and shoot before the droplets evaporate. Crop in tight to emphasize the web's pattern and intricacy.

PRO TIP

When photographing spiders, do apply a degree of caution. Some countries are home to poisonous species, and some spiders' bites are potentially life threatening.

SPIDER'S WEB
Webs are great close-up subjects. You could try recording the web in sharp focus throughout. Alternatively, why not highlight just a few strands in order to create a more arty looking result? This is easy to do by selecting a large aperture and positioning your camera at an angle to the web. Only a small part of the web will be sharp, with everything else drifting pleasantly out of focus. In this instance, flowering heather created a colourful backdrop to this abstract web image.
Nikon D300, 150mm, ISO 400, 1/30sec at f/2.8, tripod

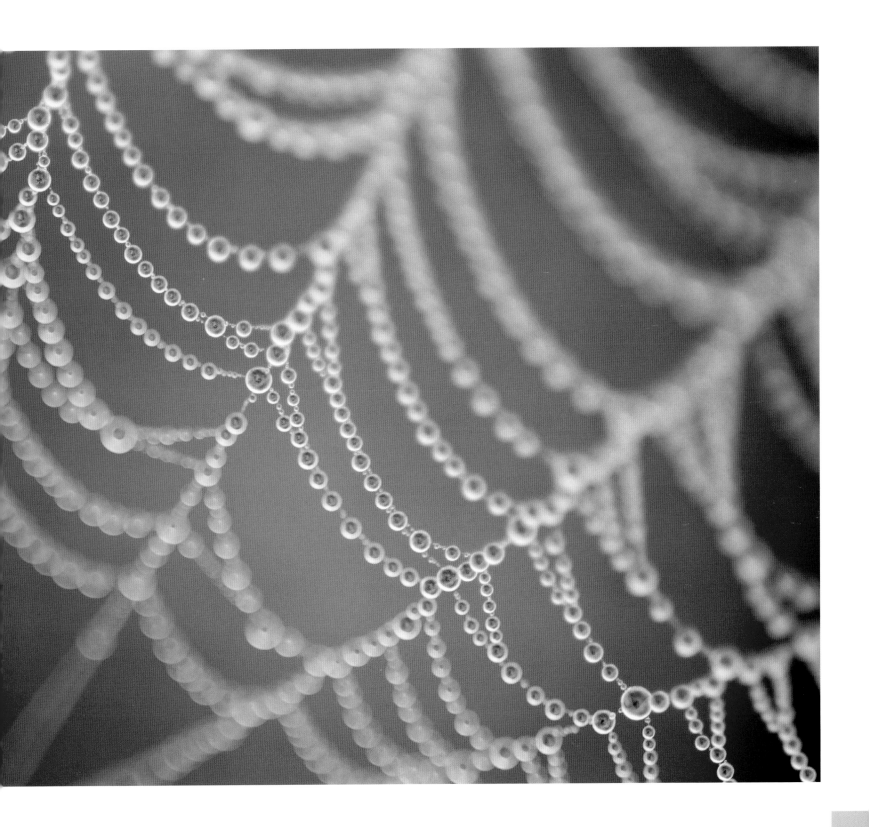

PLANTLIFE

WILD PLANTS AND FLOWERS OFFER A WEALTH OF PHOTO OPPORTUNITIES THROUGHOUT THE SEASONS.

There is no risk of running out of inspiration when shooting close-ups of plantlife. Not only is plantlife a popular subject, but it is also one of the most accessible. Local parks, woodland, countryside and heathland are all home to a wide array of flowering and non-flowering plants. However, highlighting a plant's beauty, form and design in a single frame is far from easy. Simplicity is often key, as are background choice and the light's direction. The skill is to reveal the flow, colour, design and delicacy of plants in close-up.

The ephemeral nature of flowers means that you need to plan your shoot in order to photograph subjects in peak, pristine condition. Research where and when your subject can be found flowering. When practical, visit possible sites regularly beforehand. This will allow you to monitor what stage the plant is at and help ensure that, when you do visit with your camera, it will be at just the right time. The weather generally is a key consideration. Many wildflowers are badly affected by wind movement. This is particularly true of tall plants such as cowslips and poppies. Windy conditions are among the worst for close-up photography, making it difficult, if not impossible, to achieve focus. Plant photography is best attempted in still conditions, with a wind speed ideally below 10mph (16kph).

When you have no choice but to shoot in windy conditions, look for subjects growing in sheltered areas, or employ an umbrella or windbreak. It is also possible to construct your own windbreak using heavy, clear polythene held in position by aluminium rods. Alternatively, aids like the Lastolite Cubelite will help protect small subjects from the elements, while also diffusing harsh light. Another option is clamp your subject into position, using a Wimberley Plamp (page 39). Fasten one clasp to your tripod leg, while using the other to hold your subject still. However, be careful not to damage plants if attaching the clamp to delicate stems.

When photographing plants, one of the most important skills is choosing the right subject in the first place. When potentially confronted with hundreds of plants, identifying the best one to photograph can prove daunting. Look for subjects that are in prime, pristine condition. Remember, even the smallest imperfection will be highlighted in close-up. Check that your subject is growing in a position that will allow you to isolate it comfortably from its surroundings. To help your subject stand out against its environment, employ a shallow depth of field. A degree of 'gardening' (page 148) may also be required.

COWSLIPS
While a macro lens is the natural choice when photographing plantlife, don't overlook longer focal lengths. Using a long telephoto lens, it is possible to create a very narrow angle of view, capable of isolating your subject from its surroundings. This is ideal if you wish to highlight a single plant among a carpet of flowers.
Nikon D300, 100–200mm (at 200mm), ISO 200, 1/100sec at f/4, tripod

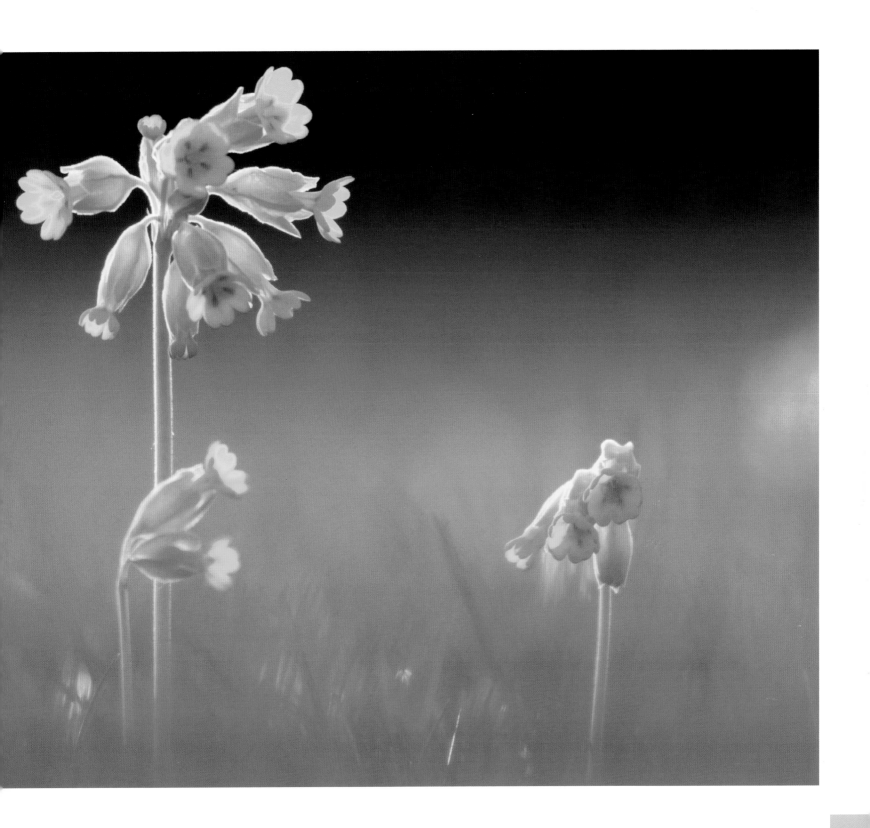

Consider your viewpoint carefully. While filling the frame can help maximize impact, a degree of negative space (page 52) will often produce a better sense of scale. Overcast light is often underrated, but suits plantlife, enabling photographers to record fine detail and colour authentically. Due to the translucent nature of flowers and foliage, backlighting is also well suited to close-up images of plants.

Creativity is also important. Subject or camera motion can transform an otherwise ordinary shot into an arty, Monet-like masterpiece. If your subject is wind blown, consider emphasizing this movement by intentionally selecting a slow shutter speed in the region of 1/2sec. The trick is achieving just the right level of subject blur. If there is too much blur, it won't be recognizable and if there is too little, the level of movement won't appear intentional.

A degree of trial and error is required; simply experiment with different shutter speeds. If necessary, attach a solid neutral density (ND) filter to artificially lengthen exposure time. Talking of filters, a polarizer (page 102) can be handy when shooting close-ups of plantlife. This reduces glare and reflections and helps to restore the natural colour saturation of petals and leaves.

GARDENING

When photographing close-ups of plantlife, what you include and exclude from the subject's background can make or break the image. While your choice of f/stop and viewpoint will greatly dictate the look of the subject's backdrop, when shooting static subjects – like plants – it may also be possible to selectively tidy up the image space. By carefully removing distracting grasses, twigs, or light-coloured or dead vegetation, you can help ensure backgrounds remain clutter free.

This technique is commonly known as 'gardening' and is a popular practice among close-up photographers. While gardening should

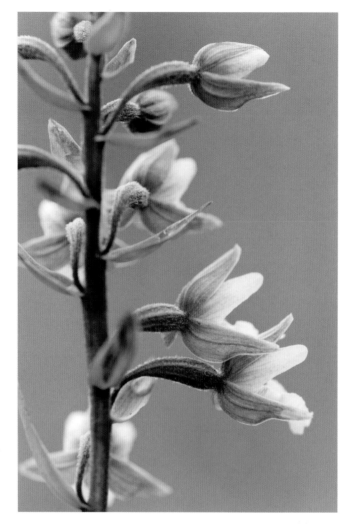

MARSH HELLEBORINE
Before reaching for your camera, examine your subject from all sides – and different angles – in order to help identify the best shooting angle or perspective. In this instance, I shot this helleborine from slightly behind the plant, to highlight the colour and detail of the flower-heads' undersides.
Nikon D300, 150mm, ISO 200, 1/80sec at f/4, tripod

always be kept to a minimum, it can help to produce much cleaner, aesthetically stronger results. Most gardening can be done by hand, by removing bits of decaying leaf matter, small twigs and so on, from around your subject. Distracting background grasses can be gently flattened using your hands, or can be carefully removed using scissors.

Normally it is best to first compose your shot and select the aperture desired. Having done this, depress your camera's depth-of-field preview button (or take a test shot) and carefully scrutinize the subject's surroundings. If you identify any distracting elements, carefully remove them before re-shooting. You may need to repeat this process several times to get the result you want.

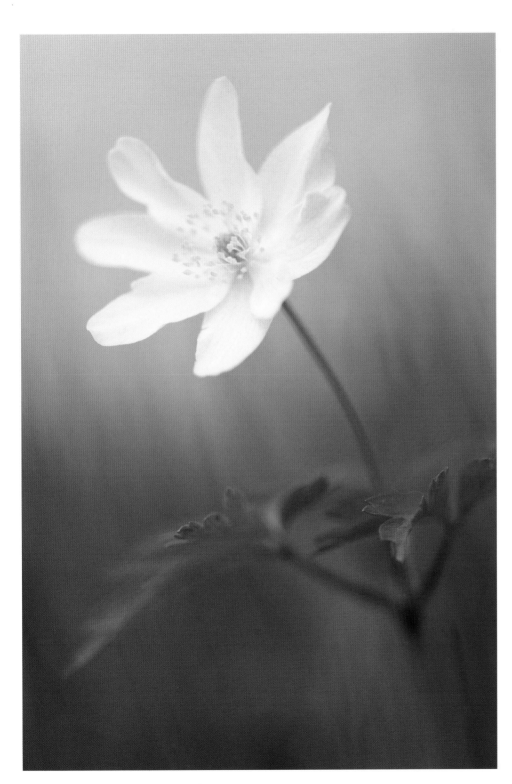

WOOD ANEMONE

One of the key skills to plant photography is selecting the right subject. In close-up, the slightest flaw or damage will appear magnified, so always opt for pristine subjects. Look for plants growing in a position where you can achieve a clean, flattering background. Although a degree of 'gardening' may be required, be careful not to damage or remove surrounding plants or flowers.

Nikon D300, 150mm, ISO 200, 1/250sec at f/2.8, tripod

FUNGI

Fungi have existed for millions of years, evolving into an extraordinary variety of types. Ranging greatly in shape, size and colour – including waxcaps, stinkhorns, puffballs, death caps and fly agaric – mushrooms and toadstools have great photographic potential.

Generally speaking, autumn is the best time to find and photograph fungi. Many types of mushroom favour moist environments and ancient woodland. The older the ground or woodland, the more mycelia (roots) will occur, increasing the likelihood of finding a good range of subjects. Therefore, visit woodland and look for subjects growing on decaying stumps and amongst rotting tree matter, fallen branches and dense leaf deposits. Some are large, grow in clumps, and will be relatively easy to find; others will be small, hidden and well camouflaged. Fungi can emerge suddenly and disappear again almost as quickly, so it can be worthwhile visiting the same locations regularly to see what will change from day-to-day.

Since fungi usually grow in dark, shaded places, a macro lens is the perfect lens choice. It allows you to capture frame-filling images and its fast maximum aperture will provide a bright viewfinder image, aiding focusing and composition. Fungi are static, sturdy subjects, so once located, they can usually be photographed relatively easily. They are rarely affected by weather or wind and a tripod can be employed to aid focusing, sharpness and composition.

However, photographing close-ups of fungi is far from easy. Natural light is normally in short supply in woodland. A mushroom's gills and stem will typically receive less light then its cap, so fill flash or reflected light is often needed to balance the light. Personally, I favour using a reflector (page 64) for flowering and non-flowering plants. The advantage of bounced light over flash is that you are able to easily regulate its effects and quickly change the angle or intensity of light as required. Equally, a sheet of white card, mirror, or tin foil can also be used to reflect light onto the subject.

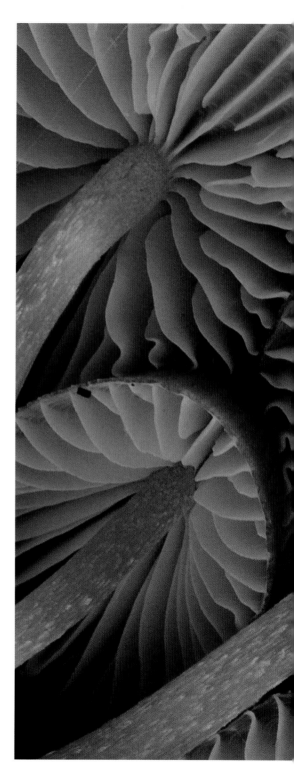

GILLS
Although a low-shooting angle can prove awkward to achieve, it will help highlight the intricate texture and detail of a mushroom's gills. Frame-filling close-ups will not only create striking results, but ensure any distracting background clutter is excluded from the frame.
Nikon D70, 105mm, ISO 200, 4sec at f/22, tripod

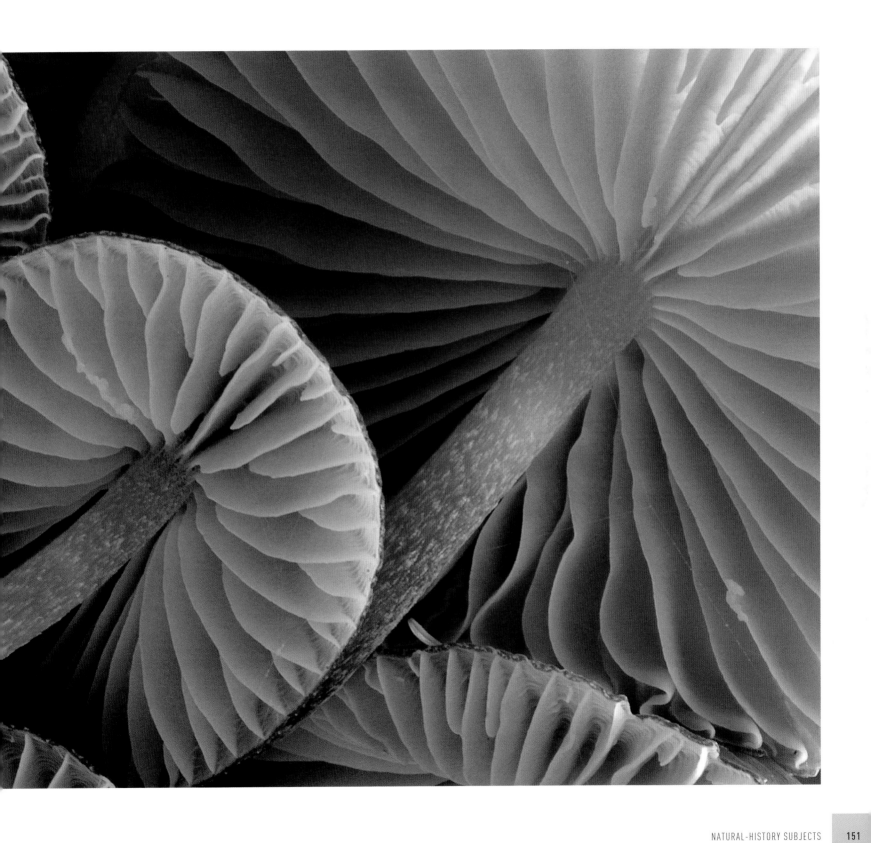

Many types of fungi are strangely shaped, which can complicate how much depth of field is required. For example, a mushroom's cap will extend closer to the sensor plane than its stalk. To keep both acceptably sharp, a smaller aperture is needed. The exact f/stop required depends on the subject size and type, the level of magnification and the effect you desire. However, f/11 or f/16 will normally provide a practical level of sharpness. Review depth of field at the time of taking the photo. You can do this either by depressing the preview button (if your camera has one), or replaying images on the camera's LCD and then scrutinising sharpness.

A mushroom's gills are one of its most photogenic features. To reveal their texture, detail and pattern, a low viewpoint often works well. However, fungi often grow in damp, awkward positions, so it is advisable to use a ground sheet when photographing them – it will help keep your clothing and kit clean and dry. Also, a right-angle finder (page 38), or digital SLR with a vari-angle LCD, is useful for this type of low-level work, greatly assisting focusing and framing. Woodland can be a messy, chaotic environment, so study your subject's surroundings carefully and, if necessary, 'garden' backgrounds to keep them clean and uncluttered. Don't overcomplicate compositions by trying to include too much in the frame. For example, it is often better to isolate just one or two mushrooms, rather than photographing a large, spread-out group.

SPECIES OF MYCENA
Look closely and only photograph pristine subjects. Since fungi often grows up through decaying wood and leaf matter, it is a good idea to use a blower brush to remove tiny, distracting specks of dirt and vegetation before taking your photos. This will save you the effort of having to tidy up the image in Photoshop later, using the Clone Tool or Healing Brush (page 176).
Nikon D200, 150mm, ISO 200, 1/15sec at f/4, tripod

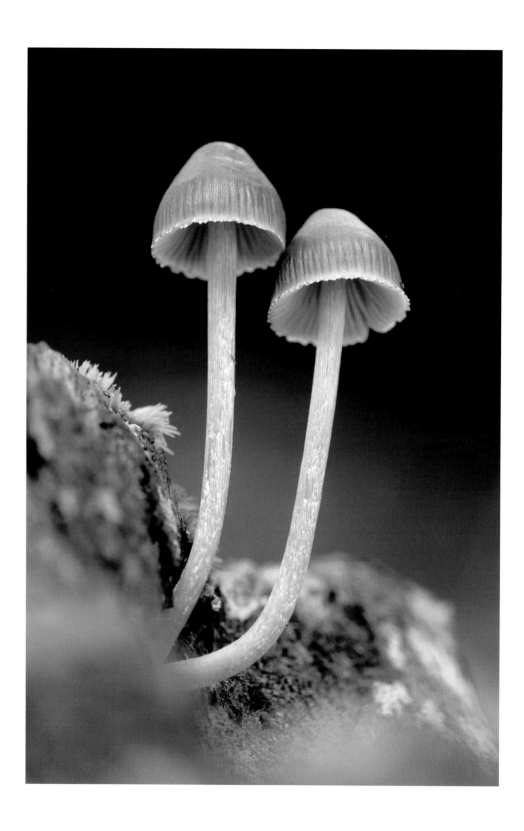

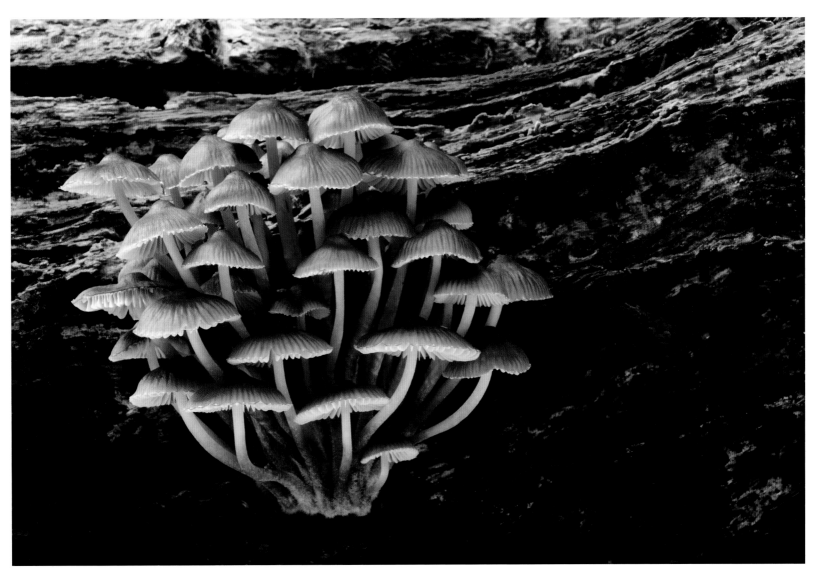

FUNGI

Fungi can grow in large, attractive groups and, potentially, can be shot using almost any focal length. A close approach together with using a wideangle lens can create really striking environmental portraits, although personally I still favour a macro for most of my fungi shots. In this instance, a reflector – placed just below the subject – proved essential for illuminating the undersides of this group.

Nikon D300, 150mm, ISO 200, 3sec at f/16, tripod

TEXTURE, DETAIL, SHAPE AND FORM

When subjects are shot in close-up, emphasis is neatly placed on texture, shape and form. There is no better source of intriguing and fascinating detail than nature, but many manmade materials also justify a closer look. For this type of photography, technique is arguably less important than the skill and imagination to 'see' the image in the first instance.

You don't have to look very far to find photogenic patterns and interesting miniature detail. New patterns are formed within nature every day and can be found all around us. For example, tree bark, the fronds of a fern, a spider's web, the veins of a leaf, a butterfly's wings, pebbles on a beach or wavy ripples in the sand all contain fascinating patterns. Curiously, when photographing close-ups of manmade objects, decay is a great provider of photo potential, such as rust and peeling paintwork (page 168). Seasonal changes also create fresh opportunities for close-ups. For example, in winter, ice, frost and condensation can all look striking in frame-filling close-up (page 162).

Although you might not ordinarily consider photographing many of the subjects mentioned in close-up, things can appear very different to the way we usually perceive them. Shape, texture and form that normally go unnoticed are highlighted, while fine detail and colour are revealed. Usually, a camera records a subject with a high degree of realism. However, an object grows increasingly abstract the more you crop into it, which is why – when shooting texture, shape and form – the subject itself is often less important. It doesn't always have to be recognizable – form is primary; content is irrelevant.

The next few pages cover just a small number of subjects that suit being shot in close-up, but with creative eyes, you will soon identify countless more.

PEBBLES
You have to train your eye to look at subjects differently, more closely and creatively. Very ordinary objects can look extraordinary in close-up. By cropping in tight on these pebbles, I produced a semi-abstract result.
Nikon D700, 150mm, ISO 200, 1/20sec at f/11 tripod

TREES

TREE BARK, WOOD GRAIN AND FOLIAGE ARE PARTICULARLY PHOTOGENIC, WHILE SPRING BLOSSOM AND
AUTUMNAL FRUITS ALSO PROVIDE GOOD CLOSE-UP OPPORTUNITIES.

Considering their size and height, you might
be wondering why trees feature in a book
about shooting miniature things. Obviously,
in their entirety, they wouldn't qualify as
close-up subjects, but look much closer, and
you'll discover fascinating detail and patterns.

BARK

If you've never taken a good, close-up look at tree
bark, it is time you did. It is very tactile and can
be highly patterned and colourful. Different types
can provide different opportunities. While local
woodland is a good starting place, an arboretum
– which is home to a much more varied and wide
choice of trees – is the best option.

If you want to highlight texture, it is often
best to shoot from an angle perpendicular to the
subject. However, if you wish to highlight patterns
or shapes in the bark's surface, a parallel
viewpoint is the best option. Shot with a small
aperture – in the region of f/11 or f/16 – you will
record everything in the frame sharply. Opting for
a smaller f/stop is also important when shooting
the bark of younger trees, as their narrower trunk
will curve away from the centre of the image
more abruptly, potentially drifting out of focus if
the depth of field is insufficient.

Bark can be smooth and glossy, rough and
textured. Smooth barks, like Tibetan cherry,
can be quite reflective, so a polarizing filter
(page 102) can be handy for restoring natural
colour saturation. Bark can also provide a
flattering or interesting natural background in
outdoor still lifes; for example, a colourful leaf
placed on bark can create a lovely contrast in
shape and texture.

HIMALAYAN BIRCH
During a visit to public gardens, I noticed the
interesting, light-coloured bark of this Himalayan
birch. I carefully positioned my camera parallel to
the tree and selected an aperture of f/11 to record
its texture sharply throughout. Overcast light helped
me to record fine detail.
Nikon D200, 150mm, ISO 200, 1/13sec at f/11, tripod

FOLIAGE

Leaves provide one of nature's most beautiful
and photogenic patterns. Just a single leaf holds
a great deal of photogenic appeal and potential.
Leaves on trees are harder to photograph in
close-up. Firstly you have to contend with wind
movement and secondly you have no real control
over the leaf's position, although it may be
possible to 'Plamp' (page 39) small branches into
position. Instead, it is easier to photograph fallen
leaves. In autumn, carpets of fallen, overlapping
leaves can create interesting patterns on the
ground, particularly when they are colourful and
beautifully shaped, like maple and beech leaves.
It is often best to use an overhead angle. Frost
will add further interest and sparkle to your
shots, while dew or rain will leave glossy leaves
smothered in tiny water droplets, each acting like
a miniature magnifier.

Although leaves can be shot in situ, where
they've fallen at the base of the tree, by moving
them you have more control over lighting and the
look of the final shot. By collecting leaves, you can
arrange them to create patterns. Backlighting
(page 62) will really help reveal a leaf's texture
and veining. A lightbox is useful for backlighting
leaves or you can tape a leaf to a lit window to
create a similar effect of translucency.

PRO TIP

In the autumn, collect fallen natural fruits, such as
conkers and acorns, and arrange them carefully to create
interesting patterns for natural still lifes.

PINE NEEDLES
Coniferous trees, like pine, fir, spruce and larch produce long, sharp needles. I find the underside of branches particularly attractive, and the needles can form a striking natural pattern when branches are overlaid.
Nikon D70, 150mm, ISO 200, 1sec at f/16, tripod

BACKLIT LEAF
By collecting fallen leaves and arranging them yourself, you have more control over lighting and the look of the final image. These colourful leaves create eye-catching patterns.
Nikon D200, 150mm, ISO 100, 1/2sec at f/11, tripod

PLANT SHAPES AND TEXTURES

PHOTOGENIC SHAPES, FORM AND REPETITION EXIST EVERYWHERE WITHIN NATURE, BUT PARTICULARLY WITHIN THE WORLD OF PLANTS.

The true design of plants often lies beyond our range of vision. The spiral formed by an uncurling fern, the sweeping curves of a succulent, or the sharp lines of a thorn all create fantastically photogenic shapes. Only close-up photographers have the ability to highlight and reveal this type of exquisite detail.

By abstracting your subject, scale and context are disguised and emphasis is placed on colour, shape and form. You have to study a plant closely and carefully, and in varying light and from different viewpoints, in order to identify the type of detail and form that will translate well into a still image. Look for contrast, colour and symmetry. When shooting a plant's shape and form, the emphasis should be on the subject, not its surroundings. Therefore, crop in tight, using a high level of magnification if required, and fill the frame in order to exclude background detail that might otherwise dilute the subject's impact. If a background is required in order to contrast your subject's shape against, opt for one that is clean and flattering – a simple black backdrop often works well, or nicely diffused, out-of-focus foliage. Potentially, light from any direction will work, but backlighting is renowned for its ability to highlight shape and form.

Composition (page 52) is all about arranging the elements in a visually pleasing and stimulating way. Lines cutting through the image can prove a particularly powerful compositional tool. Usually lines are best placed diagonally, since when placed horizontally they can appear to dissect the image, or lead the eye out of the image space. When shooting shape and form, simplicity is the golden rule. I find with this type of almost

AGAVE PLANT
One of the most appealing things of close-up photography is the ability to isolate and reveal exquisite form and detail. I looked closely at this agave plant to 'see' the photo. Look for patterns, symmetry or intriguing detail within the subject that will make a strong, stand-alone photograph.
Nikon D300, 150mm, ISO 200, 1/40sec at f/11, tripod

abstract photography that compositions have a tendency to 'evolve' over a number of frames, so review your images regularly and fine-tune your composition until you achieve just the result you want. Often, compelling close-ups of plant shape and form rely more heavily on your ability to

pre-visualize, than the actual skill and technique required to take the photo. In fact, in terms of technique, capturing patterns, shape and form is, generally speaking, a fairly undemanding type of photography; it relies far more on your creative eye than your ability to work a camera.

HARTSTONGUE FERN
Use backlight to help define shape and highlight fine detail. I placed a piece of black card behind this small fern to create a simple backdrop. This helped emphasise the spiral shape of it as it began to unfurl.
Nikon D300, 150mm, ISO 200, 1/15sec at f/16, tripod

LICHEN AND MOSS

SMALL, NORMALLY RATHER UNINSPIRING PLANTS, SUCH AS MOSS, LICHEN AND LIVERWORTS, CAN APPEAR COMPLETELY DIFFERENT WHEN CAPTURED IN FRAME-FILLING CLOSE-UP.

A macro lens – or close-up attachment – has the ability to transform the ordinary into the extraordinary. Both lichen and moss are small, slow-growing plants, which grow tight to rocks, trees or on the ground. They often create photogenic patterns as they spread.

LICHEN

Lichen is one of nature's most interesting and tactile plants. Viewed up close, they resemble some sort of miniature alien landscape. They can be found throughout the year growing on living or dead trees and branches, rocks and walls. There is a huge variety and they inhabit all types of environment, including ancient native woodland, heaths, bogs, churchyards and the coast. They can survive in extreme climates and you will find them almost anywhere where it is cool, damp and the air is clean. They are typically at their best and most colourful during wintertime. Many types also produce fruiting bodies at this time of year.

Lichen growing on flat surfaces, like walls, roof tiles, bark, old wooden benches and gravestones can create fascinating, irregular patterns. As with many other plants, diffused, overcast lighting is well suited to photographing lichen. Since lichen are flat, you don't require a large depth of field, and wind movement is never an issue.

Unless you wish to intentionally throw part of your subject out of focus for creative purposes, keep your camera parallel to the surface the lichen is growing on and opt for an aperture in the region of f/11. This should ensure images with edge-to-edge sharpness. Expect to work at quarter life-size or larger to fill the viewfinder.

GRAVESTONE
Some lichens are vibrant green, yellow or orange and create fascinating patterns as they grow and spread. I photographed this map lichen growing on an old gravestone. The lichen alone looked good in close-up, but the engraving helped add further interest to this image.
Nikon D70, 150mm, ISO 200, 1/30sec at f/11, tripod

MOSS

Mosses can form dense, green 'cushions' on woodland floors, rocks and tree stumps. In close-up, you can see a tiny jungle of fernlike foliage with intricate fronds and patterns. In winter, spore capsules also appear. In terms of

technique, moss can be approached in much the same way as lichen. However, its surface isn't as flat and regular, so you may require a smaller aperture in order to create sufficient depth of field. Typically, moss grows in dark, damp places,

such as woodland. Therefore, a tripod is essential for shooting it, as shutter speed can get lengthy when working in poor light, while using a small f/stop and working at magnification.

Don't forget to trigger the shutter remotely when shooting close-ups of inanimate subjects like this. Doing so will eliminate the risk of any camera vibration when using a slow shutter speed. A small amount of reflected light (page 64) can prove essential if you are shooting in relatively dark woodland environments. The impact of moss close-ups can suffer if the image is dominated too much by just a single tone of green. To boost visual interest, consider placing a lichen-encrusted twig, leaf or feather on the moss's surface; or even spray on tiny, photogenic droplets of water.

SPHAGNUM MOSS
When photographing small plants, such as moss and lichen, look for key points of interest, like fruiting bodies, that will add interest, colour and contrast to your photos.
Nikon D300, 150mm, ISO 200, 1sec at f/16, tripod

WINTER

New patterns and fresh photo opportunities are created within nature every day, and winter can prove a particularly productive time for discovering and photographing natural patterns. During freezing temperatures, plants will be encrusted with glistening frost, and when water freezes, thick sheets of ice, full of interesting shapes and textures, are created.

FROST

When freezing weather transforms the landscape into a winter wonderland, grab your thermals, wrap up warmly and head outdoors with your photo kit to look for wintry close-ups. Open spaces, rather than sheltered locations, are best for frost. Hard frost transforms vegetation; look for patterns among dead grasses, reeds, fallen leaves and ferns. Frozen spiders' webs are highly photogenic, creating wonderful wintry patterns. Also look for beautiful, intricate frost patterns forming on windows, glass and metal.

In close-up, you are able to reveal the texture and shape of every tiny ice crystal encrusting your subject. Overcast light can be well suited to winter close-ups, helping to keep contrast low and making it easier for you to capture fine detail throughout. However, photographed in shade, frosty subjects tend to be affected by a cool blue colour cast. This can actually enhance the feeling of coldness, but if you wish to neutralize the cast, select a warmer white balance setting (page 16). Side and direct light will give your frosty images more depth, life and sparkle. Generally speaking, avoid using flash when shooting close-ups of frost, due to the risk of washing out highlights.

Bright, white frosty subjects can fool metering systems into underexposure, rendering them grey instead of white. Therefore, when shooting wintery weather, regularly review histograms and apply positive compensation when required.

ICE

In freezing conditions, pools, puddles, lakes and canals will turn to ice, while along the edges of waterfalls and streams, photogenic icicles will form. Ice has to be among my favourite natural textures to photograph. After days of freezing conditions, overlapping layers of thick ice can create extraordinary patterns. Look for trapped air bubbles, lines and swirly detail on the ice's surface that you can isolate and use to create a strong, engaging composition. Pebbles or feathers suspended in the ice can also make obvious focal points.

Most ice close-ups have a very abstract feel to them. An overhead viewpoint is best for revealing interesting shapes and detail. However, place tripod legs with care and tread carefully, otherwise you may crack the ice, ruining your shot. Intentionally selecting a cooler colour temperature – in the region of 4,500–5,000K – will give your images an attractive blue hue. Personally, I often favour doing this to selecting a 'technically' correct white balance, as it enhances the ice's cold appearance. You don't have to do this in-camera if you shoot in Raw (page 172); you can fine-tune colour temperature during processing. Similarly, increasing contrast in post-production will deepen tones and lift highlights, giving patterns and texture greater definition.

When it is not cold enough for ice outside, it is possible to create your own by filling a clear, shallow dish with 2–3in (6–8cm) of water and placing it in your freezer. Once frozen, take it out and start shooting, either indoors, using window light, or outside in sunlight. When creating your own ice, you could even consider adding something like a leaf or feather to create a key focal point.

PRO TIP

When photographing ice patterns on large bodies of water, always keep to the edges for safety – don't risk either you or your kit falling into freezing water. A focal length in the region of 100mm is usually ideally suited to shooting ice patterns.

BRACKEN
Frost will completely alter the appearance of winter vegetation, like this bracken frond. The tiny ice crystals highlight shape and form and add interest to subjects that you might otherwise have overlooked.
Nikon D600, 150mm, ISO 100, 1/5sec at f/11, tripod

ICE PATTERN
When photographing ice, shoot from overhead with your camera parallel to its surface. This was shot with an aperture of around f/11, which should provide sufficient depth of field for edge-to-edge sharpness. Place the tripod legs carefully to avoid cracking the ice. By isolating interesting shapes, patterns and curvy lines, you will create abstract results.
Nikon D300, 150mm, ISO 200, 1/25sec at f/11, tripod

THE COAST

The seaside is home to no shortage of interesting detail and texture, like wavy sand patterns, pebbles, seaweed, anemones, shells, fishing rope and driftwood. With a creative eye and a little imagination, striking, intriguing and abstract-looking close-ups are possible.

SEA LIFE

I am lucky as I live just a short drive from the sea and often visit with my camera, looking for shapes, form, repetition and colour. Every time you visit the seaside you will discover different patterns and opportunities. Soft early morning or evening light often suits coastal close-ups best, providing attractive sidelight that will neatly highlight a subject's design and texture. Overcast light is also suitable, suppressing excessive contrast, but strong, direct sunlight is normally best avoided.

When you visit the coast, the close-up potential of some subjects – like pebbles, shells and ripples in the sand – is obvious. Patterns like this can be quite large, so a compact camera or digital SLR with a short telephoto will normally suffice. Patterns of all types normally suit being shot from a parallel, overhead viewpoint together with using a small aperture. This is true of coastal patterns too, but don't be afraid to play, either. Try different viewpoints and opt for a larger aperture in order to generate a shallower zone of sharpness to throw parts of your subject selectively out of focus. If you are struggling to discover photogenic patterns, give nature a helping hand by collecting attractive pebbles or shells and arranging them into a more aesthetically pleasing pattern.

Don't overlook the less obvious textures. Mussels, whelks, limpets and barnacles, clinging to rocky outcrops, grow in large communities and form unusual patterns. Seaweed is another good photogenic subject; in close-up, the air bladders and design of widespread species, like egg, spiral and bladder wrack, actually look very striking. It is often best to photograph seaweed wet, so check tide-times and visit on a receding tide. Many coastal subjects are shiny and reflective – wet pebbles, sand and seaweed, for example. Therefore, a polarizer (page 102) is a handy filter when you visit the beach since it can reduce distracting reflections.

SEAWEED
Viewed in close-up, seaweed is surprisingly photogenic. A polarizing filter was used for this shot to reduce glare from its glossy surface, so keep one close to hand when you visit the beach.
Nikon D300, 150mm, ISO 100, 1/4sec at f/16, tripod

PRO TIP

When photographing wavy, intricate sand patterns, push the feet of your tripod firmly into the surrounding sand to ensure stability. To help boast the warmth of golden sands, select a higher white balance setting.

BARNACLES

Soft early morning or evening light can enhance
the three-dimensional feel of detail and texture.
Barnacles clinging tightly to rocks form interesting
patterns in close-up. In this instance, I included
a limpet to add a focal point and scale to my shot.
Nikon D70, 150mm, ISO 100, 1/20sec at f/16, tripod

WATER

WATER CAN BE TRANSPARENT, REFLECTIVE OR SOMETIMES BOTH SIMULTANEOUSLY. TINY DROPLETS OF WATER HAVE THE ABILITY TO TRANSFORM A SUBJECT'S APPEARANCE ENTIRELY.

It is not surprising that water is such a popular close-up subject. Tiny droplets of water add scale and interest to images of insects and plantlife. Water can look sculptural when a single drop is photographed at high speed striking the water's surface, and it can also form striking, highly photogenic patterns when droplets form on flat, glossy surfaces, such as glass, plastic and metal.

WATER PATTERNS

Water droplets can act like tiny lenses, magnifying or refracting objects positioned behind them. So, when photographing droplets, often what the water 'sees' and reflects is more significant than the droplet itself. Water droplets will form on surfaces naturally after rainfall, overnight dew or through condensation. However, using a dropper, spray bottle or atomizer, it is possible to create photogenic water droplets and patterns at any time, on any surface. Water droplets are small, so often a high level of magnification – typically half life-size or greater – is required to capture striking, frame-filling results. One of the biggest challenges when shooting water is selecting a camera angle that will allow you to get the result you want without you and your set-up being reflected in the water's surface. It may mean that you need to fine-tune and make very slight adjustments to the position of your set-up. A larger camera-to-subject distance will also help minimize the problem, so using a telemacro can be beneficial when shooting water patterns.

REFRACTION

Refraction is the directional shift or 'bending' of light rays as they leave one density and enter another; it is the reason why your legs look shorter underwater when viewed above the surface. The way in which water refracts and reflects its surroundings and nearby objects provides endless creative potential for close-up photography. Look closely at water droplets clinging from grasses or twigs, or on clear surfaces, like windows, and you will see that they reflect perfect, miniature, reversed images within them. Photographed in close-up, you can capture this striking effect.

Colourful flowers, sweets, a flag or text are among the subjects that can look particularly eye-catching or colourful photographed through water droplets and can create an image within an image. This type of shot is best captured indoors, where you don't have to contend with wind movement. Also, by creating your own simple table-top set-up, you have more control over light and what objects you wish to refract.

One very simple method of capturing images of refracted objects in water droplets is to place your subject beneath a horizontal glass surface (like a glass-topped table) or by placing picture-frame glass on top of an open box. Create water droplets on the glass's surface by using a fine spray or dropper. Adding a small amount of glycerine to the water can help it form into more regular, consistent beads. Position your camera overhead, so it is looking straight down to the water droplets with its sensor perfectly parallel to the glass. Focus precisely on the water drops, using a small aperture, in the region of f/11 or f/16, to generate a sufficient depth of field to record both the droplets and refracted image sharply. Ambient light should suffice; exposure time may be several seconds, but your tripod will ensure that results are bitingly sharp. Be careful that nearby windows and overhead lighting don't create ugly catchlights in the droplets, though. Varying the distance between the glass and subject will provide different results, so experiment with this. Clear plastic can be used instead of glass, but you will discover in close-up that the surface of plastic is often covered in fine marks, strains and scratches that look ugly and distracting in close-up.

WATER DROPLETS

This shot was the result of luck, not planning. I'd left a broken pedal bin outside to throw away. It rained overnight and in the morning the striking, irregular pattern formed by the water droplets on the bin's brushed-metal surface caught my eye.

Nikon D70, 150mm, ISO 100, 1/6sec at f/11, tripod

H_2O

These droplets were created by condensation on a porch window. I thought I would play on the water theme by printing the H_2O symbol on a sheet of A4 paper and positioning it upside down and about 1ft (30cm) behind the glass. As a result, each tiny water particle reflected the symbol to create this eye-catching pattern.

Nikon D300, 150mm, ISO 200, 1sec at f/16, tripod

DECAY

PEELING PAINT, RUSTING METAL, SPLINTERED WOOD... WHEN PHOTOGRAPHED WELL, PICTURES OF DECAYING OBJECTS HAVE A TRULY FINE-ART OR NOSTALGIC FEEL TO THEM.

Eventually, things fall apart, get abandoned or decay. I can't explain just why dereliction and urban decay are so appealing to photographers, but they are. By cropping in tight and isolating key detail or colour, it is possible to abstract such things as blistered and peeling paintwork, rusty chains and wire, pitted steel and splintered glass.

NEGLECT

Urban decay is a popular form of photography today. However, not everyone is able see beauty or picture potential in ageing or decaying objects – don't worry if you can't; it is a very subjective subject matter. Personally, I favour photographing natural detail and patterns, but I can certainly recognize the appeal of neglect and manmade materials. You may not need to go any further than your own garden shed to find suitable subjects – look for rusty old tins, ageing tools, dusty machinery and blistering paintwork. You could also try exploring old, dilapidated buildings that you know of nearby, although only enter them if they are stable and you have permission. Farm buildings, workshops and harbours are sources of large, rusty chains, ageing machinery, tired paintwork, rusty locks and keyholes. At first glance, hardly exciting subject matter, I know. However, try not to look at the subject in its entirety or for what it is; instead, view objects simply as shapes, texture and patterns.

At the risk of repeating myself, the skill when shooting detail of any type is the ability to visualize the image in the first place; capturing the shot itself will usually prove quite straightforward. Low contrast, nicely diffused light will help you record fine detail, like corrosion eating away at a painted surface. Even in low light, try to avoid using flash – without heavy diffusion it will kill the quality and softness of ambient light. If you are using a tripod, don't worry if shutter speed exceeds several seconds.

Peeling paintwork can appear colourful and highly textured when magnified. The doors and window frames of neglected buildings, like workshops and beach huts, are among good places to look. Blistered paint alone can provide enough interest and colour, but if you are able to include a keyhole, door handle or aging lock to add a focal point to your composition, better still.

Although photographing 'junk' might have limited appeal, remember that there is beauty in everything, and in close-up you can reveal it.

KEYHOLE
You wouldn't imagine that something as mundane as blistering paintwork and an old keyhole could provide sufficient visual interest to create a compelling photo. However, in close-up, the colour and texture of aging objects like this can actually prove highly photogenic.
Nikon D200, 150mm, ISO 200, I/20sec at f/14, tripod

CHAIN
You will find yourself photographing some very odd objects when shooting rust and neglect. For example, the rusty links of this large chain created an intriguing frame-filling pattern in close-up.
Nikon D300, 150mm, ISO 200, 5sec at f/16, tripod

POST-PRODUCTION

Triggering the shutter and capturing your close-up is just the beginning of your journey as a close-up photographer. Most digital images will need at least some degree of post-production before your works of art are ready be shared, printed or published.

Contrary to popular belief, post-processing is not cheating; in fact, good processing skill is often the only way to achieve a faithful representation of the original subject. However, I cannot underline enough the importance of achieving the best exposure, composition and sharpness in-camera. How much post-production is required will greatly depend on the individual image, the file type (page 172) and the result you wish to achieve. If captured and exposed well, Jpegs should require little further work. However, if you shoot in Raw format (which I recommend), your photographs are effectively unprocessed data. To fulfil their full potential, they need processing.

You don't need to be a whizz with Photoshop to bring your Raw files to life. You need to have a good Raw workflow (page 174) and be confident and familiar with a handful of key post-processing tools. For close-up photography, cropping (page 178) is particularly relevant. Cropping an image improves composition, and will increase subject magnification. Although more complex, another useful processing technique for close-up work is focus stacking (page 180). This is when several identical images, captured at varying focal depths, are merged together to create a final result with extended depth of field.

Naturally, things like workflow, post-processing and archiving are big topics. Entire publications are dedicated to the subject; it is impossible to go into any great depth in just a single chapter. However, I have tried to single out a handful of topics that I feel are particularly relevant to close-up work.

REFLECTIONS
For most images, some degree of post-processing is required in order for them to realize their potential. Even small, simple adjustments to contrast, colour temperature and saturation can bring a Raw file to life, while cropping or changing aspect ratio can radically alter and enhance composition. Without doubt, post-processing is an essential part of successful macro and close-up photography.
Nikon D200, 80–400mm (at 400mm), ISO 200, 1/60sec at f/8, tripod

FILE TYPES

DIGITAL IMAGES CAN BE CAPTURED AND STORED IN DIFFERENT FILE TYPES.

The file format helps determine image quality, size and the amount of digital memory required to store it. You can capture images in Jpeg or Raw, and also Tiff on some digital SLRs. Once downloaded onto a computer, they can also be saved as a number of other file types, for example, DNG (Digital Negative) or PSD (Photoshop document). Jpegs require less post-production and effort, but image quality is maximized in Raw.

JPEGS
Joint Photographic Experts Group (Jpegs) require the minimum of effort. Pre-selected shooting parameters, like white balance and sharpness, are applied to the image in-camera, so the photograph is ready to print or share immediately after download. This might sound appealing, but there are drawbacks.

Jpeg are a 'lossy' file type, meaning that some data is discarded during compression. Also, they capture far fewer tonal levels and the file type is generally less flexible or tolerant. Since it is trickier to correct or alter shooting parameters post-capture, if you make a technical error, you are less likely to be able to salvage the photo than if you had made the same mistake shooting Raw. However, the quality of Jpegs is still very good. You can capture Jpegs in different quality settings and sizes. For the best results, opt for a quality setting of Fine at its largest size.

WHY SHOOT RAW?
By shooting in Raw, you are effectively capturing a 'digital negative' containing untouched, 'raw' pixel information. Unlike a Jpeg, the shooting parameters are not applied to the image in-camera, but are kept in an external parameter set, which is accessed whenever the Raw is viewed. Raw files contain more information, a wider level of tones, have a greater dynamic range and are generally more tolerant to error. Without doubt, they are the best option for maximizing image quality. They will also allow you more control over the look of the final result.

Capturing beautifully detailed images is important to macro photographers. The majority of digital SLRs record either 12 or 14 bits of data. A 12-bit sensor can capture 4,096 tonal levels, while a 14-bit chip can record 16,384 different brightness levels. Compare this to a Jpeg that is converted in-camera to 8-bit mode, reducing the levels of brightness to just 256 levels.

By retaining the sensor's full bit depth, Raw enables photographers to extract shadow and highlight detail during conversion that would otherwise have been lost. Higher bit depth also reduces an image's susceptibility to 'posterization', in which abrupt changes from one tone to another are visible.

Once downloaded, Raw files require processing with compatible Raw conversion software. It is at this stage that you are able to fine-tune the image and adjust settings such as exposure, contrast, brightness and colour temperature.

Raw files are larger and require more space to store and archive. They also require the photographer to spend more time working on a computer. However, despite this, for most types of photography the argument for shooting in Raw format is hard to ignore.

TAGGED IMAGE FILE FORMAT (TIFF)
In addition to Raw and Jpeg files, some digital SLR cameras are also capable of capturing images as Tiffs. Tiffs are 'lossless' files, so photographers who shoot in Raw tend to save and store their images in Tiff format, once the original file has been processed. However, shooting in Tiff in the first instance has its disadvantages.

A Tiff is a fully developed file with the pre-selected shooting parameters already applied – similar to a Jpeg. Therefore, it cannot be adjusted with the same impunity as a Raw file. In addition, unlike compressed Jpegs, Tiffs are large and fill memory cards quickly, slowing the camera's burst rate. Therefore, they are better suited to storing converted Raw files than they are for image capture.

RAW CONVERSION SOFTWARE

A Raw file is unprocessed digital data until it is converted and cannot be opened and viewed without using appropriate, dedicated software. Digital cameras are bundled with propriety programs, but their capabilities vary tremendously. As a result, most photographers prefer using third-party software for processing and converting Raws. Adobe, Apple, Phase One, DxO and even Google market Raw convertors. These allow you to download, browse, correct and process your Raw files with the minimum of fuss. I favour Adobe Lightroom for Raw conversion.

DOWNLOADING YOUR FILES

Using a card reader to download your images is more convenient than connecting your SLR to the computer. Since hardware can fail, back up your images on an external hard drive or remote storage before formatting memory cards for reuse.

RAW WORKFLOW

IN ORDER TO GET THE MOST FROM YOUR RAW FILES, YOU HAVE TO BE PREPARED TO SPEND A LITTLE TIME PROCESSING THEM APPROPRIATELY. THE RESULTS WILL MAKE IT WORTHWHILE.

Raw software is very sophisticated and powerful. In order to get the most from the package you buy, I suggest you invest in a detailed manual for that program; it will provide a much fuller, more detailed explanation of the tools available to you than is possible for me to outline here. However, whatever package you opt for, your basic workflow will be very similar. The next few pages give a brief overview of the key tools, but you will soon develop your own personal workflow.

SETTING BLACK AND WHITE POINTS

Although your workflow doesn't have to be in any set order, setting the black and white points is a logical first step. Gaps between the right and left limits of the horizontal axis indicate that the image is not using the full tonal range and might lack contrast as a result. Although this can suit certain images, it is usually best if the tones of an image spread across the full range of the histogram.

The black and white points are typically set using the Levels control. The histogram will be displayed alongside the image when it is opened in your Raw converter and beneath the histogram are usually three sliders. The pointer on the far right represents pure white (255); the pointer to the far left, pure black (0); and the middle pointer represents the mid-tone (128). To set the black point, move the black point slider to the right, to the point just in front of the first line of the histogram. The image will grow darker. To set the white point, drag the white point slider to the left, to the point just after the end of the histogram.

The image will lighten. Using the middle slider, you can adjust the mid-tones – pushing it to the left will brighten the image overall, and moving it to the right will darken it. Some images require more contrast than others, so always adjust the black and white points to taste. Remember, every image is unique, and will need individual treatment.

COLOUR TEMPERATURE

Before making too many adjustments to your Raw file, it is wise to achieve the correct colour temperature. You can do this quickly and precisely using the software's white balance or colour temperature control. Raw software will present you with the normal choice of white balance presets (page 16) to select from, or you can manually set a value. Colour temperature can be altered with greater precision during processing than in-camera. You can set a warmer or cooler temperature, and also adjust tint (the amount of green or magenta).

There is also normally an Eyedropper tool; you simply click on an area of neutral colour to set an appropriate colour balance. However, remember that a 'technically' correct colour temperature won't always produce the most pleasing result. Therefore, always set white balance to suit your subject matter.

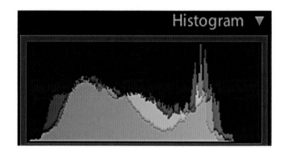

BLACK AND WHITE POINTS
By setting the black and white points, you are spreading the tones of an image and providing contrast. The gaps between the right and left limits of the horizontal axis that you can see here indicate that the image may lack contrast.

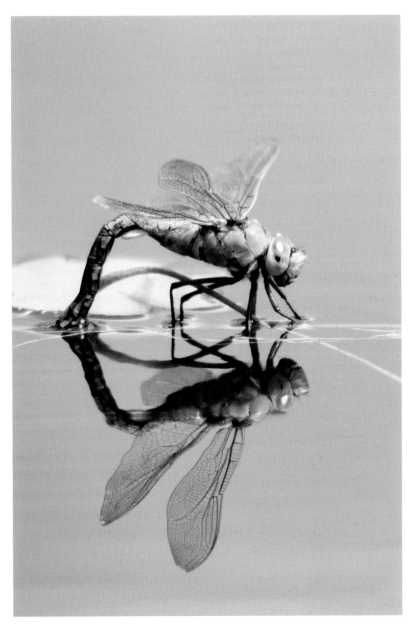

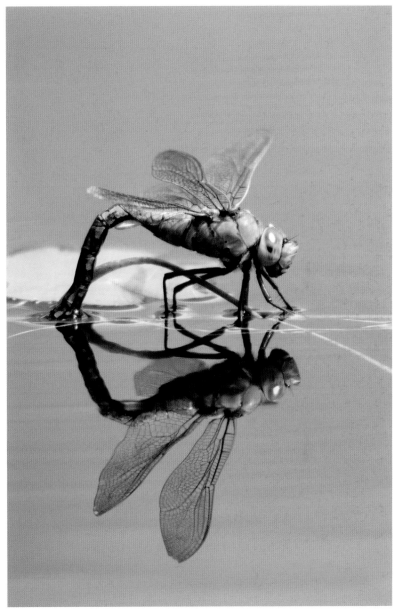

1

2

COLOUR BALANCE
You can fine-tune colour temperature during post-production. You can either select from a
number of presets or manually adjust colour temperature and tint. In this instance, Auto white
balance (1) gave the image an artificially warm, mucky cast. By customizing colour temperature
to suit the image, I was able to produce a far more attractive and natural result (2).

CURVES

Even after setting the black and white points, you may decide that your close-up would benefit from further adjustments to contrast. Most Raw converters have a basic Contrast slider, allowing users to quickly increase or reduce contrast. However, for greater control, use Curves.

The Curves box shows a graph with a line, cutting diagonally at a 45° angle. The bottom left corner represents pure black (0); the top right corner white (255); and mid-point the mid-tones (128). The horizontal axis of the graph represents the original brightness values of the pixels (Input levels); the vertical axis represents the new brightness levels (Output levels). By clicking and dragging the line into different positions you can 're-map' the image's tonal range and adjust contrast.

If you wish to increase contrast, add an S-shaped curve. Do this by pulling down the 'quarter tones' slightly and pushing up the 'three-quarter tones'. You can also create anchor points by clicking on any point along the line. Then, by either dragging them up or down, you can create your customized 'curve'. By moving a point on the grid up, pixels of that tone within the image will become lighter; drag them down and they will become darker.

DUST SPOTTING

Although most digital SLRs now have sensor cleaning systems, any camera which allows you to change lens is prone to dust and dirt entering the camera and settling on the sensor, causing ugly, telltale dust spots. Any marks on the sensor grow more defined and obvious when employing smaller f/stops. Thankfully, it is normally quick and easy to remove marks and dust spots from images using the Clone Tool, which is built into photo-editing software. This allows you to 'clone' pixels from a neighbouring area in order to remove blemishes. The size and opacity of the brush can be adjusted as required.

Some programs also have a Healing Brush Tool. This works in a similar way, but also matches the texture, lighting, transparency and shading of the sampled pixels to the ones being healed. As a result, the repaired pixels appear to blend seamlessly into the rest of the image.

CONVERSION FOR OUTPUT

Once you have finished processing your Raw file, convert the image to your chosen file format. When archiving images, Tiff is generally considered the best option. During the conversion process, you will be given various options. If you intend to make any further adjustments to your image in Photoshop, save Tiffs at their 16-bit setting in order to preserve image quality. If you are positive you have finished working on the file, it is fine to archive images as 8-bit Tiffs to create a more manageable file size.

Export images at 300 pixels per inch in Adobe RGB – this is the industry standard. Name your file as you wish, to suit your naming system. Personally, I tend to give my images a custom name followed by the original file number. This helps me quickly locate the original Raw file should I need to do so, for example, 'blue_butterfly-1234'. Finally, click Export.

CURVES
Curves is a powerful, flexible tool for stretching and compressing tones. By creating a simple 'S' curve, you will increase overall image contrast.

NOISE REDUCTION

One of the final things to do before exporting your processed image is to look for noise (page 19) and, if required, apply a degree of noise reduction. Exposing well, by pushing exposure to the right (page 44), will help keep noise levels low. However, a small degree of noise reduction at the conversion stage can be beneficial. Typically the Noise reduction software built-in to Raw packages is sophisticated. However, since it is effectively obscuring and destroying fine detail, do not be too aggressive with it, and only apply the minimum amount required. A certain degree of luminance noise, resembling film grain, is generally acceptable to the eye, but colour noise is ugly. The amount of noise reduction you need to apply will depend on the individual image.

REMOVING DUST SPOTS

Before exporting your photographs, view them at 100% and check for any distracting marks or dust spots. Normally, they are easy to remove using the Clone Stamp or Healing Brush Tool. It is important to tidy up images before you share or print.

EXPORTING PHOTOS

Once you have finished processing your Raw file, including tweaking such things as exposure, contrast, colour temperature and saturation, your last action is to convert the file. Tiff is the best file format for archiving images. Use a custom name for easy identification and click export.

CROPPING

CROPPING IS A TERM WHICH REFERS TO THE SELECTIVE REMOVAL OF THE OUTER PARTS OF AN IMAGE IN ORDER TO IMPROVE COMPOSITION, MAGNIFY THE SUBJECT, OR TO CHANGE THE ASPECT RATIO.

For most types of photography, cropping is simply a compositional tool. It can also allow you to remove distracting elements from the edge of the frame. Furthermore, you can also change the aspect ratio of the image if your subject doesn't suit the standard 3:2 ratio. For example, you might decide your photograph suits a square format better. However, for close-up photography, cropping an image is also a method of effectively magnifying the subject and is useful when you are unable to get close enough to the subject at the time of capture.

While some cameras allow you to crop images using in-camera editing, it is best done using the Crop Tool in image editing software like Photoshop. Cropping allows you to remove unwanted or distracting elements from the periphery of the frame. For example, you may wish to remove out-of-focus highlights or grasses. It can also be considered a method of increasing subject magnification, as doing so will effectively make your subject larger in the image space. As a result, to some extent, cropping can compensate in situations when you couldn't get close enough to the subject to capture the image you wanted.

However, when you crop an image, it is important to remember that you are discarding pixels and, therefore, reducing the image's resolution and quality. It is for this reason that, while cropping is an important and legitimate tool for close-up photography, you should only do so when it is necessary or genuinely beneficial. However, the quality and resolution of digital sensors is so high today that it is normally possible to crop images without significantly

degrading image quality. For example, my present digital SLR has a resolution of 36 megapixels. As a result, I could crop my images by 50%, which would effectively double the reproduction ratio, and still retain a good-quality, high-resolution file.

Although discarding so many pixels isn't recommended, it is certainly an option in situations when you can't get any closer to your subject due to the risk of disturbing it, or in situations when you are unable to employ a higher level of magnification in-camera. There are other advantages of employing a reduced level of magnification and then later cropping the image accordingly. For example, the risk of camera shake is reduced at lower levels of magnification, and depth of field is larger.

Also, many optics perform best towards the centre of the lens than at the edges. However, personally speaking, when possible to do so, I would always favour getting things right in-camera and only cropping images for the sake of improving composition.

CROPPING

All good image editing software, including Raw converters, have a Crop Tool. Having clicked on the tool, use the selection handles to highlight the area you want to retain. You can normally 'lock' a particular aspect ratio or create your own. Alternatively, you can unlock the aspect ratio and crop images to the exact size you think suits that particular shot best. To perform the crop, click on the selection or press Enter and the area outside your selection will be discarded. Always keep an unaltered copy of the original image, just in case you later decide you don't like the cropped version, or wish to crop the image differently.

UNCROPPED

CROPPING

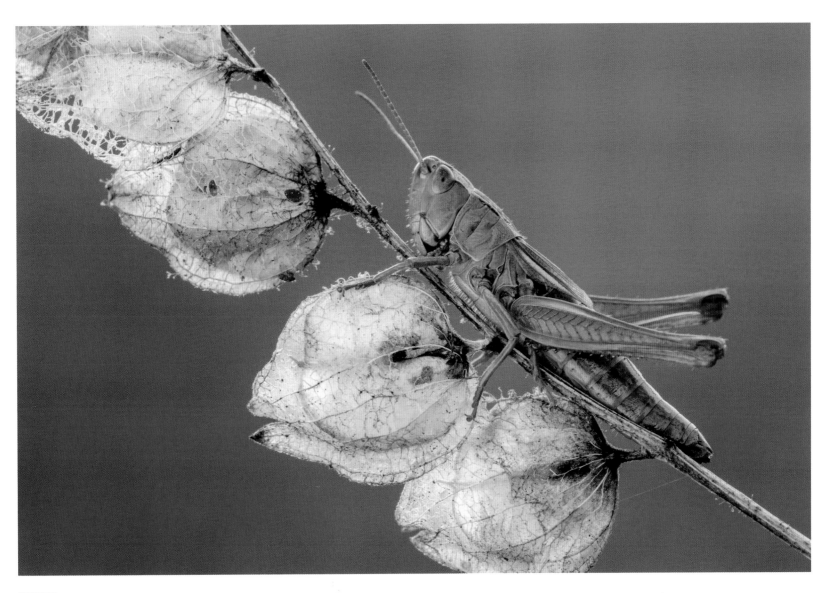

CROPPED

FOCUS STACKING

DEPTH OF FIELD IS OFTEN VERY RESTRICTED IN MACRO PHOTOGRAPHY, BUT AS YOU'LL SEE HERE FOCUS STACKING PROVIDES A HANDY WAY OF EXTENDING IT.

Focus stacking is an image-blending technique, designed to extend depth of field. Put simply, the photographer takes a sequence of images – each captured at different focal depths – and then merges them using software. It is not dissimilar in principle to High Dynamic Range (HDR) photography, only the idea of focus stacking is to extend back-to-front sharpness, rather than dynamic range. Focus stacking is particularly useful for macro photography, where depth of field is often very restricted. At high magnifications, it is not always possible to achieve sufficient depth of field, even at small f/stops, so focus stacking is the answer.

ADVANTAGES OF STACKING

Focus stacking offers photographers a great deal of flexibility. It allows you to capture images using your lens's optimum (diffraction free) aperture – its 'sweet spot' if you like – which is typically between f/5.6 and f/8. Images with a varying level of depth of field can be generated in post-processing and the effect can be altered, depending on the result you require. The technique allows photographers to create results that would be physically impossible using traditional in-camera techniques or equipment. It is a method growing in popularity among close-up and commercial photographers, and also for specialized work, like optical microscopy.

While the principle might sound complex, focus stacking is actually quite easy to do. The starting point is identifying a subject that suits 'stacking'. Due to the nature of the technique, your images need to be taken from an identical perspective. Therefore, ideally, your subject should be static and photographed indoors – wind or subject movement can make it difficult to precisely merge images, although software today is very good at aligning images. Subjects like water droplets, flowers and plants are good objects for first attempts.

Having arranged and composed your shot, take a series of images captured at different focal depths. In other words, you need to vary focus in small increments from in front of the subject to behind it, so that a different part of the subject is in focus each time. This is best done by focusing manually (page 56), using a focusing rail if you have one.

Effectively, you are 'focus bracketing'. In some instances, a sequence of just three or four images will suffice, but typically it is recommended you capture a sequence upwards of 10 files. The amount of photographs required for stacking will depend on the subject, aperture in use and the level of magnification. It is best to err on the side of capturing too many, rather than too few. If you don't capture a sufficient sharpness overlap between images, your composite will not be smooth and will contain 'ghosting' at the edges of detail.

While none of the individual shots will record the subject entirely in focus, the sequence as a whole should contain all the data required to generate an image where the subject will be sharp throughout.

Having captured your sequence, you require appropriate software to align and blend the images together. It is possible to do this in the latest versions of Photoshop, but there are also several, excellent dedicated programs to download online. CombineZM is one of the most popular free focus-stacking programs. Helicon Focus and Zerene offer more functionality, but you pay to download the full versions.

With your sequence uploaded into the software, the program will carefully align and blend the images to create one seamless result with extended depth of field.

STEP 1

Open your image sequence by clicking: File > Scripts > Load files into stack. A Load Layers dialog box will appear. Select your files and click OK. Keep files in the order they were shot.

STEP 2

Select all the layers in the Layers Panel and click: Edit > Auto-Align Layers. In the Auto-Align Layers dialog box, click on Auto and wait for layers to be aligned.

STEP 3

Now, click: Edit > Auto-Blend layers. Check the Stack Images box in the Auto_Blend Layers dialog box and click ok. Photoshop will process the image stack by creating maps that take the sharply focused parts from each frame and combine them to produce enhanced depth of field.

STEP 4

Because of the blending being done, the sides of the final stacked image are often slightly blurry. Simply crop (page 178) the image slightly to resolve this. Make any final adjustments to contrast using Levels or Curves.

VIBRANCE AND SATURATION

SOMETIMES YOU WILL FIND THAT COLOURS IN YOUR PHOTOGRAPHS REQUIRE AN EXTRA LITTLE BOOST IN ORDER FOR YOUR WORK TO REALLY COME TO LIFE.

I've already highlighted the role and impact that colour can have on your close-up images (page 114). However, the colours of unprocessed Raw files, particularly Exposed To The Right images, will often look weak at first. A good degree of natural colour saturation will be restored once the black and white points have been set and contrast correctly adjusted (page 176).

All Raw convertors and image editing software have colour saturation tools with varying degrees of sophistication. Colour saturation shouldn't be confused with colour temperature (page 174). Although you can enhance (or reduce) the colour saturation of any image, it is best applied to the Raw file during processing. All Raw converters have a Saturation control, while some also boast a Vibrance slider. The difference between the two is quite straightforward. Saturation is linear, boosting all colours equally; Vibrance is non-linear and is designed to boost the colours in your image that are less saturated. As a result, the Vibrance tool is typically capable of more natural-looking results. Personally, it is the tool I favour when I feel my images would benefit from a slight colour boost. Vibrance is certainly better suited to natural subjects, like wildlife and plantlife.

There is no magic formula for adjusting Saturation or Vibrance. Simply drag the slider right to increase colour saturation, or left if you want to reduce it. Adjust saturation to taste and keep adjustments small. Caution should always be applied; it is easy to be seduced by the look and instant impact of colour saturation and overdo the effect. In fact, you see a lot of perfectly good images ruined due to photographers getting overenthusiastic with the Saturation

1

slider. Normally, you will want to keep your images looking natural and faithful to the original scene. For even greater colour control, most Raw converters also allow you to fine-tune the Hue, Saturation and Lightness (HSL) of individual colours using a colour wheel, colour picker or a targeted adjustment tool.

2

MARBLED WHITE

Often, adjustments to colour saturation should only be small. Typically, I will apply in the region of +10 to +20 Vibrance and rarely adjust Saturation at all. If I do, it would be by only a small amount. While happy with this image of a marbled white butterfly (1), I felt the colours needed to be slightly enriched, so I increased Vibrance by +15 in Lightroom. The result (2) retains a natural look and has more impact than the unaltered original. The effect might be subtle, but it enhances the photo.

CONVERTING TO BLACK AND WHITE

THE APPEAL OF MONOCHROME IS TIMELESS AND THANKS TO DIGITAL TECHNOLOGY IT HAS NEVER BEEN EASIER TO PRODUCE STRIKING BLACK AND WHITE IMAGES.

Although arguably it is a medium best suited to moody landscape and portrait images, black and white also suits a number of still life subjects as well as many natural subjects. Converting colour images into mono is a relatively quick and simple process and requires just a little time and effort.

Removing colour helps place emphasis on the subject's shape and form and also composition and light. Black and white is often able to convey more drama and mood than its colour equivalent. Although almost all digital cameras allow photographers to capture greyscale images in-camera (or convert captured files in-camera via a Retouch menu), more tonal information is recorded in colour. Therefore, to maximize image quality, continue to shoot in colour and convert to mono in the digital darkroom.

You can convert your images to monochrome either at the Raw processing stage or, having saved your file as a Tiff, in Photoshop. In Raw converters like Lightroom, you have the option to apply various black and white presets that are a handy and quick method of creating good results. However, most photographers prefer using Photoshop or dedicated software like Silver Efex Pro to convert their images.

PHOTOSHOP

There are a number of different ways to convert images to black and white in Photoshop. The simplest is clicking Image > Adjustments > Desaturate, but this offers no control over the result. One of the most popular methods is to use the Channel Mixer (Image > Adjustments > Channel Mixer). This allows you to mix the three colour channels of red, green and blue to simulate the effects of colour filters, in order to adjust the image's tonal range and contrast. When using this method, try to keep the combined total of the three mixer settings to 100%. However, photographers are given even more control over the look of their black and white images in the latest versions of Photoshop, with the Image > Adjustments > Black and White dialog.

STEP 1
Having selected a close-up image suited to conversion to monochrome, click Image > Adjustments > Black and White. There are various options in the dialog box. You can click on Auto and let Photoshop make all the decisions for you. There are also a number of useful presets. However, it is better to adjust the colour channels yourself.

STEP 2
The colour sliders are designed to mimic traditional back and white filters that are used to adjust and control contrast and tone. Using the sliders, it is possible to lighten or darken specific tones by increasing or decreasing selected colours. Doing so can help a subject stand out from its surroundings rather than merge into them.

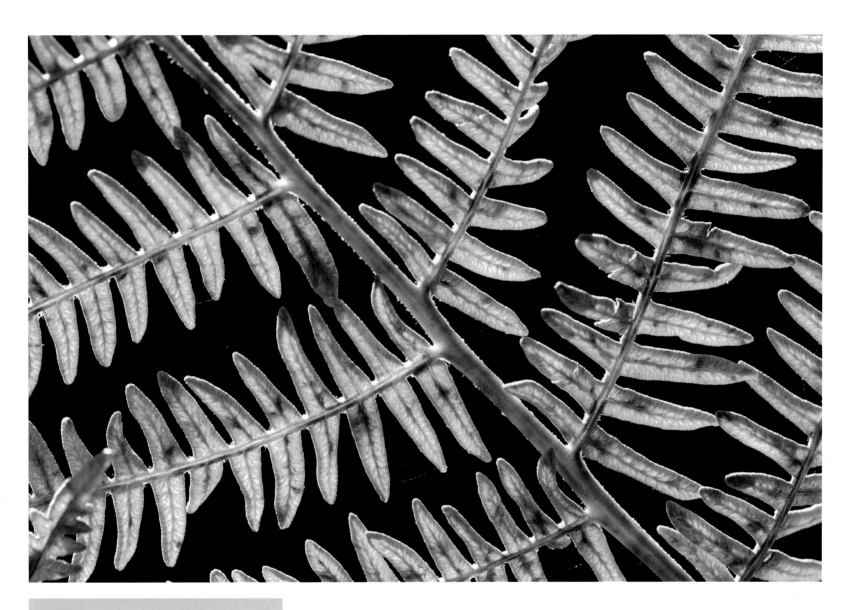

STEP 3

Every image will need individual treatment.
Intuitively adjust the sliders until you achieve just
the result you want. If required, make any final
adjustments to contrast by clicking Image >
Adjustments > Curves. Finally save and export
your black and white. Remember to use a different
file name to the original colour version.

GLOSSARY

Ambient light: Light available from existing sources, as opposed to artificial light supplied by the photographer.

Angle of view: The area of a scene that a lens takes in, measured in degrees.

Aperture: The opening in a camera lens through which light passes to expose the image sensor. The relative size of the aperture is denoted by f/numbers.

Autofocus (AF): A through-the-lens focusing system allowing accurate focus without the user manually focusing the lens.

Bracketing: Taking a series of identical compositions, changing only the exposure value, usually in half or one f/stop (+/–) increments.

Camera shake: Movement of the camera during exposure that, particularly at slow shutter speeds, can lead to blurred images.

CCD (Charge-coupled device): One of the most common types of image sensor incorporated in digital cameras.

Centre-weighted metering: A way of determining the exposure of a photograph, placing emphasis on the light-meter reading from the centre of the frame.

CMOS (complementary metal oxide semi-conductor): A microchip consisting of a grid of millions of light sensitive cells; the more sensors it has, the greater the number of pixels and the higher the resolution of the final image.

Colour temperature: The colour of a light source expressed in degrees Kelvin (K).

Compression: The process by which digital files are reduced in size.

Contrast: The range between the highlight and shadow areas of an image, or a marked difference in illumination between colours or adjacent areas.

Depth of field (DOF): The amount of an image that appears acceptably sharp.

Diffuse light: Lighting that is low or moderate in contrast, as, for example, on an overcast day.

Diffuser: An object used to diffuse or soften light. Often a diffuser is used to soften the shadows of flash light.

Dynamic range: The ability of the camera's sensor to capture a full range of shadows and highlights.

Evaluative metering: A metering system whereby light reflected from several subject areas is calculated based on algorithms.

Exposure: The amount of light allowed to strike and expose the image sensor, controlled by aperture, shutter speed and ISO sensitivity. Also the act of taking a photograph, as in 'making an exposure'.

Exposure compensation: A control that allows intentional over- or underexposure.

Extension tube: A ring fitted between the cameras and lens to increase the distance between lens and image sensor to provide a larger reproduction ratio.

Fill flash: Flash combined with daylight in an exposure. Used with naturally backlit or harshly side-lit or top-lit subjects to prevent silhouettes forming, or to add extra light to the shadow areas of a well-lit scene.

Filter: A piece of coloured, or coated, glass or plastic placed in front of the lens for creative or corrective use.

F-stop/number: Number assigned to a particular lens aperture. Large apertures are denoted by small numbers such as f/2.8 and small apertures by large numbers such as f/22.

Focal length: The distance, usually in millimetres, from the optical centre point of a lens element to its focal point, which signifies its power.

Highlights: The brightest areas of an image.

Histogram: A graph used to represent the distribution of tones in an image.

Hotshoe: An accessory shoe with electrical contacts that allows synchronization between the camera and a flashgun.

Hotspot: A light area with a loss of detail in the highlights. This is a common problem in flash photography.

ISO (International Standards Organisation): The sensitivity of the image sensor measured in terms equivalent to the ISO rating of a film.

Jpeg (Joint Photographic Experts Group): A popular image file type, compressed to reduce file size.

LCD (liquid crystal display): The flat screen on the back of a digital camera that allows the user to playback and review digital images and shooting information.

Lens: The 'eye' of the camera. The lens projects the image it sees onto the camera's imaging sensor. The size of the lens is measured and indicated as focal length.

Macro: A term used to describe close focusing and the close-focusing ability of a lens.

Manual focus: This is when focusing is achieved by manual rotation of the lens's focusing ring.

Metering: Using a camera or handheld light meter to determine the amount of light coming from a scene and calculate the required exposure.

Metering pattern: The system used by the camera to calculate the exposure.

Megapixel: One million pixels equals one megapixel.

Mirror lock-up: Allows the reflex mirror of an SLR to be raised and held in the 'up' position, before the exposure is made.

Monochrome: Image compromising only of grey tones, from black to white.

Multiplication factor: The amount the focal length of a lens will be magnified when attached to a camera with a cropped type sensor – smaller than 35mm.

Noise: Coloured image interference caused by stray electrical signals.

Overexposure: A condition when too much light reaches the sensor. Detail is lost in the highlights.

Perspective: The way in which the subject appears to the eye depending on its spatial attributes, or its dimensions and the position of the eye relative to it.

Photoshop: A photo-editing program developed and published by Adobe Systems Incorporated. It is considered the industry standard for editing and processing photographs.

Pixel: Abbreviation of 'picture element'. Pixels are the smallest bits of information that combine to form a digital image.

Polarized light: Light waves vibrating in one plane only as opposed to the multi-directional vibrations of normal rays. This occurs when light reflects off some surfaces.

Post-processing: The use of software to make adjustments to a digital file on a computer.

Prime: A fixed focal length. A lens that isn't a zoom.

Raw: A versatile and widely used digital file format where the shooting parameters are attached to the file, not applied.

Reflector: A surface from which light is reflected for use as an additional light source.

Remote release: A device used to trigger the shutter of a tripod-mounted camera to avoid camera shake.

Reproduction ratio: The ratio of the size of the real-life subject to its image in the focal plane.

Saturation: The intensity of the colours in an image.

Shadow areas: The darkest areas of the exposure.

Shutter speed: The shutter speed determines the duration of exposure.

SLR (single lens reflex): A camera type that allows the user to view the scene through the lens, using a reflex mirror.

Stalking: To track or observe a subject stealthily.

Telephoto lens: A lens with a large focal length and a narrow angle of view

TTL (through-the-lens) metering: A metering system built into the camera that measures light passing through the lens at the time of shooting.

Tiff (Tagged-Image File Format): A universal file format supported by virtually all image-editing applications. Tiffs are uncompressed digital files.

Underexposure: A condition in which too little light reaches the sensor. There is too much detail lost in the shadow areas of the exposure.

Viewfinder: An optical system used for composing and sometimes focusing the subject.

White balance: A function that allows the correct colour balance to be recorded for any given lighting situation.

Wideangle lens: A lens with a short focal length.

USEFUL WEBSITES AND DOWNLOADS

CALIBRATION
ColorEyes Display: www.integrated-color.com
ColorVision: www.colorvision.com
Xrite: www.xrite.com

CAMERA CARE
Visible Dust: www.visibledust.com

CONSERVATION PROJECTS
2020VISION: www.2020v.org

OUTDOOR EQUIPMENT AND CLOTHING
Paramo: www.paramo.co.uk
Wildlife Watching Supplies:
www.wildlifewatchingsupplies.co.uk

PHOTOGRAPHERS
Ross Hoddinott: www.rosshoddinott.co.uk
Matt Cole: www.mattcolephotography.co.uk

PHOTOGRAPHIC EQUIPMENT
Canon: www.canon.com
f-stop gear: http://fstopgear.com
Gitzo: www.gitzo.com
Hoya: www.hoyafilter.com
Joby: http://joby.com/gorillapod
Kenko: www.kenkoglobal.com
Lastolite: www.lastolite.com
Lexar: www.lexar.com
Manfrotto: www.manfrotto.com
Nikon: www.nikon.com
Novoflex: www.novoflex.com
Olloclip: www.olloclip.com
Olympus: www.olympus.com
Pentax: www.pentaximaging.com
Sigma: www.sigma-photo.com
Sony: www.sony.com
Tamron: www.tamron.com
Wimberley: www.tripodhead.com

PUBLISHER
Ammonite Press: www.ammonitepress.com

SOFTWARE
Adobe: www.adobe.com
Apple: www.apple.com/aperture
Combine ZM: http://hadleyweb.pwp. blueyonder.
co.uk/CZM/News.htm

SUNRISE AND SUNSET DIRECTION
The Photographer's Ephemeris:
www.photoephemeris.com

USEFUL READING
Buglife: www.buglife.org.uk
Dragonfly Society: www.british-dragonflies.org.uk
Digital Photography Review: www.dpreview.com
Digital SLR Photography magazine:
www.digitalslrphoto.com
Discover Wildlife: www.discoverwildlife.com
The Wildlife Trust: www.wildlifetrusts.org

ABOUT THE AUTHOR

Ross Hoddinott has had a deep passion and fascination for the natural world from an early age. He would spend hours peering into ponds and observing the wildlife close to his parent's home in north Cornwall, UK. His parents introduced him to photography when he was 10 by giving him a compact camera as a present. Ross instinctively photographed wildlife and soon he was hooked.

In 1990, Ross won BBC Countryfile's junior flora and fauna category in their annual photo competition. Encouraged, Ross continued taking pictures. By the time he won the Young Wildlife Photographer of the Year competition a few years later, he had already decided to pursue a career in photography.

Now Ross is among the UK's leading outdoor photographers. A regular contributor to a number of national magazines, including *Outdoor Photography* and *Digital SLR Photography*, his work is published widely. Ross is contracted to NaturePL and the National Trust is among his list of clients. He has enjoyed multiple successes in the international Wildlife Photographer of the Year competition and in 2008 was on the judging panel for the competition. In 2009 Ross won the British Wildlife Photographer of the Year competition at the annual BWPA awards. He is also the author of five photography books, including *Digital Exposure Handbook – Revised Edition*, *The Landscape Photography Workshop* (co-authored with Mark Bauer) and *The Wildlife Photography Workshop* (co-authored with Ben Hall). Ross is also one of the 2020VISION photo team – the largest, most ambitious multi-media conservation project ever staged in the UK. He is an Ambassador for Nikon UK and also one of Manfrotto's Local Heroes.

Ross is best recognised as a close-up photographer, specialising in photography of insects and wild plants. He is also known for capturing evocative landscape images of the South West of England's stunning landscape and coastline. This region, and its natural history, is a constant inspiration to him. Working close to home allows him to gain an intimate knowledge of the area, while also minimising his carbon footprint. Ross and his wife, Fliss, presently live close to the north Cornwall/Devon border, together with their three children.

Find out more about Ross at:
www.rosshoddinott.co.uk

ACKNOWLEDGEMENTS

So many people have helped to make this book a reality, that I feel quite guilty having only enough space to say a brief 'thank you'. Firstly, thank you to the team at Ammonite Press, particularly Gerrie Purcell, Jonathan Bailey, Wendy McAngus and Robin Shields. Also, thank you Canon, Lastolite, Lexar, Manfrotto, Nikon, Novoflex, Olloclip, Sigma and Wimberley for supplying product images; and to Matt Cole for sharing his specialist knowledge on macro flash lighting, together with his fantastic images.

However, as always, the biggest 'thank you' is reserved for my fabulous family. Their love, support and encouragement is never failing. My marvellous parents, Mike and Trisha, supported and encouraged me from such a young age to pursue a career in photography. You are amazing people and friends. My wife, Fliss, is simply the most wonderful person I've ever met. She understands me and the demands of my work. She is my best friend and the most fantastic mother to our beautiful children, Evie, Maya and Jude. I love you all...

INDEX

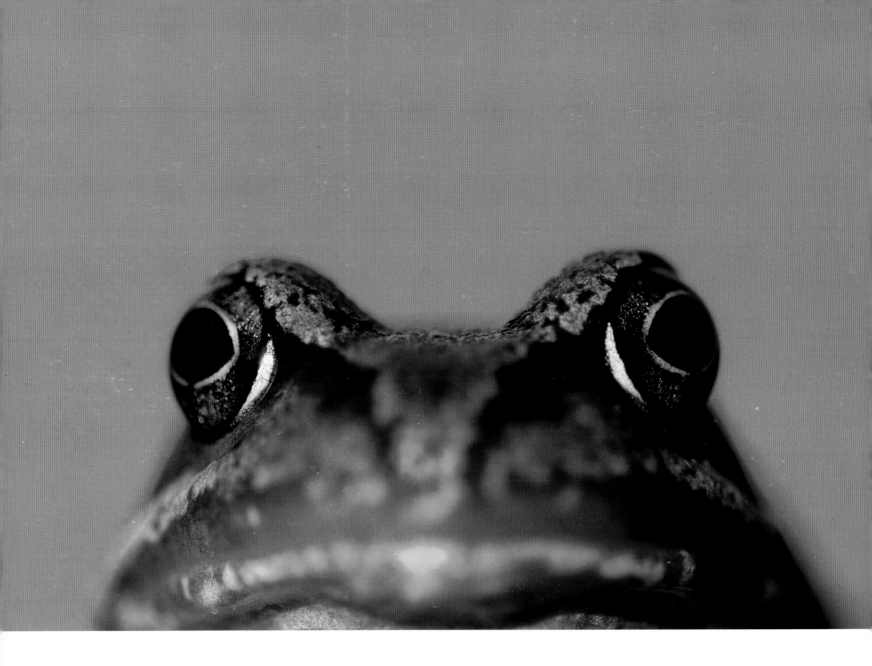

AMMONITE
PRESS

To place an order, or request a catalogue, contact:
Ammonite Press
AE Publications Ltd, 166 High Street, Lewes, East Sussex, BN7 1XU, United Kingdom
Tel: +44 (0)1273 488006
www.ammonitepress.com